Mastering
Silhouettes

Mastering Silhouettes

Expert instruction in the
art of silhouette portraiture

CHARLES BURNS

STACKPOLE
BOOKS

*To Kazumi, my wife and best friend, for all her help and support
in the making of this book.*

Conceived, edited, and designed by Fil Rouge Press Ltd
110 Seddon House, Barbican, London EC2Y 8BX

Published by
STACKPOLE BOOKS
5067 Ritter Road
Mechanicsburg, PA 17055
www.stackpolebooks.com

ISBN: 978-0-8117-0149-5

Printed in China

10 9 8 7 6 5 4 3 2 1

First edition

Cover design by Tracy Patterson with Wendy Reynolds

Cataloging-in-Publication Data is on file with the Library of Congress

Working with art materials inherently includes the risk of damage or injury, therefore the
author and publisher cannot guarantee that the information in this book is safe for everyone.
For this reason, this book is sold without warranties or guarantees of any kind, expressed or
implied, and the publisher and author disclaim any liability for any injuries, losses, or damages
caused in any way by the content of this book or by the reader's use of the techniques and
tools herein. The publisher and the author urge readers to thoroughly review the information
and to understand the use of all tools and techniques before starting any project.

Fil Rouge Press
Publisher Judith More
Managing Editor Jennifer Latham
Designer David Jones
Editor Claire Cross

Contents

Foreword

Throughout history we have relied on portraits to gain an insight into the people of the past, yet, frustratingly, most painted portraits conceal as much as they reveal—in many cases the clothes, accoutrements, or setting are as much the contrivances of the artist as the play of the smile or the twinkle in the eye. Often, portraits hanging on a gallery wall seem to entomb the past rather than enliven it. As a result, we often turn to the artist's sketches—when we have them—or caricatures, for a glimpse of the unique vitality of the sitter.

Silhouettes (an art that has echoes of the "cameos" of the ancient world) combine the appeal of both the sketch and the caricature—the incisive capturing of individuality through simplification and exaggeration—to provide their own special insight. Their heyday in the eighteenth to mid-nineteenth centuries, and again in the twentieth and twenty-first centuries, coincides with the heyday of the caricature, yet, unlike the classic caricature, they are often affectionate, charming, and wonderfully delicate. The reduction of the detail to a single line still allows the artist to add accessories such as a ribbon, hat, or cigar, which, as well as providing a flourish, add character and also bring the viewer's focus back to the carriage of the head, the strength of the jaw or the fullness of the lips. All by cutting a single piece of paper in a few moments.

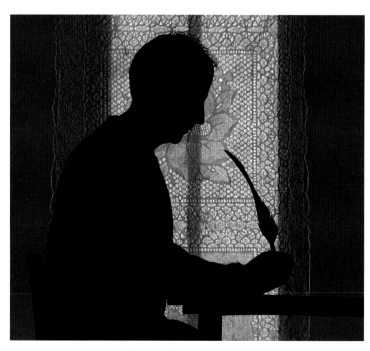

Peter Furtado at his desk, by the author.

Silhouette art requires decisiveness, confidence, and an ability to "see" a person in an instant and to capture their essence. Charles Burns has that ability, built up over many years' practice. Having your portrait cut by Charles takes just a minute or two, but when you are presented with the finished article, it becomes clear that something exceptional has just taken place: you know you have been "seen," and a little miracle has taken place.

In this book, Charles shares his knowledge and his craft. Enjoy.

Peter Furtado
Editor, *History Today* magazine
1997–2008

Introduction

A gentleman by Isabella Beetham (collection of Diana Joll).

When people ask what I do, I always describe myself as a self-taught silhouettist. Of course, nobody is truly "self-taught," and what I mean to say is that I had no living teacher. All of my teachers (and there have been many) have taught me through the many portrait "shades," or silhouettes, they left behind. It is only by examining these portraits and thinking about how they were made that I have learnt as much as I have about this fascinating but obscure art.

My plan is to introduce you to each of these "teachers" in turn: to take a brief look at their work, reveal a little about the lives they led, and then outline in some detail the lessons they taught me. This will take the form of a series of projects that you can follow, each demonstrating some aspect of silhouette art and providing practical ways to create interesting portraits. We will follow the same path I took in my own study of the art, although not in exactly the same order; I hope the order I have chosen is more logical and helpful than my own chaotic development as an artist over the last 25 years or so!

This book is written for the thousands who, on having their silhouette cut, found themselves both fascinated and full of nostalgia. It is especially for those who are eager to create their own portraits of family and friends to hand on as heirlooms to future generations. I have tried to create projects where beginners to the art can achieve good results without the many years of practice normally required.

Many of the projects can be undertaken by people of moderate ability and little artistic experience, although I hope artists, both amateur and professional, will also find new ideas and inspiration. Finally, despite their at times austere appearance, silhouettes are a social art; for those looking for ways to entertain a gathering of friends, whether at a children's party or a daughter's wedding, there are plenty of ideas.

How I became a silhouettist

I first became aware of silhouettes while working as a street artist in Covent Garden, drawing ten-minute pencil portraits for visitors to London. I had been doing this happily for many years after leaving art college when, one summer, a Spanish artist turned up, cutting profiles from black paper with scissors. As soon as I saw his work, I realized two things: firstly, that this was an art I had always known about, without ever researching it; and secondly, that he wasn't very good. None of his portraits had that all-important but elusive "likeness," and a number of his clients were walking away (rightly, in my view) without paying. After a few weeks he left Covent Garden, and I decided to give silhouettes a go myself.

I started by cutting silhouettes of friends and family with a pair of ordinary scissors. After an initial

period of rapid progress, I quickly ran into problems and began to feel the lack of a teacher. It was at this point I realized the extent to which silhouette had become a lost art, so I began looking at the work of historical artists, searching for clues to improve my own practice.

An alternative history

I quickly realized that researching the lives of past silhouettists was an unusual course to take; the few books available tend to be written by a small—but enthusiastic—band of collectors, seemingly bewitched by the beauty of shadowy portraits created many years ago.

However, while reading them, I became aware of an alternative story of art unfolding before me. Alongside the history I had learned at art college—one of classicism, artistic renaissance, mannerism, and various artistic revolutions from the Impressionists onward—here was quite a different story to discover. I found a succession of (mostly) honest men and women: unknown characters with names like John Miers, Isabella Beetham, and Augustin Edouart. Professionals all, they spent their lives earning a living—some of them quite a good living—from art. Their clients were ordinary, hard-working people with little in the way of disposable income. Theirs was an art that seemed not to take itself too seriously (exhibiting none of the pretensions of the fine art establishment), which yet had its own periods of renaissance, mannerism, and decadence, of total collapse after the invention of the camera and a quiet revival early in the twentieth century. The earlier history corresponds roughly to the Georgian period from 1760 onward, through the Regency and early Victorian periods until about 1860.

Frustratingly, there always seemed to be one piece of information missing, and as an artist, this seemed to me the most important of all: how were these works created? What methods did these artists use? For this reason, most of my research has been conducted via a process of artistic trial and error. Although information on their methods was missing, when I looked at the work of each, rather than ask, "How did they do that?" I thought, "How could I do that?" I then applied any insights gained to modern subject matter, to the many real people who have been kind enough to lend me their profile for a few minutes' experimentation.

How to use this book

You should approach this book armed with some simple art materials and with the help of a friend to act as a model. Whether your main interest is in the history or the art itself, if you immerse yourself in the projects, the works of the artists from the past will come alive for you as they have for me. There is a real sense in which you "meet" an artist by following their methods and practices, and looking at the ways they overcame their problems. At the start of each project, I will indicate how difficult it is and give a list of the materials you will need.

The materials used are modern equivalents of those that would have been available in the eighteenth or nineteenth centuries. Do, if possible, use good-quality materials. Apart from projects requiring junk mail and newspaper (for which anything will do), it is worth investing in good-quality paper, pencils, and brushes. Bear in mind that as silhouettes are small in size and tend to be made from simple materials, whatever you use will be in small quantities.

Although I do not expect you to do the same, I have tried to complete most of these projects without the use of a camera. I felt this was important to replicate truly the methods used by past masters. My thinking has been that if I can get a good result without using a photograph, then it is at least possible that this was the way it was actually done. Historians, quite rightly,

will be quick to spot the error in my thinking: without documentary evidence, I cannot guarantee that these projects reflect the way early silhouettes were made. All I can do is rely on my own intuition as an artist, which tells me that this is so.

I have also made use of archaic machinery such as pantographs and the *camera obscura*. Since I do not imagine you have access to such equipment, I will assume you have a digital camera instead, together with the means and knowledge to print out draft-quality photographs in a range of sizes.

Commissioning a portrait

People tend to think of silhouette as a forgotten art. Actually, it is alive and well, and silhouettes are still available from a wide variety of artists for a fraction of the cost involved in commissioning a portrait in oils or watercolor. You may have come across such an artist in Disneyland, or even Montmartre, Paris. A quick search on the internet will reveal plenty more, some better than others, offering to cut or paint a silhouette from a photograph. The question, therefore, is not how to find an artist, but rather which one you should choose.

There are three ways to commission a silhouette: send a photograph, arrange to visit an artist's studio, or look out for an artist making a public appearance—for example, in a local department store. This last option was once a common way for silhouettists to work, but is increasingly rare today, largely because of the prohibitive cost of advertising such appearances. However, prices at these events are often very reasonable, perhaps as little as a quarter of the studio price, so you lose little by taking a chance on an unknown artist. If you find one, these events are not to be missed. Nowadays, as you can send photographs by e-mail, you can commission a silhouette from anywhere in the world, but do bear in mind that the artist won't have met you. Also, the resulting silhouette will only be as good as the photograph you send, so find out what the artist needs and send exactly that. If the artist is local, check if there is a studio or gallery where you can see their work. Many artists these days take part in "open studio" event days, when members of the public can visit what are normally private studios. Find out if there is such an event in your area and ask to be put on the artist's e-mail distribution list to receive information about exhibitions and public appearances. This is often the best way to meet silhouette artists and gain an insight into their work.

Booking a private sitting at an artist's studio is quite an exciting occasion. Find out what you should wear: whether to arrive wearing your best outfit or everyday clothes. The impulse to look your best for the artist is almost universal, but many artists (myself included) prefer clients not to do this. In fact, the best portraits are often those that show us as we are in everyday life.

The Queen of England and the Duke of Edinburgh cut freehand with scissors, 2006 (by kind permission).

Basic
Skills

Shadows as Portraits

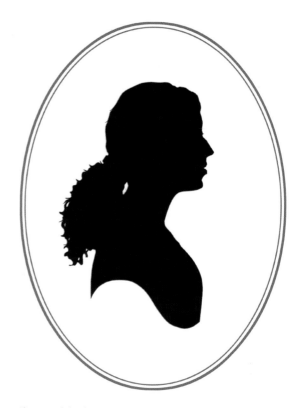

This book will introduce you to a wide variety of silhouettes and the techniques to make them. There are almost as many styles of silhouette as there are artists. Yet, however they are made, you will find that silhouettes all have things in common. In general there are three stages in the making of any silhouette:

1) Taking, or capturing, your sitter's profile.

2) Reducing the scale.

3) Creating the finished silhouette.

Sometimes you will find yourself combining two or even all three of these stages in one operation, but keeping these stages clear in your mind will help enormously as you seek to create a successful portrait; they map out the route to becoming a competent silhouettist. However, the most basic skill of all is learning what it is that makes a successful silhouette.

Above: Look for the eyes and ears in a good silhouette.

Below: A set of half silhouettes cut with scissors. Some are easier to "see" than others; can you tell which they are?

Recognizing a good silhouette

Today silhouettes are often seen as slightly nostalgic references to times past, collectable for their decorative qualities, and, as such, we tend not to view them as likenesses in the way that people living two centuries ago did. Yet silhouettes are most definitely portraits, and on greater inspection, many are often surprised at how closely they resemble individual people. The German writer Johann Wolfgang von Goethe (1749–1832) described them as "the purest of all portraits" and as "those which most clearly expose the soul of the sitter." Portraiture is often considered one of the most difficult aspects of learning to draw, the struggle to capture likeness being a challenge for any artist. It is as portraiture that silhouettes work best of all, and so it is as portraits they should be judged.

If you are familiar with the subject of a silhouette, it is relatively easy to judge the likeness; the problem arises when you do not know the person. As shades from the Georgian and Regency periods are portraits of people long dead, and even modern silhouettes are likely to be of people you may never meet, how can you judge whether the silhouette is a good likeness?

Although it is impossible to be certain, it is possible to judge whether a silhouette *could be* a good likeness. Silhouettes, or "shades," rely on an ability we all have to piece together the bits of a face we cannot see, which is partly why they are so effective. Our eyes are tuned to spot even the most minute differences in the faces around us, partly so that we can recognize each other but also to communicate the way we feel by reading subtle changes in expression. Perhaps because of this skill, we tend to see faces and expression in everything around us, from the fronts of cars to the shape of a tree. On looking at a good silhouette, initially you see the outline only, then slowly you begin to see where the eyes should be, and then the ears. The flow of the hair (or lack of it) around the face begins to become apparent and the shape of the shoulders indicates how the person is standing, in turn giving subtle clues about their character.

This ability to construct a complete portrait from a shade is at the heart of how to recognize a good silhouette. If you find yourself looking, yet are unable to "see" the eyes or ears, you are not looking at a successful silhouette. If, on the other hand, the shade gradually begins to seem so real that it might almost speak, then you are almost certainly looking at a good likeness. Practice this skill as you look through the following pages, as it will provide you with the means to judge the success of your own work, as well as to criticize that of others.

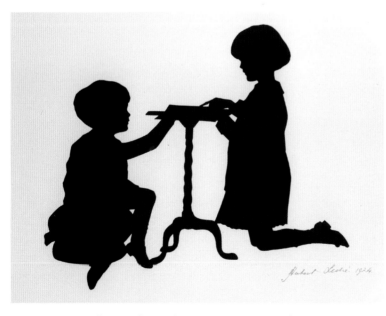

An evocative 1920s silhouette of two children reading. Can you see where their eyes are looking, their hairstyles and the kind of clothes the girl is wearing?

John Miers
(1758–1821)

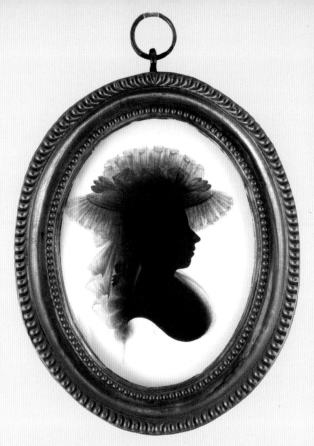

Lady Mary Montagu, by John Miers (collection of Diana Joll).

The first stage in making a silhouette involves taking a likeness from a shadow. This is a popular childhood project that you may have tried at school, probably ending up with an enormous black cut-out shape of a classmate. It is commonly thought that silhouette art was popular in Victorian times, but in actual fact the Victorians were dismissive of the practice, considering it old-fashioned. We therefore need to look further back, to the methods used by John Miers, to learn the art of creating a silhouette.

A silhouette renaissance

John Miers is known as the master of silhouette and his profiles are widely regarded as some of the finest ever made. He set up one of the most respected silhouette studios in London, toward the end of the eighteenth century, where he painted the most evocative and beautiful of Georgian silhouettes, featuring the delicate hats and lacy costumes of the day. He employed a number of assistants and artists, one of whom, John Field, also became a well-known silhouettist and eventually inherited the business (together with Miers's son), naming it the Miers & Field studio.

Miers painted his best-known silhouettes onto small, oval slabs of white plaster. Plaster is rarely used as a base for artists today, but it does offer some advantages, the main one being that it does not yellow with age. Indeed, many of Miers's silhouettes seem as fresh today as the day they were made.

Miers came from a family of artisans in Leeds, England. His father was a coach painter and there were a number of other crafts within the family business. He acquired many of these skills, including the mixing and packing of artist's paint. His early interest in silhouettes seems to have been an attempt to bring another product line into the family business. From the start, he was keen to employ assistants in the studio, who would help create the slabs of plaster on which he worked, and the hammered brass oval frames in which his silhouettes were set. As well as being a skilled artisan, Miers was also adept at marketing his services, stating that his work was "made by a new method far surpassing any other." Indeed, whatever this method was, it stood him in good stead throughout his career.

Miers's life is well documented. His early days were spent establishing a reputation as a craftsman in his birthplace. Later followed a brief period when he traveled around Britain (sometimes with his growing family in tow), working in various northern cities

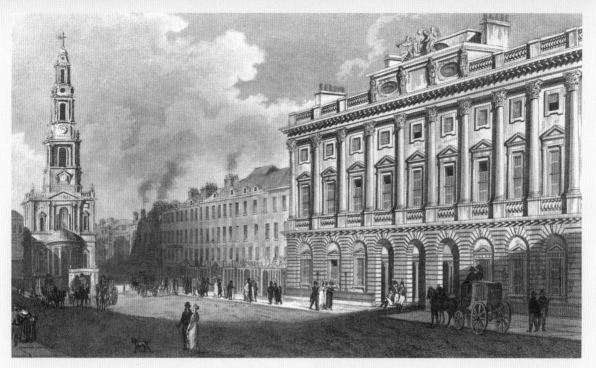

The Strand, London, in the early nineteenth century.

including Liverpool, Newcastle, and Edinburgh. In the late 1780s, he arrived in London, setting up his studio on the busy Strand. At that time, this area was the main center for miniaturists and silhouettists, and visitors would stroll along the wide road, looking in at the artists' studios lining the street. Much of the evidence for Miers's movements is drawn from advertisements placed in the local press at the time, as well as the trade labels that appear on the backs of his silhouettes. However, this information tells us little about the day-to-day running of the studio and its working practices.

Working methods

Miers's press advertisements state that customers needed to sit for one minute only and that a second draft of a silhouette could be supplied without the need for a second sitting, in much the same way photographers offer reprints from a store of negatives. This suggests that Miers made a preliminary, and very rapid, working sketch or "cartoon" of his subject, from

which the finished silhouette was later produced, and that these cartoons were filed away in the studio for further use as requested. Another clue to Miers's methods comes from the hours of the studio, which is recorded as being open from noon until 4 p.m. each day, suggesting that there were long periods when the artist did not want to be disturbed.

A 1930s biography of Miers provides a further clue to his working practice. The author mentions that he had once seen a life-size profile drawing signed and dated by John Miers. The fact that it was life-size suggests that it was a tracing of an actual shadow projected onto paper, then accurately and quickly traced by a practiced hand. This drawing was one of the original one-minute cartoons, somehow escaped from his studio, from which all Miers's silhouettes were made. From this cartoon, silhouettes could have been reduced to almost any scale with the use of an instrument called a pantograph (see page 23): a device which would have been known to the young Miers starting out in Leeds.

To Capture a Shadow

This project introduces two simple ways to take a profile. The first is based on the classic "school project" method, while the second is more advanced and closer to the technique used by John Miers. Both methods are fun and quick to execute, and will lead to a greater understanding of the relationship between shadow and likeness. This is how the first silhouette portraits, both amateur and professional, were created.

Portraits à la mode: a French print showing method one in action.

YOU WILL NEED:
- Model
- A chair
- Some large sheets of paper (flip-chart paper or heavy drawing paper)
- Adhesive tape
- Marker pen or soft graphite pencil
- Slide projector or a table light with a clear lamp
- Portfolio for storing drawings

Optional (for the life-size project at the end):
- Large sheet of black paper
- Household scissors
- Large sheet of white cardstock

1) USING THE SCHOOL PROJECT METHOD

Take a large sheet of white paper and stick it to the wall. Shine a light directly at it with a slide projector, if you have one, or else a table light with a clear lamp (a diffused lamp will blur the shadow). The light needs to be as far from the paper as possible to avoid distortions while still casting a clear shadow.

Place a chair in front of the paper and ask your model to sit sideways, so that you can see a shadow of their profile. Move them as close as possible to the paper, so that their shoulder is actually touching it, as the further from the paper they sit, the larger and more blurred their shadow will be.

A captured shadow of the author taken with a lamp.

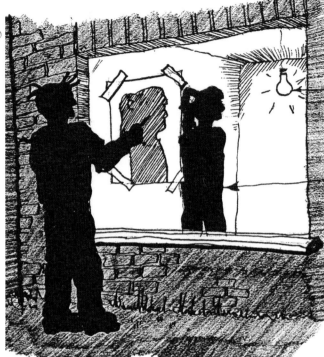

Taking a silhouette from a window (courtesy of Michael Herbert).

Take a marker pen or large soft pencil and draw around their shadow. You can start at any point, but, as far as possible, try to draw in one flowing line.

Although John Miers would have completed this process in just one minute, it isn't as easy as it sounds. At first, you may find that your own shadow keeps overlapping that of your model, in which case ask them to remain seated while you try again. Worse, your model will probably try to give you some space by moving out of the way of your hand as you draw. Although frustrating, this is a natural reflex caused by the uncomfortable proximity of the back of your hand to their face. Hopefully, you will manage to overcome these teething problems and end up with a simple line drawing that is similar to the illustration shown above on the left. Take heart that with practice you will become faster and more skilled.

2) USING THE JOHN MIERS METHOD

An easier way to achieve an outline involves waiting until it is dark. Stick a large sheet of paper to the outside of a window in between the sitter and yourself, then draw their shadow in reverse. A large plain window is best, with your model seated inside, their shoulder against the window. Shine a light on the paper as before, making sure that all the other lights in the room are switched off, and go outside to make the drawing. Start at the lower edge, where the shadow leaves the paper (either the front or back) and draw in one flowing line, right around the upper body and head, finishing again at the lower edge of the paper.

This technique solves both the problems of your own shadow getting in the way and your model trying to move out of the way as you draw. Your model can

sit in blissful meditation as you work, without the inconvenience of you occasionally trying to climb over their lap to avoid breaking the line.

Appreciation

Whichever of these methods you use for this first stage, two things will strike you about your first captured shadow. The first is its size. It will seem far bigger than life-size and your model may be particularly struck by this, wondering if they really have such a big head!

The second thing that may strike you is that it bears little resemblance to the model and that the all-important "likeness" is lacking. You may wonder how this can have happened, but at this point you need to have faith in the process. Likeness is a fugitive quality in any portrait; it does still reside in your drawing, but has gone into hiding for now. And yes, your model's head really is that big.

Although you cannot see a true likeness, you can still claim your drawing is a true shadow, which is an important distinction to make. John Miers would have had exactly the same problem with likeness at this point in the proceedings. It's likely that he didn't even show his clients the result of their one-minute sittings for this very reason, preferring to shroud the whole process in secrecy, keeping the drawing well hidden behind a screen.

However, this shadow drawing forms the raw material for the next stage of the silhouette project: To Reduce the Scale (see page 22). So write the sitter's name at the base, then sign and date it, just as John Miers would have done, and keep the drawing safely filed in a large artist's portfolio for future use.

3) CREATING A LIFE-SIZE SILHOUETTE

If you wish, you can now complete the classroom project by cutting out a life-size silhouette. This will have a certain grandeur, and you will need a large space to display it.

Begin by making a copy of your original drawing. To do this, lay the drawing on a table or tape it to a window, then secure a second sheet above it and trace the line as accurately as possible. You can repeat this process as often as you like, but make sure that you always copy the original signed drawing so that you don't end up making a copy of a copy.

Place a large sheet of black paper underneath the newly traced outline and stick the edges together with tape. Using a pair of household scissors, cut around the outline. Later on you will learn how to use scissors more professionally (see Natural Wave Exercises on page 32), but at this large scale, it's best simply to cut as carefully as you can, following the line.

You can now mount the resulting life-size shade onto a large piece of white cardstock. To do this properly, you will need to use wallpaper paste or another adhesive, but for an immediate appreciation, a few pieces of adhesive tape will do.

Is there a likeness?

Prop the card against a wall and stand back to have a look. Given its size, it might help to take it outside so that you can stand a long way back. You should now see the beginnings of a likeness; distance will certainly help!

Now that the outline has become an edge, rather than a drawing, your eyes can begin to read the shape as a head. The sitter may complain that it makes them look overweight; reassure them that this is an illusion, and enjoy the moment of having created your first silhouette portrait. You have used a traditional and relatively easy technique and succeeded in creating a recognizable likeness.

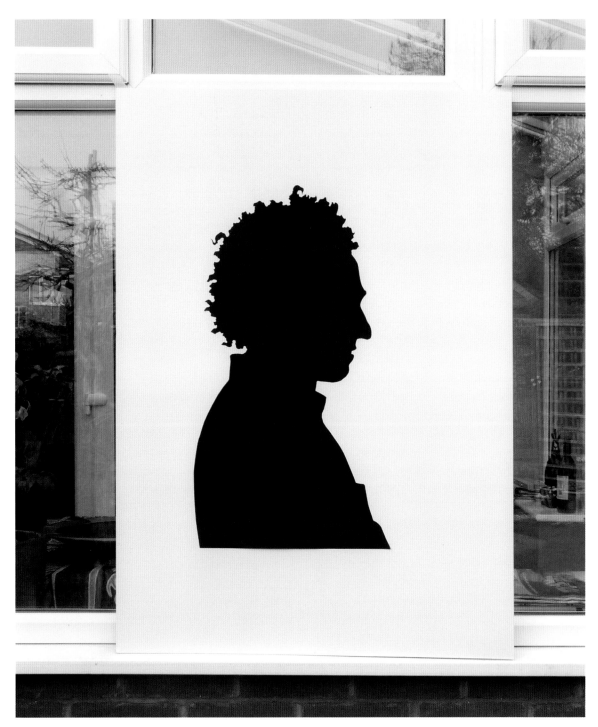

A life-size silhouette of the author, cut from black paper and mounted on card.

Facietraces and Cameras

While life-size shades have their own appeal, the vast majority of silhouettes are created at more manageable sizes. Reducing the scale is the second stage in making a silhouette. The traditional small size of eighteenth-century silhouettes creates a feeling of intimacy in the viewer quite different from the effect of a larger portrait.

Miraculous technology

Today we naturally regard an artist who works freehand as being more skilled than one who relies on technology. In the early nineteenth century the opposite was the case. Works of art created by new-fangled machinery were considered superior in every way to those made by a mere artisan.

At this time, the fashion for silhouettes had spread far and wide. Large numbers of silhouettists were plying their trade in towns and cities all over England and across the New World. As popularity increased, prices fell rapidly. In the 1790s, John Miers (see pages 14–15) was charging seven shillings for a shade on plaster, but in the early 1800s, the going rate was only one shilling, or one shilling and sixpence for two copies of the same shade. Many new artists relied on a variety of mechanical contrivances to take profiles, some with bewildering names such as "prosopagraphus." These machines were highly popular and must have seemed almost miraculous at the time. They were part of a brave new age, one of innovation and invention, when technology seemed about to change everyone's lives. People were hungry for the latest ideas, and the silhouettists' machines pandered to this need.

One such "family" of machines were loosely labeled "facietrace," or "physiognotrace" in England. Earlier versions, of which there were many, were based on a device called the pantograph. Pantographs are a copying aid used by artists for a variety of purposes; however, the facietrace promised far more than one of these. It was designed to take and reduce a profile automatically, directly from the sitter's face, by passing a rod over their features. The sitter had to sit absolutely still in a chair while the rod was passed up the face and around the back of the head, maintaining a steady and even pressure all the way around. To ensure that the sitter remained completely still, the chair incorporated a shoulder clamp and round metal plate pressed against the sitter's cheek.

In 1806, Charles Schmalcalder (1781–1843), an inventor based in the Strand in London, did away with the pantograph by patenting a device based on a simpler idea involving a long pole (see opposite).

The idea was much copied. The images opposite top left show a facietrace that belonged to John Volger, a nineteenth-century silhouettist based in Salem, North Carolina. The pole was pivoted on a fulcrum and had a hard pencil lead in the short end, which pressed onto a small piece of thin white paper held firmly against it by means of a spring. As the long end of the pole was passed around the face, the pencil drew an upside-down profile on the paper. This design was so simple that the pivot mechanism was hidden inside a box, perhaps to fool the public into thinking some kind of modern mechanical magic was at work. It was also portable, the rod being easily detached, and popular with itinerant artists of the day.

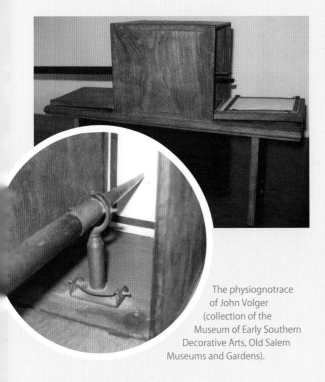

The physiognotrace of John Volger (collection of the Museum of Early Southern Decorative Arts, Old Salem Museums and Gardens).

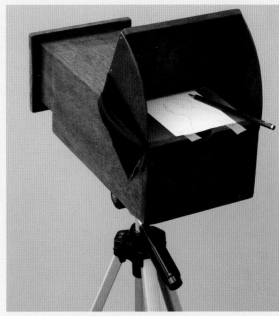

A portable *camera obscura* in use to trace a profile from an image projected on the back of the paper.

Other devices made use of lenses and mirrors. The *camera lucida* was a clever arrangement of mirrors that superimposed an image on top of the artist's hand and a sheet of paper, allowing them to trace the profile from life by hand. Portable versions of the *camera obscura* became available (earlier seventeenth-century versions took up a whole room); they used a moveable lens to focus an image on the back of a thin sheet of paper resting on glass. A profile could then be traced by the artist in reverse. This last device was eventually modified by coating the paper with a thin film of light-sensitive chemicals, heralding the birth of photography.

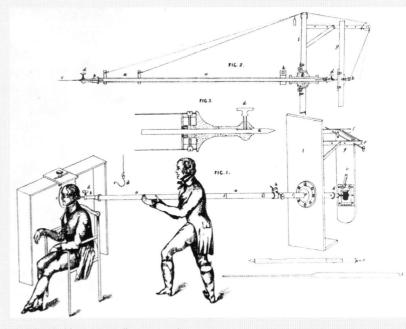

Mr. Schmalcalder's patent silhouette machine.

To Reduce the Scale

This project explores a reliable way to change the scale of a life-size drawing simply by using a grid and also looks at a faster method that needs more specialist equipment. Lastly, we will explore the best way to "cheat" by using a camera.

YOU WILL NEED:

- Life-size drawing from To Capture a Shadow (see pages 16–18)
- Long ruler and a short ruler
- Right-angle square or an L-square ruler
- Pencil
- Paper

Optional:

- Pantograph (method 2)
- Digital camera and inkjet printer (method 3)

1) USING A GRID

Grids have been used by artists for hundreds of years, so this is an interesting exercise for anybody who wants direct experience of the methods used by artists over the ages. Artists understand that the task of drawing a freehand copy of a complex composition becomes easier if it is broken down into smaller pieces. The grid is a simple way to do just that, by dividing a drawing into a number of boxes.

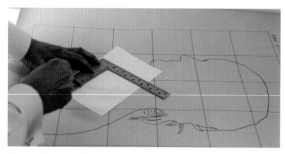

Using a 90-degree L-square ruler to make a grid.

First, decide the ratio by which you wish to reduce your original drawing. To emulate eighteenth-century silhouettists and work at "true miniature scale," you need to reduce to ¹⁄₁₀ of life size, which is a demanding scale to work at. Most modern silhouettes are bigger: anywhere between a quarter and ⅛ scale is quite acceptable. The example here will reduce a life-size drawing to ⅛ scale. If you wish to use a different scale, simply alter the numbers.

Take a long ruler (or large L-square) and draw a 4-inch (8-cm) grid over the life-size profile, either on the original drawing or a copy. You need to measure 4-inch (8-cm) intervals all around the profile to ensure the grid is square, but there is no need to cover the whole paper with a grid. Next, choose a piece of paper to transfer the image onto (your choice of paper depends on whether you plan to cut or paint a silhouette) and draw a ½-inch (1-cm) grid using a smaller ruler. Make sure that this grid is also square and has the same number of boxes as the large grid.

Now for the difficult part. Begin copying the line of the original profile, box by box, onto the smaller paper. If you have never done this before, you will find it a strange experience. The trick is not to look at the outline as a whole, but just at the shape in each box. For each, consider whether the line enters at the top or at the side of the box. At what angle does it travel? How far along the edge of the box does it enter? With a little practice, you will be able to estimate these proportions quite quickly.

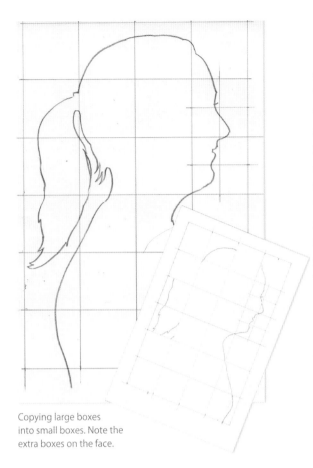

Copying large boxes into small boxes. Note the extra boxes on the face.

One alternative still in use today is known as the "stork's bill," or pantograph. This consists of a series of interlocking rods, arranged as a parallelogram. A line traced with a pointer in one corner is exactly reproduced by a pencil in another, at a different scale. Commercially available pantographs are designed to be taken apart and reassembled in various configurations, allowing them to either reduce or enlarge a drawing in a range of different ratios, usually varying from two to ten. This range of scales is perfect for silhouette work, so you may find that it's worth buying one of these.

Tape your large drawing onto a flat table with the pivot of the pantograph clamped securely next to it, so that the pointer reaches the furthest part of the outline when fully extended. Tape the smaller paper next to this, underneath the pencil, so that the pencil is in approximately the same position on the small paper as the pointer is on the large. Now take the pointer to the beginning of the line. Make sure that the pencil is touching the paper and move the pointer carefully along the line of your life-size drawing.

Pantographs are tricky contraptions and take a bit of getting used to. After a few false starts, though, you should find that you can produce a scaled-down drawing in a fraction of the time that it takes to use a grid. The trick is to move the pointer in a clean, smooth line. Any wobbles will tend to transfer all too clearly to the scaled-down drawing.

A limitation of commercially available pantographs is size. Most will just about accommodate a life-size drawing of a human head, but if you want to make full-length silhouettes from shadow drawings, you will need either to revert to using a grid or make your own pantograph. Detailed instructions on how to build an eighteenth-century stork's bill are beyond the scope of this book, although plans for a homemade device are included for those who might wish to attempt it (see page 25).

Draw the small profile slowly and carefully using a sharp, hard pencil; it's easy to find yourself in the wrong box if you work too fast. If you find a particular 4-inch (8-cm) box too complicated, sub-divide it into four 2-inch (4-cm) boxes and treat each one separately. At the end you should have an accurate copy of the larger drawing.

2) USING A PANTOGRAPH

Even though grids require no specialist equipment, and are reliable and easy to master, they have one big disadvantage: the process is slow. You may not object to this, but the silhouettists of Georgian England felt that it was a severe limitation. For them, time was money, and although they were familiar with artists' grids, they didn't have much time for them, preferring faster alternatives.

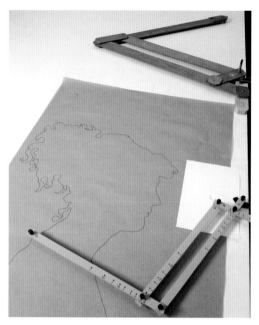

A modern pantograph in action reducing a captured shadow to ⅛ scale. Next to it is a larger home-made pantograph capable of reducing a full-length shadow.

Appreciation

Whether you use a grid or a pantograph, you now have a ⅛-scale version of a captured shadow. You should find that your overall proportions have trans-ferred to the smaller scale successfully, but individual details, such as chins and noses, may seem slightly indistinct. If so, go over the line again, smoothing out the profile and redefining the details. With practice, you should find the need for such redrawing lessens, and you can proceed straight to cutting or painting the silhouette. As with a full-size drawing, the likeness will be hard to see in a line drawing. Once the line becomes the edge of a silhouette, it will be clearer.

3) USING A CAMERA

The invention of the camera in the nineteenth century put most silhouette artists out of business almost overnight (although a number of them did go on to become successful early photographers). However, today the cheap and easy availability of digital cameras and inkjet printers represents a unique opportunity for would-be silhouettists. Although it is important to experience the traditional method of taking and reducing a life-size profile, many projects can be carried out easily using photographs.

Bear in mind that a good photograph doesn't necessarily make a good drawing, and that a good drawing doesn't need to have been made from a good photograph. This means that there is no need to be a good photographer, nor any need to have a good camera, to create a successful silhouette from a photograph. Any camera will do. You probably have the best tool for the job in your pocket right now: your cellphone.

Taking a photograph

To make a silhouette from a photograph, you need an exact profile showing the whole head and shoulders. Pose your subject so that they are looking to one side. If they have long hair, include this. Ask the subject to assume a composed face while you take a photograph. You might wish to take two or three in case the first one blurs, but usually one is all you need.

Once you get the idea, such photographs are easy to take. Bear in mind that you are not trying to shoot an award-winning photograph, just raw material for a silhouette. At a gathering of friends and family, it will take a matter of minutes to capture suitable profiles of everybody in the room. This may well give you enough material to go on and complete all the projects in this book.

There are two optional considerations that can make a photograph easier to work from. First, avoid the use of flash, which creates awkward shadows around the face. Second, position the subject against a plain wall so you don't get confused by background clutter. If no suitable plain wall is nearby

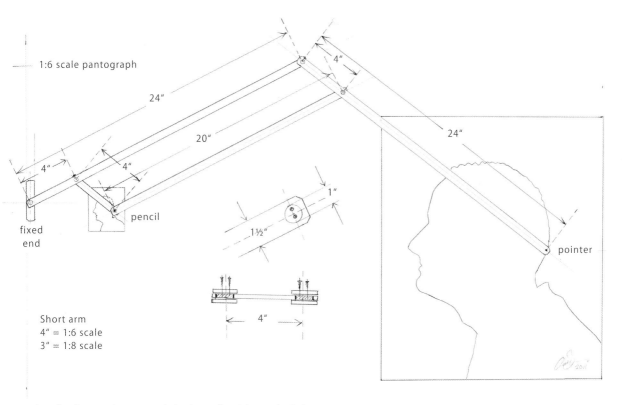

Plan of a silhouettist's pantograph, for those who wish to make their own.

(or if there seems no way to turn off the flash), don't worry and take the photograph anyway.

To see an example of an ideal photograph for silhouette, watch a television police drama and note the moment when the suspect is photographed at the police station: one shot from the front, a second in profile. It's that profile you need!

Working with photographs

Resize and print your photograph onto plain white paper using your home inkjet printer. There is no need to use expensive photographic paper or to switch your printer to "fine-quality" mode (which will use more ink) as the regular paper and printer settings that you use every day are adequate for your needs. The scale that you print at will depend on the

kind of silhouette you are planning to make. You will find notes about this in the projects that follow. In general there are two choices:

1) Print as large a photograph as possible. This makes it easier to see details of hair and clothing, and is a good idea if you are planning to copy the photograph, for instance by scaling it down with a grid or pantograph and painting it onto cardstock.

2) Use photo-editing software to scale the photograph to the size of your finished silhouette. This is a good idea if you are painting on glass or cutting the profile with scissors. This way the camera and computer can both take the profile and reduce the scale, so you can proceed directly with cutting or painting your silhouette. If in doubt, print both sizes.

Scissors

One of the most popular ways to complete a silhouette today is to cut out the profile from black paper with scissors. A professional silhouettist can cut a freehand silhouette in as little as one minute, but for most purposes such speed is quite unnecessary and, in any case, can only be obtained after a great many years of experience. However, if you are planning to cut out your own silhouettes, it is worth studying the techniques used by the artists who do this. "Natural waves" are a series of cutting exercises designed to help you use your scissors in a natural, relaxed, and effortless manner. With regular practice, a pair of scissors should begin to feel almost like an extension of your own hand.

Historical scissors

Scissors have been around for a surprisingly long time. The Chinese have used a form of sprung iron scissor for many thousands of years, while the Egyptians and Romans both invented variations of this same idea. Hinged scissors are a more modern invention.

Until the mid-eighteenth century all scissors were made by hand. For this reason they were relatively expensive and not readily to hand in every household. They were individually designed and tended to vary in quality. The breakthrough for artists came in 1761 when Robert Hinchliffe of Sheffield, England, began to use cast steel to make scissors, thus mechanizing their production. For the first time, good-quality, durable scissors became easily and cheaply available.

This technological development had a big impact on the development of the silhouette. Some of the earliest professional silhouettists began working

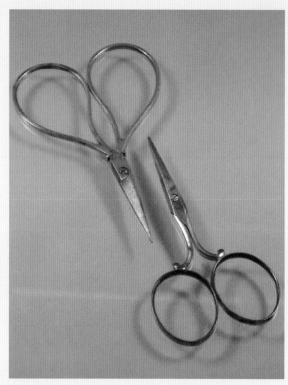

Early nineteenth-century scissors typical of those that may have been available to artists of the time (courtesy of Joe Herinckx).

Various ancient sprung scissor designs, cut from paper.

at almost exactly this date, and by the early 1800s scissors had become the tool of choice for most artists, especially those who relied on machines to draw a profile before cutting.

Natural Waves

The first question most people ask is: "What kind of scissors should I use?" Unfortunately, there is no obvious answer to this. There seem to be as many different kinds of scissors in use as there are artists to use them.

YOU WILL NEED:
- Pair of scissors
- Some old, unwanted paper (junk mail is best)
- A couple of sheets of black paper

FINDING THE BEST SCISSORS FOR YOU

Traditional silhouette scissors are fairly small, with round handles and short, pointed blades. However, these don't suit all artists and many prefer surgical scissors, sewing scissors, or even larger household scissors. Some artists have a range of scissors for different jobs, while others use the same pair for everything. Carew Rice, a well-known American silhouettist and paper cutter of the 1930s and 40s, bought a pair of ordinary scissors for 25 cents as a boy and continued to use them throughout his life.

So there is no need to rush out and buy an expensive pair of scissors. Whatever you have lying around the house will be fine for these exercises. As you become more fluent, you will begin to form your own ideas about which kind of scissors suits you best. The best advice is to choose simple, relatively small ones. Scissors with small blades will turn corners more easily; also try to avoid scissors with bulky plastic handles.

Left-handed scissors

The only exception is if you are left-handed, in which case you do need to use genuine left-handed scissors. If in any doubt about which kind you have, it's easy to check. Lay your scissors on a table so that the blades are pointing away from you. For right-handed scissors the blade that points to the left always lies over the blade pointing to the right; it doesn't matter which way up the scissors are. Turn the scissors over (still keeping the points facing away from you) and place them down on the table again. Note that the blade on top is still pointing to the left. If the upper blade is pointing to the right then you have a pair of left-handed scissors.

The reason for this asymmetry lies in the way scissors work. Scissors don't need to be sharp to cut, nor does the screw at the pivot need to be tight. Some artists use the same scissors for many years; over time the blades become worn and the pivot becomes so loose that the blades rattle on the screw, yet they continue to cut as well as ever. This is because scissors work on the principle of shearing. The natural action of a human hand pushes the blades toward each other as the scissors are closed, shearing through whatever lies in between. However, this only works if the scissors are held in the correct hand. If you try to use left-handed scissors in your right hand, the opposite occurs: the natural action of your hand now pushes the blades apart, rendering even the sharpest of scissors useless. For this reason, please don't try these exercises using right-handed scissors in your left hand (or left-handed scissors in your right hand), whichever way your natural dexterity lies, as that road will lead only to frustration.

If you are left-handed and have bought a pair of scissors labeled as "left-handed," you may be feeling rather mystified at this point, wondering if you have found a basic error in this book. You may have carried out the table test with your scissors, but whichever way you tried it, the uppermost blade stubbornly pointed left. This is because some scissors sold as being left-handed are actually right-handed. Rather than go to the expense of forging a new set of blades (which is what true left-handed scissors require), the manufacturer has tried to make do by fitting the scissors with a special set of molded plastic handles. These purport to offset the natural tendency of the left hand to push the blades apart. They may also incorporate a tight pivot screw designed to keep the blades closer together. For general household use, this solution is probably fine, but not for silhouette cutting. The plastic handles are too bulky and will get in the way, while the tight pivot means your hand is working too hard, making it difficult to

cut in a natural and relaxed manner. Worse still, the upper blade of the scissors will obscure the line of your cut, making it difficult to see the line. So for the left-handed there are two options: find a pair of small, genuine left-handed scissors suitable for silhouette cutting, or learn to cut with your right hand. However, don't attempt to use right-handed scissors in your left hand.

If this seems unnecessarily harsh, there is some good news: silhouette-cutting is an ambidextrous art. Both hands are involved: one to manipulate the paper, the other to cut with the scissors. Right-handed artists therefore have a similar problem learning to use their left hand quickly and deftly.

The first stage in this project involves learning to hold the paper. If you are left-handed and not sure whether to buy an expensive pair of left-handed scissors, you might wish to try this exercise first. You may decide that learning to cut with your right hand is not such a bad option after all.

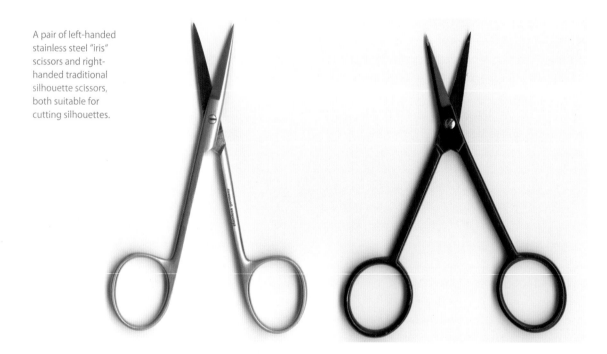

A pair of left-handed stainless steel "iris" scissors and right-handed traditional silhouette scissors, both suitable for cutting silhouettes.

HOLDING THE PAPER

The aim is to learn how to hold a small piece of paper in one hand and turn it smoothly in both directions without touching it with the other. It takes practice, but is important for cutting silhouettes, as much of the work is done with the hand holding the paper. It will enable you to cut by turning the paper into the jaws of the scissors—rather than trying to turn the scissors around the paper—which is a far more comfortable and natural way to work.

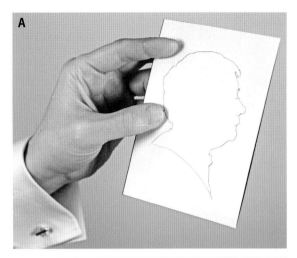

A) Begin by folding some paper and holding it in your left hand, as shown. The paper here is a quarter of an A4 sheet, but any small size will do. Hold the paper firmly at two points: near the top between the index and middle fingers (the upper grip), and below, between the thumb and ring finger (the lower grip). The little finger is tucked away into the palm of your hand. This "double grip" is crucial for maneuvering the paper quickly and fluently, although it will feel awkward the first time you try it.

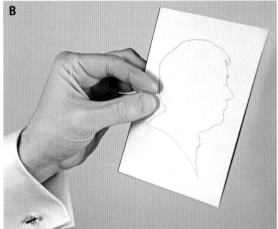

B) Keeping the paper still in your hand, let go of the upper part of the paper with the index and middle fingers while keeping your thumb and ring finger firmly on the paper. Slide your index and middle fingers down the paper to a point just above your thumb and re-grip the paper.

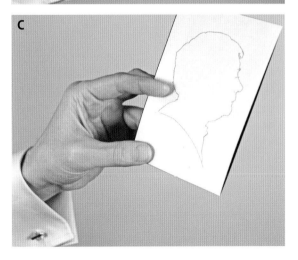

C) Still gripping the paper with the upper fingers, now let go with the thumb and ring finger. Move your index and middle fingers back up to their previous position, taking the paper with you. Although your hand does not move, the paper should slide up easily between your thumb and ring finger. Find a new position for your thumb near the bottom edge and re-grip the paper. Your hand will now be in the same position it started, except that the paper has moved up a step, as shown.

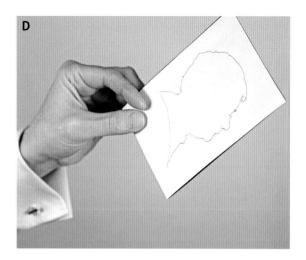

D) To turn the corner, repeat the process. Let go with the upper grip. As the paper is now higher in your hand, it should fall away naturally from your hand. Slide your fingers down the paper to a point just above your thumb and re-grip the paper.

E) Let go with the lower grip and lift the paper up with your index and middle fingers. As you are now holding the bottom of the paper, it will continue to fall away as it slides up between the thumb and ring finger. Find a new position for your thumb at the bottom of the short edge and re-grip the paper.

If you are using left-handed scissors you need to perform this exercise with your right hand as shown.

This method of moving paper is known as "walking" the paper through your hand. So far, you have taken two steps with your fingers down a long and a short edge of the paper. Continue taking several more steps, until you can comfortably move the paper clockwise in a complete circle through the fingers of your left hand (or counter-clockwise through your right hand). Keep practicing until the paper turns smoothly and continuously while your fingers "walk" at a steady pace around the edge.

Now try to reverse the motion and walk your fingers back the way they came. Most people find this much harder. One problem is that the paper no longer falls around the corners. You can overcome this by turning your wrist so that your hand is palm up. Gravity will take over and the paper will fall counter-clockwise through the corners as before.

A word of warning: don't practice too hard! This exercise uses muscles in your hand that you may not use much, especially in the grip between the index and middle fingers. If your hand gets tired after a couple of minutes, take a break and try again later. As with any new motor skill, your body needs

At a glance

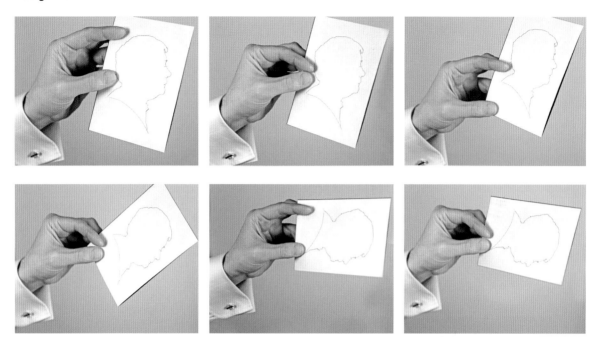

time to process the unfamiliar motion, and after a rest you will find that it gets easier. You will learn faster if you practice for a couple of minutes several times a day than if you practice for longer periods less often.

Once you become fluent, you will be able to turn the paper in any direction at will. When you reach this stage, it will be time to learn to use your scissors.

HOLDING THE SCISSORS

Although you need to practice rigorously how to hold paper, you can be far more relaxed about how you hold your scissors. Artists around the world use many kinds of scissors, and there are numerous ways to hold them.

Your grip will usually be dictated by the design of the scissors. Embroidery scissors are designed to be used between the thumb and index finger, whereas hairdressing scissors are held between the

thumb and middle finger, incorporating an extra "lever" on the lower grip so that the ring finger can help in the repetitive work of closing them. The longer-shanked surgical scissors favored by many artists are usually operated between the thumb and ring finger. Many household scissors have lower grips designed to accommodate two or even three fingers at once.

Whatever scissor you use, your grip should be relaxed and natural. If your hand is tense, you may end up grinding the blades of the scissors together, leading to an early demise for your scissors. It helps if your scissors are fairly loose on the pivot: they should open and close without any obvious resistance. If yours feel tight (brand-new scissors often do), try cutting lines through newspaper until they loosen up a bit.

Don't forget: the secret to successful silhouettes lies in the way you hold the paper, not the scissors.

NATURAL WAVE EXERCISES

You will need some paper, ideally from the recycling bin; junk mail is ideal. For practice fold the paper in half so that you are effectively cutting through two sheets. Hold the paper in one hand, using the grip you have learned, and hold the scissors firmly, but loosely, in the other, with the points facing away from you.

The illustrations here show the outline of a fairly rapid series of cuts, as well as a drawing showing the direction of each one. The drawings show the point where each cut begins and ends, including some "over-cutting." They are all right-handed cuts, so if you are using left-handed scissors, you need to reverse them. When practicing, try to keep your scissors relatively still and "walk" the paper through the scissors to make the curves. A certain amount of movement with the scissors is okay, but the majority of the work should be done with the hand holding the paper.

At no point in these exercises should the scissors be pointing toward you. Apart from the obvious safety hazard, it's difficult to cut this way. Keep the scissors pointing away from you and turn the paper with the other hand. The aim is not to produce a perfect sequence of waves, but rather to study the way your scissor and paper hands work together while cutting.

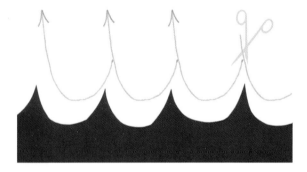

Choppy waves. Imagine a small boat at sea being tossed about by small waves with no particular direction or regularity. Each wave has a sharp point with a smooth curve in between. This exercise introduces the idea of over-cutting known as "breaking away" from the line. Each wave is formed with a single cut, so that you close the scissors just once, cutting in from the right and curving back out to the right, breaking away beyond the point you wish to end the wave. To begin the next cut, use the over-cut line to gain access with the scissors, pushing the excess paper out of the way with a finger or lower blade. Note that the heavier the blades, the longer these breakaway cuts need to be.

SYMMETRICAL CUTS

Although not strictly necessary for cutting silhouettes, an interesting scissor exercise is the symmetrical cut. Begin by making a series of simple curves or waves, then turn the paper and cut exactly the same shape on the other side. You can use this technique to cut any symmetrical object, such as a wine glass. It's a good test of accuracy, since any error in the second cut will be made immediately obvious by the lopsided nature of the glass.

Surfers' waves. Imagine surf crashing in a regular rhythm onto the beach. Each wave rises up into a peak just before it rolls in a mass of foam onto the shore. This exercise is a double curve made with a single cut. Turn the paper first to the right, then to the left, in one fluid motion without reopening the scissors. Break away from the line and begin the next wave at right angles to the over-cut line.

Surfers' waves can be cut in both directions, although the sequence is slightly different for each. Turning the paper first to the left and then to the right (rather than right first, then left) will produce a backward wave, seeming to move away from your hand.

This is the wave where you need to take the most care to keep the scissors pointing away from you— turn the paper, not the scissors.

Rolling waves. Imagine a deep ocean swell, each wave rising and falling in a regular and steady fashion. This exercise involves a series of alternating curves: right then left, then right again, without any breaks. You need to close and reopen the scissors gently between the curves, taking care not to leave

any telltale nicks. Although this looks easier than the previous exercise, it's actually harder as there is no chance to "take a breath" and no excess paper to fold away from your scissors. Use this exercise to practice a relaxed and natural grip. Once mastered, the rolling wave should show a clean, smooth, and regular line.

Tacking. Your scissors behave like a sailing boat tacking into the wind. Make a series of straight cuts into the paper, turning the paper at least 90 degrees after each one. The aim here is to make an even, regular zig-zag. Mentally divide the paper in two, each side of the cut. The paper "inside" your scissors (the side you are holding) is needed, while the paper "outside" your scissors is waste. Make a few zig-zags. When cutting in (that is, into the needed side) cut slowly and carefully, measuring the distance by eye so that it's equal to the previous cut. You should be able to see a clear, neat triangle inside the scissors. When cutting out (that is, into the waste side), notice how the triangle outside the scissors is now hidden by the blade, making it harder to measure by eye. Ignore this and make a rapid, bold cut at least twice as long as needed. To begin the next cut, position the blade about halfway in and make a slow, careful cut of exactly the right length. Try to build this up into a rhythm, cutting out with a strong, confident line and cutting in with a more careful, considered approach.

Random waves. Imagine a stormy and unpredictable sea, in which waves are piled on top of waves, breaking over each other on top of a deep ocean swell. Practice all the exercises in any order you like. Allow the movement of your hands to become free and spontaneous, without thinking too much about which wave you will cut next. Spend plenty of time on this exercise, cutting your junk mail into long and complex spirals of paper. See how many patterns you can create using only these waves and nothing else. Try to develop a relaxed and continuous rhythm to your cutting. Think about the way waves move at sea, and keep your scissors and paper hands moving in a similar way. Waves neither speed up nor slow down, and certainly don't stop to see where they are going next. Try to develop a similarly methodical, continuous, and yet restless movement with your hands.

BASIC SKILLS

At a glance

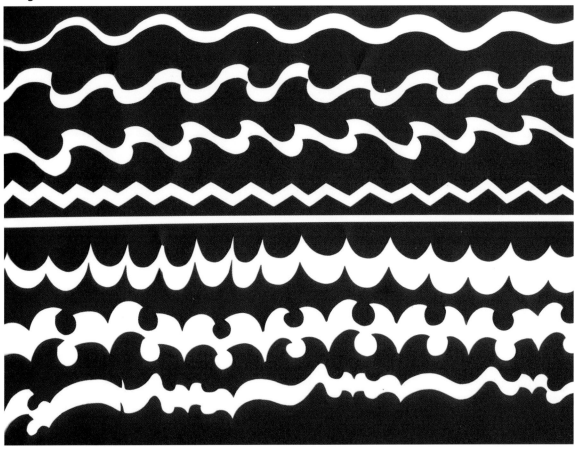

Finishing up

Here are a set of cuts to copy using black paper. All the exercises learned so far are included, plus a couple more. Feel free to create your own as well:

Opposing waves. These are surfers' waves moving alternately toward and away from you as you cut.

Calm sea. The straight line across the middle; this was cut without a ruler—not as easy as it seems.

Profile wave. At the bottom of the example. You are unlikely to ever see this one at sea. It consists of a simple swell (the chin), followed by two surfers' waves moving away from each other (the lips), and one long rolling wave (the nose and forehead).

Appreciation

By the end of this third project, you may feel that you don't have much to show for your efforts apart from a large pile of junk mail cut into small ribbons. In actual fact, you have now learned most of the basic skills that you need to cut silhouettes with a pair of scissors.

Choose a few of your best "waves" and keep them safe by pasting them onto a piece of cardstock or into a scrapbook devoted to your silhouette work. They may not look like much now, but these first cuts will be of great interest when you look back over your progress later on.

Any
Color
You Like
...as long
as it's
black

The Search for Likeness

By this stage, you will have made a couple of scaled-down drawings—or have some printed photographs—and will also be more at ease using scissors. You should feel ready now to cut out or paint your first portrait silhouette. Before you start, here are some thoughts about the art of capturing a likeness, and why this seemed so elusive in the first project.

Proportion in silhouettes

To create a convincing likeness, you need to forget any notion of a silhouette being simply a copy of a shadow; if only life were that simple! Miniatures and silhouettes both contain an element of caricature. Despite the various contraptions in use in the nineteenth century to capture shadows, the most successful artists were not those who could faithfully copy the proportions of the human face, but those who could most effectively alter those proportions to accentuate likeness.

Take a look at the silhouette above by John Miers. It appears a natural portrait, but careful inspection reveals a few surprises. The features are slightly too pronounced in relation to the head, which in turn seems a little narrow. Also, the bust is raised in an unnatural manner, giving the whole silhouette a neat, compact feeling.

The extent to which silhouettes are "altered" varies from artist to artist. Sometimes this can result in either obvious flattery (which may be the artist's intention) or a rather brutal caricature. In general, your aim should be to enhance the likeness, rather than distort it to either extreme. Alterations are made to overcome a particular problem with shades not encountered in other fields of portraiture. This problem is an optical illusion caused by the two-dimensional nature of a

A silhouette by John Miers showing mild exaggeration of the features (collection of Diana Joll).

silhouette, which results in our reading the "edge" as being slightly wider than it actually is. Human faces don't have edges: the front of a face gently curves around to the side, which in turn gives way to the back. Silhouettes on the other hand definitely do have edges. You may have already encountered this in your first life-size silhouette. Did your sitter complain that they seemed rather overweight? They were right, and this is the essence of the problem.

Take a look at the illustration opposite top. On the left is a shaded drawing of a glass. The object next to it is also a glass, although you may not have spotted that as it is shown in silhouette. Does the silhouette appear wider? Surprisingly, they are both the same size, but our eyes tell us that the silhouette is wider. Silhouettes tend to spread, making us see objects

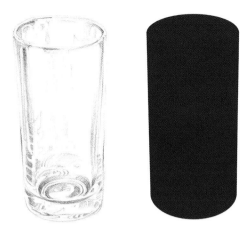
A tall glass shown both as a drawing and a silhouette.

as wide and flat, rather than rounded. The shaded drawing makes the volume clear and so the glass seems narrower and closer to its true width.

Practiced silhouettists develop an intuitive understanding of this effect and so rarely create a silhouette as an exact shadow. They understand the solution is to modify the profile itself, to accentuate the natural curves of the face and neck, exaggerating the difference between the widest and narrowest points. The artificial line at the bottom of a silhouette, known as the "bust line," in particular causes problems. This line, which defines the bottom of a classic silhouette, has no basis in nature and causes another illusion of its own. For this reason, the upper body is usually altered far more than the proportions of the head.

Artistic research

Looking closely at the work of John Miers (see pages 14–15), some of his earlier profiles have a faint yellow line outside the face. The line is too faint to be seen by the naked eye and is only visible with the aid of a magnifying glass. Some experts assume that this line is an impurity leached out from the paint, but my theory is that it represents the original line traced by the artist's pantograph, because the face has been painted slightly inside the line in exactly the way I would do. The nose has been strengthened by exaggerating the

curve near the eyes, while the tip of the nose almost touches the line. The lips, which tend to appear similarly indistinct in any pantograph drawing, have been clearly redefined with two confident curves, and the double chin has been slightly "tucked up."

Furthermore, the yellow line appears only around the face, not near the hair or under the bust (where an impurity could equally be expected to leach). This indicates that Miers used a pantograph only to define facial features, and painted the head and bust, which require more alteration, freehand. Silhouettes from his London studio generally don't show this line, as by then he had refined his technique. This offers an interesting insight into his work and provides a clue as to how to create a silhouette, which will be the focus of the project on pages 42–7.

A detail of a face by John Miers, showing the original shadow line.

Hubert Leslie
(1890–1976)

After looking at the work of Hubert Leslie, your next task is to use his technique to create a likeness with scissors. Although I never met him, Leslie was in effect my first teacher. He left behind a set of duplicate albums now in the archives of the National Portrait Gallery in London. As a street artist in Covent Garden I would visit the gallery when it rained, where the staff were kind enough to let me look at the archives. I spent many happy hours poring over his cuttings, trying to work out how the scissors were used and admiring his economical and elegant use of line. It was during these sessions that I discovered the natural waves technique for creating a profile.

Some of Hubert Leslie's duplicate albums from Brighton Pier (collection of the National Portrait Gallery, London).

An artful artist

Hubert Leslie was part of (and generally considered the best of) a new generation of silhouettists who revived the art early in the twentieth century. These artists abandoned the various contraptions used by nineteenth-century artists and concentrated instead on cutting freehand with scissors. Leslie worked in the tradition of seaside pier artists throughout the 1920s and 1930s, taking over the West Pier silhouette concession in Brighton, England, in 1921.

Leslie worked on sable surface paper, which was fairly thin, white on one side and a rich, slightly glossy, black on the other, and easily available at that time. He folded the paper in half before cutting, so the white was on the outside. This gave him two copies of each silhouette: one for the client, pasted onto white cardstock, and the other for his duplicate albums. While many of his silhouettes are bust length, others are full length. Leslie cut bust lengths freehand, and for the full lengths, he made a pencil sketch on the white side to serve as a cutting aid.

After leaving Brighton, Leslie concentrated on his career as an artist/entertainer, creating a stage act based on a combination of art, silhouette, juggling, alliteration, and various balancing acts. He toured all over England, appearing

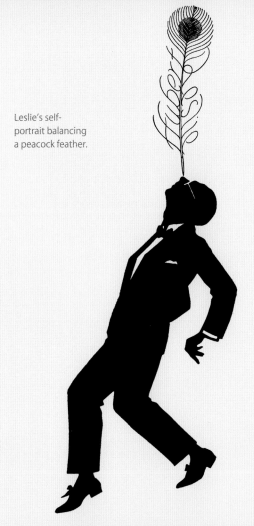

Leslie's self-portrait balancing a peacock feather.

would simultaneously recite a 500-word alliteration called "S-s-sylvia's S-s-silhouette." A reading of this could form another project: your challenge is to read this short section out loud.

S-s-sylvia's S-s-silhouette

"Suddenly she spies small swinging shop sign saying 'Silhouette Studio'. Straightaway she stops, shyly scrutinising specimens shown; sees silhouettist's shiny sensitive scissors (superior selected Sheffield stainless steel, specially sharpened) skilfully shaping several sable surfaced sheets simultaneously.

Sylvia soliloquises, strangely stirred. Should she speculate spending some small sum? Stay! Such singularly striking souvenirs should surely satisfy Sandy's sempiternal sigh-ings? (Supremely sentimental swain, Sandy, Sylvia's strapping Scottish subaltern suitor, since soldier service scraping small salary selling stocks, shares.)

Soon Sylvia's sumptuary scruples seem satisfactorily settled.

'Spiro, spero!' she says, sanguinely. 'Sero sed serio: slowly, still spontaneously!' (such shrewd slogan, so seasonably spoken, shows Sylvia's sound scholarship).

So she seeks said silhouettist's skill sketching self same sitter's shadow, seen sidewise. Some sixty seconds speed silently. Sylvia stands stock still, scarcely stir-ring. Soon, surveying subsequent scissored sciagraph, Sylvia smiles sweetly, showering small silver, shillings, sixpences."

Hubert Leslie

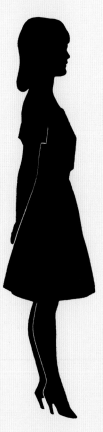

Sylvia.

mostly at boarding schools as entertainment for the pupils. His publicity material had a silhouette of himself balancing a peacock feather on his nose. Apart from balancing acts and art, Leslie was fond of word games (he was the kind of person who could complete *The Times* cryptic crossword in a single sitting) and introduced a number of these into the act. He would invite the audience to call out random alliterations and would instantly create a drawing based on the shape of the letter they chose to alliterate, incorporating illustrations of all the words they used. The highlight was to cut freehand from memory a full-length (and nearly life-size) silhouette of a fictional character called Sylvia. While cutting, he

Scissor-cut Portraits

This project introduces my own routine for cutting portraits with scissors, learned by cutting well over 100,000 silhouettes! Other artists may have their own routines, but all silhouette artists begin by cutting the face first and the shape of the head second. Right-handed artists generally find it easier to cut the right profile, while those using left-handed scissors will tend to prefer the left. This is because it feels more natural to hold the emerging silhouette in your free hand, while the paper outside the blades is waste. This is certainly the way you should begin.

YOU WILL NEED:
- Black or black-surface paper, 100 gsm or lighter
- Scaled-down captured shadow or photograph printed at the right scale for cutting
- Adhesive tape
- Red crayon
- Your favorite pair of scissors
- Some waste paper for warming up
- An envelope or glassine slip
- LED light

Optional:
- White cardstock

CUTTING SHADES
Preferably use black art paper that has a smooth surface. Alternatively, use silhouette paper, which is black on one side and white on the other.

A) Take a scaled-down drawing or photograph (see pages 22–5). This acts as a cutting guide, so it should be drawn on thin white paper (80 gsm is ideal) or the white side of black-surface paper. Tape a sheet of black paper to the back at the bottom of the drawing, or fold black-surface paper in half. For comfort, the combined weight of the papers shouldn't exceed 200 gsm.

Figure 1: Natural wave pattern for a cut silhouette, showing breakaway lines outside the silhouette.

ANY COLOR YOU LIKE

B) Thinking about the conventions of proportion, take a look at the outline and try to imagine how it would look in black. Start to draw in your alterations with red crayon, for example narrowing the neck or reducing the shoulders. Take another look at the detail by John Miers on page 39 to get an idea of the sort of minute adjustments made to the face. Decide what type of bust line you want at the bottom of the silhouette (for example, a traditional "S"-shape) and then reconsider the shape of the upper body. The illustration shows such alterations in red, while the original reduced shadow can be seen in pencil. The aim is to create a pleasing overall composition that accurately reflects the weight and demeanor of your subject.

C) Spend a minute or two cutting wave patterns (see pages 32–5) in scrap paper to warm up your wrists.

D) Cut through the tape, or fold, at the bottom of the paper, up the body and neck, and then around the face, working from the bottom to the top. Cut slowly, but continuously, with a regular rhythm, using a series of smooth, confident curves (see Figure 1, opposite). As you turn the paper and start going down the back of the head, resist the temptation to speed up; continue to cut the hair in relaxed, natural waves. At this stage, the head will be upside down, so trust your drawing and follow the line.

E) When you reach the end, ignore the bust line and cut straight out through the bottom of the paper. This completes the "first cut" and means that the cutting guide and silhouette are still joined together, which is important if you wish to do more cutting. Open the hinge and have a look, holding the black shade up to the light. Can you see a likeness? If you have planned your cutting well and practiced your scissor skills, the likeness should be plain to see. If not, consider what might have gone wrong.

B

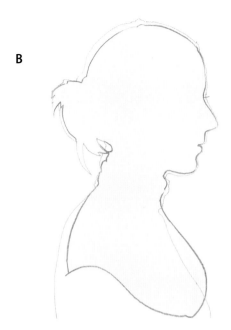

D

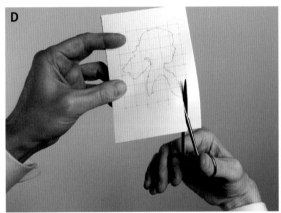

E

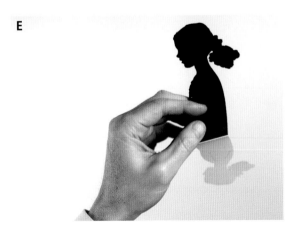

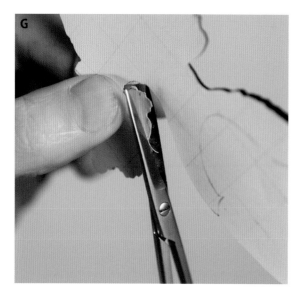

G

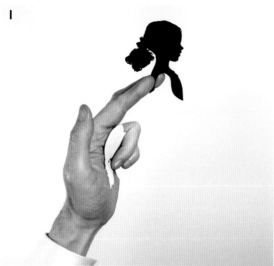

I

holding both sheets of paper firmly between thumb and forefinger. In this position, it's no longer possible to "walk" the paper through your hand; instead, turn the paper with your right hand in between making a series of small individual cuts. There is no longer any need to make long, flowing cuts.

G) Once you are happy with the basic shape, decide whether you want to add any details, especially to the hair. Go around the profile taking out small nicks and waves, or peeling away the odd strand of hair, cutting against the flow of the hair. This "second cutting" adds interest and is fairly easy to do.

To peel away a strand of hair, lay the scissors against the direction of the hair and carefully peel away a thin sliver of paper—no wider than the paper is thick—as shown. This little arrow of paper will lift itself away from the scissors in a delicate curl reminiscent of a fly-away hair. Let it rest exactly where it lies.

H) You may find yourself wanting to pierce holes in the profile, for example when cutting the space behind a ponytail. The easy way to do this is to make an "access" cut, first cutting a line under the hair, then cutting out the shape with the jaws of the scissors. A more difficult way is to push one point of the scissors through the paper at the edge of the hole you wish to make, then snip out the hole with the points. These two techniques, known as "slash" and "point" work, are big subjects and form the basis of the project Scissor-cut Embellishments on pages 103–7. If you would like to add an eyelash, see the instructions on the next page.

I) When you have finished, separate the cutting guide and silhouette by cutting along the bust line with a smooth double-wave cut. Hold the silhouette to the light for a final look. You can now paste it onto white cardstock (see pages 140–3 for information on

Were your alterations too cautious? If the silhouette seems too heavy, this may be the case, but some judicious alterations might still be possible.

F) Close the hinge and mark any new alterations on the cutting guide if needed (bearing in mind you can't do this too often as the silhouette can only get smaller). Change your grip with the left hand, now

pasting) or leave it unmounted for inclusion in another project. If in any doubt, leave it unmounted. There is something magical about a well-cut silhouette held up to the light, and sometimes it seems a shame to mount them on card. Keep the silhouette safe by placing it in an envelope or glassine slip (a bag made from non-absorbent paper). You can keep several silhouettes together quite safely in one slip.

Appreciation

To really appreciate the shadowy nature of these portraits, you need the help of a small bright light, such as an LED flashlight. Hold the cut silhouette in one hand a yard (a meter) or so from a plain wall and shine the light at it with your other hand. Now the shade has once again become a full-sized shadow.

THE EYELASH DEBATE

There is a convention among many silhouette artists to include an eyelash. This helps a viewer locate the eyes, as otherwise a shade can sometimes appear "blind." Also, an eyelash gives the profile a clear focus, as well as providing miniscule detail, which people delight in.

Anatomically speaking, though, the placement of an eyelash isn't always correct. The average Caucasian face has eyes set behind the bridge of the nose, so the eyelash isn't visible outside the profile. Leslie is one of the few artists who didn't add eyelashes for this reason. Looking at an Oriental face, however, the eyelash does protrude into the profile, often together with part of the eyelid as well, so even Leslie included these.

While the convention to include an eyelash does exist, there has never been agreement on how it should be done. Some artists add eyelashes afterward, either making a small nick with the scissors or drawing them in with a pen or brush, while others cut them directly into the paper during the first cut. A few even stick them on afterward using small slivers

of paper inserted under the silhouette itself. Some silhouettes have eyelashes so fine you can barely see them, while others are impossibly large.

For those with a specialist interest in antique silhouettes, the subject of eyelashes could form the basis of a whole new book. Some experts claim all artists create eyelashes unique to them, making them one of the best ways to identify an unsigned silhouette (or a possible fake).

A word of warning: including an eyelash can cause the invisible eyes of the sitter to apparently move forward, distorting the face and making it difficult to read a likeness. This can diminish an otherwise recognizable silhouette.

Adding an eyelash to a finished silhouette

Position your silhouette over a piece of cardstock and insert a sharp pencil under the edge of the paper, at the point where the eyelash should be. Make a mark, then remove the silhouette and either paint or draw the eyelash, starting from the mark you made. Do this in one quick movement, using either a soft (but sharp) pencil or a fine brush and India ink. Make some practice eyelashes on scrap paper beforehand.

Reposition the silhouette at the exact place where the eyelash feels right, usually when just the smallest tip of your mark remains visible. You can now paste the silhouette down in this position. A trickier method is to cut a few eyelashes by peeling away small slivers from black paper, which are then stuck to the back of the silhouette. This is a good idea if you are not planning to paste your silhouette onto a card immediately. Before you glue the eyelash down, ask yourself if it really improves the silhouette. As soon as you see it in place it should bring the profile to life. If it doesn't, or worse still, if the likeness lessens, abandon the idea and mount the silhouette without an eyelash. This is perfectly acceptable as on some profiles, eyelashes simply don't work.

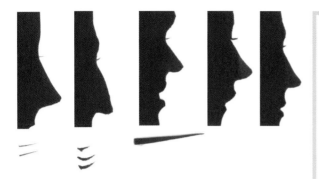

Various eyelashes. From left to right: pencil, watercolor, stuck paper, added during the second cut and cut during the first cut.

Including the eyelash as you cut the silhouette

If you don't mind the risk of destroying the entire silhouette, you can add the eyelash during the second cut. This looks skilful if performed successfully in front of an audience, but can easily go wrong. Lay the scissors along the profile near the bridge of the nose, about 1–1.5 mm below the point you wish to add the lash. Peel away as thin a sliver of paper as possible, cutting 1–1.5 mm up the profile. Then flick the scissors away from the profile at a 90-degree angle. The sliver of paper should stand out from the profile as an effective eyelash, although if you do this too violently, you will tear a hole at the top of the nose.

The last, and most difficult, method is to cut the eyelash during the first cut. As you approach the bridge of the nose, interrupt the rolling wave and turn the paper 90 degrees, making a quick bold cut (as if tacking). Now turn the paper 180 degrees, laying the scissors alongside the cut you just made. Begin cutting at the exact length of the eyelash. Peel away a fine sliver of paper, stopping as you reach the profile edge. Now make another 90-degree turn and continue the rolling wave up the forehead, as if the flow had never been broken.

When cutting eyelashes, the smaller you make them, the better. The closer people have to peer to see the eyelash, the more they will be amazed.

SOME NOTES ON FREEHAND CUTTING

Many professionals work from life using some kind of freehand cutting technique. It can be difficult to get silhouettists to talk about these techniques as traditionally they are shrouded in secrecy, but they are all based on similar ideas. Some artists cut one line around the head, starting and finishing at the lower right-hand corner. Others cut up the face, then return to the bottom of the paper and make a second cut up the back. Whichever method is favored, all artists tend to develop their own tricks and flourishes to aid fast and accurate cutting. What all have in common is that they condense the three stages of creating a silhouette (taking the profile, reducing the scale and creating the finished artwork) into one fluid operation. Done well, this is a highly impressive skill that people love to watch.

At silhouette workshops, people enjoy having a go at cutting a freehand silhouette. However, unless you are prepared to put in many hundreds of hours of practice, cutting literally thousands of profiles, avoid this as your method of choice. If this is a route you are determined to follow, the paper handling (see pages 29–31) and "natural waves" cutting exercises (see pages 32–5) provide the basic skills you need. The rest is up to you. Practice, practice, and, yet again, practice.

Here are a few ways to avoid common mistakes:
1) There is a natural tendency, the first time you are faced with a blank sheet and a live model, to forget wave exercises and find yourself making a few tentative snips. Try to resist this, even though your first few attempts may go horribly wrong. Don't try to cut fast, but concentrate instead on cutting at a relaxed and regular rhythm.

2) Before cutting, try to visualize the overall shape of the head and the posture of the spine. For example, look at the way the head sits on the shoulders. This is more important in capturing an instant likeness than accurately reproducing individual features such as the chin and nose (even though these are the ones most commented on).

3) Initially, you may find it hard to keep the scale constant, for example you might cut a ⅙-scale face with a ¼-scale head, resulting in a slightly deformed-looking silhouette. Don't worry, as all artists go through this stage. Simply keep practicing; in time, your hand will develop a natural feel for scale, and you will begin and end your cuttings at the same size.

4) Although difficult, practice both right and left profiles from the outset. For reasons mentioned earlier, you will certainly find one side easier than the other, but if you don't try, you will gradually find it less and less easy to do the "difficult" side. Mastering this early on means you won't find yourself stuck as a "one-side-only" silhouette cutter.

5) As you begin to develop a natural sense of scale you may find that your silhouettes, although better proportioned, are increasingly turning out all the same size. Try to resist this by deliberately cutting some small and some large. If you don't do this, the habit will become harder to break and you may become a "one-scale-only" cutter.

6) Finally, avoid the temptation to create formulaic profiles. One professional artist was fond of saying that there were really only six different kinds of nose, five chins, and some other number

Artist's view of the freehand cutting challenge; start and finish at the lower right-hand corner.

of foreheads and necklines. His technique was to create all his silhouettes using different combinations of these, together with various hairstyles. What really happened was that all his silhouettes started to look the same. Bear in mind that all profiles are unique, as are all people. The most important thing is to keep observing.

Mr. Charles
(1768–unknown)

Collectors of antique silhouettes usually consider silhouettes that are painted, whether onto card, glass, or plaster, superior to cut-outs. As an inveterate "cutter" myself, I sometimes feel the urge to object to this preference, but the reasons are clear. The first thing you notice about a painted silhouette is how much softer the line is, and how much richer the degree of detail. A small paintbrush can create a complexity of minute detail that is quite impossible to render with a pair of scissors, while the softer line lessens the optical illusion caused by the artificial edge of a cut-out profile. Much can be learned from studying one of my favorite artists—Mr. Charles—partly from his loose, gestural style, but also because he was such a showman.

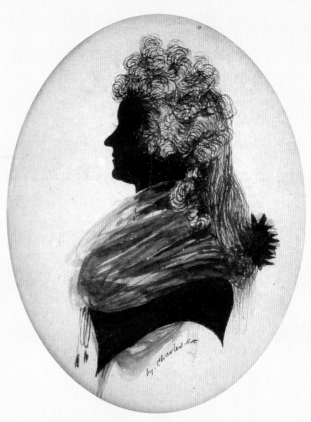

A lady with a shawl, by Mr. Charles (collection of Diana Joll).

Painting with a flourish

Based in the Strand in London, two minutes' walk from John Miers's studio (see pages 14–15), Mr. A. Charles painted silhouettes on paper in full public view at the window of his studio. His work is highly prized by collectors today and is relatively easy to identify as it was always signed (which, alas, is not true of all silhouettists of the day). He claimed to be able to paint a freehand silhouette in a three-minute sitting and a portrait miniature in "one hour by the watch."

This does not mean that he took three minutes to draw a Miers-style cartoon; in that time, he painted the silhouette itself! The examples illustrated here are typical Charles silhouettes: the face expertly painted on paper, and details of clothing and hair carefully picked out, neatly in the case of the gentleman and with an impressionistic flourish in the case of the lady. These are not rapid scissor cuttings, but carefully painted watercolors full of detail.

Most collectors of silhouettes put Charles's claims down to showmanship, part of the decadent culture of eighteenth-century London. Certainly, he was not above making exaggerated claims, describing himself as a "professor of painting" and often signing his silhouettes as "Charles, RA" or "Charles, MRS" without confirming what these initials stood for. Such self-aggrandizement was common among eighteenth-century entertainers and showmen, which is why his claims are often taken with a large pinch of salt. Collectors who have paid hundreds of pounds for one of Charles's miniature miracles may balk at the idea that it was knocked out in a mere three minutes, but could this have been possible? In my own

street-artist days, I advertised that a large pencil portrait took eight to ten minutes. This was certainly an approximate time, and while many clients did not mind whether or not I stuck to this, others clearly did. It was not uncommon for sitters to start looking at their watches if I took longer, wondering how long they were expected to sit. Ten minutes is not long, but can seem uncomfortably so if you are sitting still while an artist studies your face. A lesson I learned quickly is to claim that you can draw a portrait in eight to ten minutes only if you are sure that you can.

The importance of this was brought home to me recently while cutting silhouettes at a dinner. I approached a table of somewhat skeptical guests who, on hearing what I was about to do, asked to see samples. I replied that the only samples I carried were contained within my scissors and the paper in my pocket, but if I could have a volunteer to pose, I would show them a sample within 60 seconds. This claim was greeted with amazement, but no sooner had I said it than I regretted my words. All my publicity material at the time carried the boast "silhouette portraits cut in 90 seconds," so I have no idea what on earth prompted me to deduct a full third, but the words were said and nothing was going to bring them back.

Quickly, a volunteer was found, and thankfully he was a man with neat and short hair. A young woman produced a cellphone with a stopwatch while I readied my scissors and paper.

"Ready, steady, go!" she cried enthusiastically.

"Ten seconds," she called out, in what seemed a heartbeat later.

"Twenty seconds," and so on.

Fortunately, I was able to cut an accurate silhouette in 56 seconds; this feat was greeted with wild applause and requests for several more silhouettes on the table. The fact that many of these took a little longer (women with long hair especially so) did not seem to matter any more.

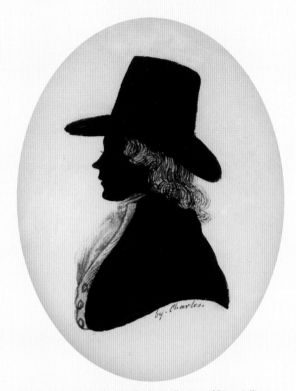

A hatted gentleman, by Mr. Charles (collection of Diana Joll).

So what of Mr. Charles, sitting in his window in eighteenth-century London? The Georgian period was the era of the fob, or pocket, watch, and many of Charles's clients would have carried one. As these were expensive and fashionable items, they would have loved an opportunity to use them. After reading his publicity in the London press or at his shop, they might have considered it great sport to see if he could live up to his word. To judge by his evident success, it seems likely he could. It is safe to assume therefore that if Charles said he could paint a silhouette in three minutes, he must have been fairly confident that he could, at least some of the time.

To show how this might have been possible, it is time to take a closer look at what painting a silhouette actually involves.

Painted Silhouettes

Most people are familiar with paintbrushes. However, painting a clean edge with a brush is not as easy as it seems. This project begins by looking at the nature of a painted line and the way a brush behaves. We will then apply those lessons to painting a simple silhouette.

YOU WILL NEED:

- Smooth watercolor paper, A5 or A6 size
- Scrap paper
- Scaled-down captured shadow or photograph
- Range of small, round sable paintbrushes, sizes 1 to 000; a larger brush is also useful for "filling in"
- Black or sepia India ink, watercolor, or gouache
- Pen
- Hard pencil and eraser
- Ruler and/or L-square

Optional:
- A lightbox

PAINTING IN NATURAL WAVES

Figure 1 opposite shows more natural wave exercises (see also pages 32–5), designed to help you learn to use a brush. The brushes used most widely for painting silhouettes are small, round sable brushes. Pick one up, dip it in water, and make a mark or two on some scrap paper. There are two things to notice. First, the brush moves naturally in the opposite direction from scissors: while scissors naturally cut a line away from you, a brush is far easier to use if you pull it toward you. Second, while scissors clearly make a single line as they cut through paper, it's less clear what sort of line the brush makes, or even if it makes a line at all. The wet area left behind on your paper should be considered as just that: an area. This area has an edge, in that it is surrounded by a clear line of its own. This is the "line" you will use to make a silhouette.

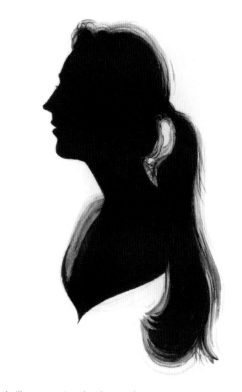

A silhouette painted with gouache.

Now paint a wandering line down the middle of a piece of paper. Note that the line you think you are making is not the line that lands on the paper. You are in fact creating two lines, one each side of an area of paint. If you painted with a bold, confident stroke, these two lines will be some distance apart. If you used a more tentative, hesitant stroke, they will be closer together, but there are always two lines. Worse,

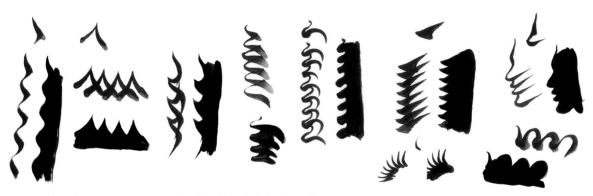

Figure 1: Natural wave patterns painted with a brush by a right-handed artist.

neither of these will be the line you intended to paint; instead, that line runs, quite invisibly, between them.

For most painters in watercolor this isn't an issue, and they don't think about the marks they make in these terms. Watercolor paintings are made with areas of thin paint, layering colors on top of each other so the lower areas show through. Silhouettes are different, as a profile only needs one edge and is ideally painted in a single layer of paint. So the natural question is: which of these two lines should you use to paint your silhouette? The answer depends once more on which hand you use. For right-handed artists, it will generally be the line to the left of the brush. For the left-handed it will be the line to the right. This is simply because this is the easier side to see at the point where the paint flows off the brush, the other side being hidden behind the brush. As brushes, unlike scissors, don't come in left- and right-handed versions, there are no other issues to consider, so you can start to practice using your brush in this way.

The purpose of these exercises is to gain control of one of the two lines made by a brush while ignoring the other. This has been done in the painted waves in Figure 1, above. Each wave is started with a single brush stroke, which is then repeated a number of times to create a wave pattern, in much the same way as you do when using scissors. Although each mark you make has two clear edges, look at just one side of the brush stroke as you paint the line. Right-handed artists should concentrate on the left side while ignoring the right. Continue each stroke into the "empty" space to the right, as you would when breaking away with scissors. Since this space will be filled in, you can use it to give yourself room to begin and end each wave. This allows you to paint with a confident, clean line, knowing that you won't need to stop the brush suddenly when it reaches a corner in the profile.

Next to each pattern is the same set of waves with the right side filled in. The shape of the wave is now much clearer.

Practice these exercises regularly, treating them as a warm-up for your paintings. Use a well-loaded brush with paint thick enough that the brush strokes themselves are not visible when you fill in the shape afterward. Take your time with these exercises. Although Charles would have been able to paint these very quickly, if you go too fast at first you will make a mess. Instead, paint at a relaxed and steady pace. As your hand becomes used to the movement, you will speed up naturally over time.

The waves illustrated here are by no means exhaustive. Your brush can create an enormous number of different curves, loops, and squiggles, so feel free to invent your own as you practice.

Painting in black

There are a variety of materials available to paint a silhouette. Some artists use India ink, others gouache or watercolor. John Miers used his own recipe: a mixture of beer and soot from the chimney. Do try this out if you feel like it! India ink creates a rich black with a slightly shiny surface, while gouache is solid and matte. Watercolor is wonderfully responsive, as you will discover if you practice wave patterns with it, but to create a solid black you need to build it up in layers. Beer and soot work best if you use a fairly heavy beer such as stout.

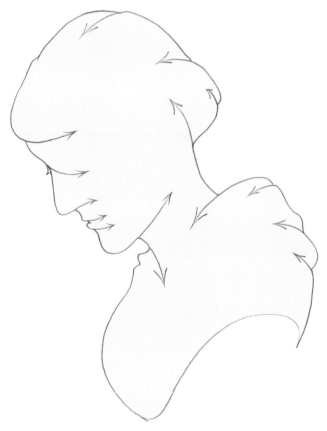

Figure 2: Natural wave pattern for a painted silhouette, showing breakaway lines inside the profile.

PAINTING A SILHOUETTE

The main difference between painting and cutting is that you paint the profile itself. While a scissor artist cuts away the paper around the profile, breaking away into the negative space around the head, a painter paints the actual head. Painting "positive space" in this way is an easier and more natural concept to grasp. Your lines "break away" inside the profile, rather than outside. It is generally easier for right-handed artists to paint the left profile, while left-handed artists will find it easier to paint the right.

A) Begin by reducing and transferring your outline to cardstock or paper. Whether you use a grid (see page 22) or a pantograph (see page 23), make sure that you draw lightly, using a sharp, hard pencil, as you need to rub away any visible pencil marks with an eraser once your silhouette is complete. If you have access to a lightbox, you can avoid using a grid altogether. Create a scaled-down drawing, including any alterations, on scrap paper using a dark pen. Place this underneath your paper on the lightbox and lightly trace the outline. If you are working from a scaled-down photograph on relatively thin paper, you might even be able to trace directly from the photograph this way.

Another way to avoid using a grid is by "rubbing." If you are painting onto a solid surface, such as the plaster slabs John Miers was fond of using, you will not want to use a grid as it may not rub out. Place a scaled-down outline facedown on a lightbox, or against a window, and draw the outline on the back in soft pencil (say, 3B). Next, place this face up over your surface and retrace the outline using a metal point or a sharp, hard pencil. With practice, you will be able to transfer the outline itself, ideally very faintly.

B) Dip your brush in the paint and, before you start, use some scrap paper to paint a few waves and other squiggles (see Figure 1, page 51). This will

warm up both your hand and brush, as well as test the consistency of the paint, which should be thin enough to flow easily, yet thick enough to create a rich, opaque black. Once you begin, be brave and start with the facial profile.

C) Begin at the top of the face and work your way down, making a series of confident wave marks to delineate the forehead, nose, mouth, and chin. Immediately fill in some of the area behind before the paint dries, as this helps to keep the profile smooth as well as making it easier to see the face as it emerges. Pause and look at the work so far.

One of the advantages of starting with the face is that if it goes wrong not too much time has been lost. If you do make a mistake, you have two options:
1) Move fractionally to the left (or right if left-handed) and paint a new face a little outside the first. Hopefully this one will be better. You will later need to move the whole silhouette, so bear this in mind as you paint the back of the head and work inside the line.
2) Throw it away and start again. You can only move left a limited number of times, and at this point not too much time has been lost.

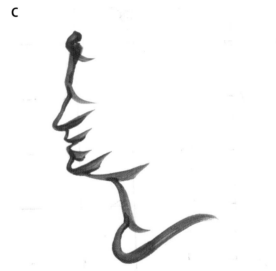

D) Once you are happy with the face, paint the back of the head. Depending on the hairstyle, make an initial painting inside the outline. If the hair is thin, paint the shape of the skull rather than the outside of the hair. Paint in confident, clean wave lines, turning the paper as you do so. This is to keep the line you are painting on the visible side of the brush. It means that the silhouette will appear upside down. When complete, fill in the whole head with black paint using a larger brush. Similarly, work around the bust in a series of waves and fill in that area as well. You should now have a complete shade with a carefully painted face and a more roughly painted head.

Detail of solid hair technique.

The exception (there is always one) is if your subject is bald. In this case, you need to paint the whole head with the same care as the face.

E) As with a scissor portrait, you can now add hair and other details. There are two approaches to this:

1) The first is to take a fine brush and continue with the same consistency of paint as the rest of the profile. Look closely at the direction and general style of the hair, and begin making a series of small flicks and marks around the head. Practice these on some scrap paper to get the feel of them. They are not "wave" patterns, as both sides of the brush are in use. It's important to have a good-quality brush that comes to a fine point. Work your way around the back of the head, putting in as much or as little detail as needed. You can also add details of clothing, such as buttons or ribbons. Over time, you will find you can add these details quite quickly. If possible, complete this process while the paint is still wet.

2) This second approach is the one pioneered by John Miers (see pages 14–15) and is more time-consuming, but rewarding if you can get it right. Dilute the paint and go around the outline at the back of the head in stages, using progressively thinner paint for each one. The detail of the Miers silhouette above shows this technique clearly. The idea is to show the effect

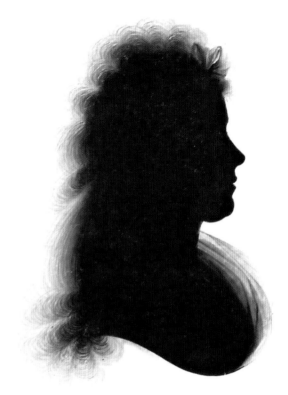

Detail of John Miers's hair technique.

of light blending with shadow and shining gently through the hair. Keep some scrap paper next to you to test each dilution of paint before you apply it. Give each stage a chance to dry before you apply the next, or else the layers will simply bleed together on the paper. As well as for hair, you can use this technique to add details to clothing. It gives the cloth a slightly ephemeral quality, as if made from a see-through fabric. Some of Miers's most spectacular silhouettes are of women with hats and feathers, which lend themselves particularly well to this treatment.

F) Now is the time to add an eyelash (see page 45), if you wish, with a single flick of paint from your finest brush.

G) When the paint has dried, use your eraser to remove the grid lines.

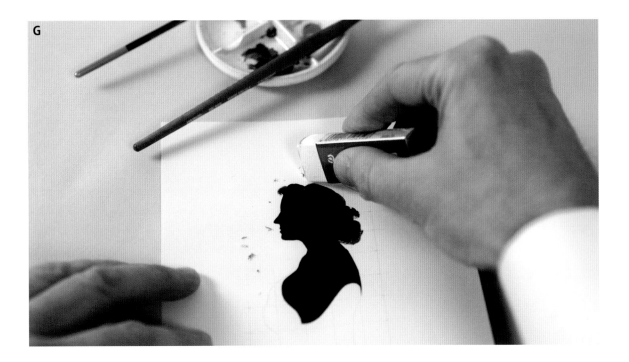

G

Appreciation

Take a moment to look at the silhouette. There may be time to "touch in" areas that should be black but have paper showing through as the paint dries. The success with which you can do this depends on the medium you are using: gouache is particularly forgiving, while watercolor is not. Sign your work under the bust line with a fine black pen or a sharp pencil. You have created a plain black shade in paint on card. This is the simplest kind of painted silhouette, which should now show a clear likeness.

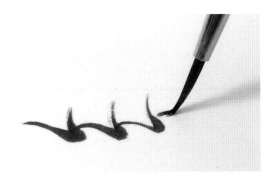

SOME NOTES ON FREEHAND DRAWING

If you are an experienced sketcher, you could try a simple freehand sketch using a light pencil. Due to the difficulty in transferring the outline to thick paper or plaster, this may have been a preferred option for some artists, especially in the days before lightboxes. Either sketch from a photograph or from life. First, consider placement within the page (a cut silhouette can be stuck anywhere, but a painted silhouette needs to be drawn in the right place). For this reason, you should start by lightly sketching the overall position of the head and bust before drawing a more considered line for the profile itself.

Another option is to follow the example of John Miers by reducing the face with a pantograph, then drawing the head and bust freehand around this (see page 39).

Augustin Edouart
(1789–1861)

One of the things that first attracted me to silhouette art was that it didn't seem to take itself too seriously. However, my next "teacher," a Frenchman named Augustin Amant Constant Fidèle Edouart, is the exception.

A French émigré in England

Augustin Edouart discovered silhouettes relatively late in life. After fighting in France during the Napoleonic wars, he arrived in England in 1815 as a refugee with his wife, a growing family, and hardly any money. He made his first foray into silhouette art ten years later at a gathering of friends in Cheltenham. The host was showing off a recently acquired machine-cut shade, quite possibly describing the latest scientific method by which it was made. Edouart was not impressed, declaring he could do a better job with an ordinary pair of scissors. The guests called his bluff, scissors and paper were found, and some minutes later he had cut his first silhouette. He was evidently a natural, as the profile was greatly admired, and a couple of months later he had set up shop as a professional artist.

Ten years later he published an account of his work entitled *A Treatise on Silhouette Likenesses*, which opens by listing the royals and noblemen who had sat for him. Rather egocentric in tone, the book gives the impression of someone with a slightly autistic personality, formal in his dealings with others and obsessed with cataloguing and detail. Many stories about Edouart originate from the book, especially concerning the slights (real or imagined) he received from what he considered the unappreciative English public. One such incident involved a man who commissioned a full-length silhouette at Edouart's Cheltenham studio. Not satisfied with the likeness, he left without paying the five-shilling fee. Hugely insulted, Edouart cut away at the body of the silhouette, turning it into a corkscrew with the man's head as a handle, so it was instantly recognizable to all who knew him. Edouart then offered it for sale in his window with the caption "a patent screw for five shillings." The client paid up.

Edouart is credited with bringing the French word *silhouette* into the English language. At the dawn of the Victorian era, the art of the profilist was in rapid decline and facing competition from early forms of photography. The day was not far away when "penny profile cutters," working the streets of Victorian London, would be regarded as little more than beggars. By calling himself a "silhouettist" rather than a profilist, Edouart sought to elevate his art above that of the street and give his cuttings a more refined air. That his work was worlds apart from that of many other silhouette artists of the day is beyond doubt. While profilists all over the country were abandoning their art for the camera, he alone stuck to it, determined to bring it to higher public appreciation.

In 1839, Edouart left England for the New World, and toured America as an artist for many years. His freehand technique was widely admired, and he cut many silhouettes of important public figures during this formative period in American history.

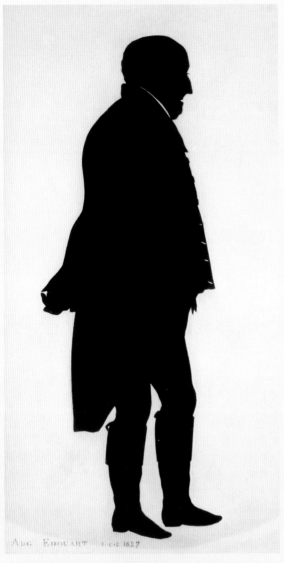

A gentleman with hands behind his back (collection of Diana Joll).

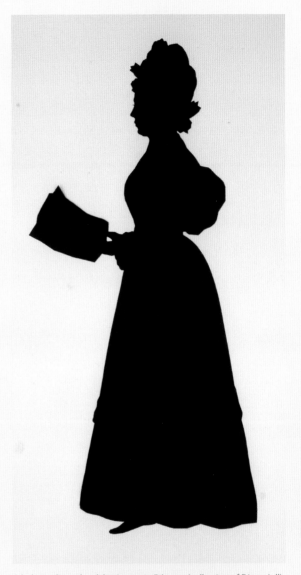

A lady reading a book by Augustin Edouart (collection of Diana Joll).

Edouart's working method

To this day a difficult challenge for any artist, cutting full-length silhouettes with scissors was pioneered by Edouart. From early on, he appreciated the importance of keeping copies, in line with the tradition established by John Miers, who kept life-size cartoons. Working with the newly available sable surface paper, he would fold a sheet in half and draw a freehand sketch loosely on the white side to establish the proportions and general demeanor of the pose. Traces of his sketching can still be seen on the reverse of some of the silhouettes that have become unstuck from their backing. He then cut the outline freehand with scissors, creating the face and other fine details

that characterize his work, the initial sketch showing little more than the position of the head. This procedure gave him two copies: one "correct" and one in reverse. One of these (whether the correct or reverse was probably the client's choice) was pasted onto a presentation card, sometimes with a lithograph or watercolor background. Couples could choose to have one person correct and the other in reverse, so the two silhouettes would face each other, even though they were almost certainly cut in the same direction. Duplicate silhouettes were retained and later pasted into a folio, together with the client's name, date, and place of cutting, and sometimes

A self-portrait from the frontispiece of *A Treatise on Silhouette Likenesses*. The shelves in the background show his collection of duplicate albums.

their age and other notes about them. These details were written out five times: right away onto the back of the silhouette; later into Edouart's "day book;" into the duplicate folio itself (under the silhouette); into the index to that folio; and lastly into a general index.

Shipwreck

Edouart's story ends rather sadly and in a way that shows him in a sympathetic light. In 1849, after ten years in America, he decided to return to his native France. Near the end of the journey, his ship was wrecked in the treacherous waters off Guernsey. Although he escaped with his life, most of his folios of duplicates were either lost or ruined beyond repair. He stayed in Guernsey for some months, having been offered shelter by a local family while those goods that could be salvaged were taken off the wreck. Tragically, out of a total of over 100,000 silhouettes cut throughout his life, only 12,000 were rescued. Perhaps Edouart felt that these remaining folios, originally intended to form a complete record of his life's work for posterity together with the lost folios, were not much use as a partial record bereft of their various indices. Whatever his motives, he left them behind in Guernsey as a thank you to the family who had sheltered him. He returned to France, but did not work professionally as a silhouettist again; only one silhouette cut by him has ever been found after this date. Meanwhile, the folios remained in Guernsey for over 60 years before being discovered and catalogued.

Today Edouart's work is widely collected and quite valuable. Some of the remaining folios have been divided up, the sheets of duplicates finding their way into private collections. Artists in America still regard him as the father of silhouette, since he so clearly showed the superiority of freehand cutting over the machine-cut profiles common at the time. To this day, most professional silhouettists in America prefer to work freehand.

Full-length Silhouettes

Creating a full-length silhouette introduces a whole new set of problems and is a more challenging proposition than a bust-length shade. The main aim of this project is to help you obtain a good outline drawing from which to work. It is possible to capture a shadow in full length, although it's an ambitious undertaking. However, this isn't an easy way to make a full-length silhouette, so for this project it's best to work from a photograph.

YOU WILL NEED:

- Digital camera and inkjet printer
- Paper to print on
- Pencil, ruler, and red crayon
- Materials to make a finished silhouette: either black paper, tape, and scissors from Scissor-cut Portraits (see page 42), or watercolor paper, paint, and brushes from Painted Silhouettes (see page 50)

SHADOWS IN FULL LENGTH

This project uses the same techniques as the previous two projects, and you should have completed at least one of these before embarking on this one. To Reduce the Scale (see pages 22–5) introduced a simple way to use photographs to create bust-length silhouettes. It suggested photographing a whole room full of people to obtain enough material to complete all the projects in this book. The exception, however, is this one, as taking a photograph for a full-length silhouette requires more thought and careful consideration of the pose.

Striking a pose

Your sitter should adopt a relaxed and natural pose. However, nothing is more calculated to make people feel awkward than telling them to "look natural." The pose needs to compensate for the silhouette's illusion of "flatness" (see pages 38–9). As with previous projects, there are conventions for doing this, some of which need to be considered from the outset.

A bust-length silhouette is quite happy floating on a white background; people accept the bust line as a construct that doesn't need further explanation. The same can't be said of a full-length silhouette, though, which can feel unanchored when floating in white. Rather than serve as a background, the white becomes an empty space into which the figure appears to "fall." This happens because we expect a standing figure to stand *on* something. If that something isn't visible, or at least indicated by some contrivance, the basic composition becomes unbalanced, leading to an uncomfortable impression that the silhouette is about to fall over.

In the nineteenth century, it was not unusual for artists to paint a floor for their silhouettes to stand on, complete with a shadow emerging from under the feet. Other artists would just paint the shadow, feeling that was enough to ground the silhouette. The shadow was painted by lifting the feet of a cut silhouette and then painting a single tapering stroke of gray watercolor out from underneath. Edouart used a set of lithographed backgrounds, placing his silhouettes in

an empty room with a window and patterned carpet. The shadows were painted over the carpet and usually radiated away from the window.

Edouart also pioneered another more subtle solution, although he didn't rely solely on this. He would indicate the presence of a hard surface by giving his silhouettes one flat foot (see Figure 4, opposite). This has since become a convention in which the sole of the leading foot is always cut dead flat and exactly horizontal. The "leading foot" is the one that points in the direction the silhouette is facing and is usually the left foot if the figure is facing right. In reality, you would never see a foot this flat unless you were viewing it at floor level, and it certainly won't appear flat in your photograph. The convention works because our eyes extend the horizontal line, indicated by the leading foot, thus creating the illusion of a flat surface on which the figure is standing.

A second convention concerns hands. Many people, when asked to pose for a standing silhouette, adopt a rather straightened pose in which both feet face forward and the hands drop down at the side. This doesn't work for two reasons: there is no clear leading foot and the arms disappear so the figure appears to have no hands. At least one hand therefore should be outside the outline (see Figure 1, left). This is easily achieved by giving the subject something to hold, and for this reason, many early silhouettes show gentlemen holding hats and gloves. My own favorite device is to give adults a glass of wine to hold and children a treasured toy. A few people are able to pose naturally without holding anything, such people can be asked to make a gesture with their hand, as if making a point in conversation, and then to freeze it mid-way. If done convincingly, this pose can work extremely well (see Figure 4).

Figure 1: A full-length shadow drawing with alterations in red. A foot has been added to give the pose a base, while the hand has been moved from the original position in front of the stomach.

ANY COLOR YOU LIKE

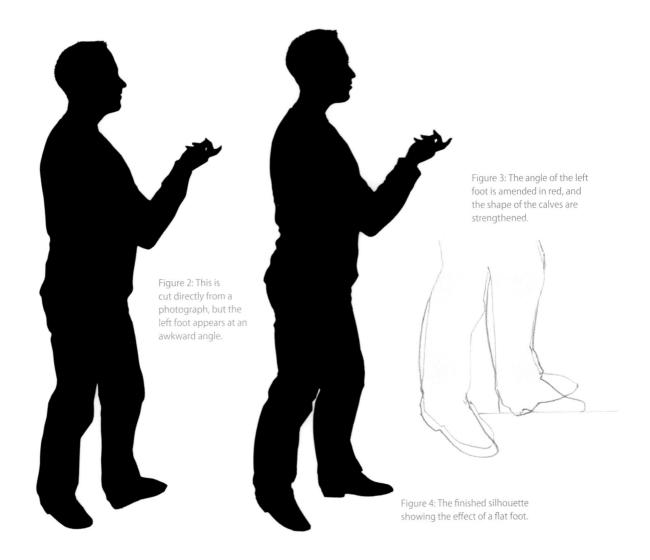

Figure 2: This is cut directly from a photograph, but the left foot appears at an awkward angle.

Figure 3: The angle of the left foot is amended in red, and the shape of the calves are strengthened.

Figure 4: The finished silhouette showing the effect of a flat foot.

CATCHING A FIGURE WITH A CAMERA

The two requirements of looking natural while at the same time working within the conventions of a standing pose compliment each other well. Ask your model to stand with one foot forward (usually the foot furthest from the camera) and to strike a pose with the weight on the rear leg. Make sure that they are facing the correct side (if you are right-handed, ask them to face to the right if you are cutting, and the left if painting), and that they have something to do with their hands. Also ask them to stand tall and look straight ahead. Concentrating on all of these instructions will hopefully distract them from any concerns they have about looking unnatural.

Ideally, take two or three pictures, making sure that you include the whole figure from head to toe, and shooting both sides of the pose as a reference.

Preparation

Print out a photograph on thin paper at the correct scale: around ⅛-scale for cutting and around ⅒ for painting. At these scales, a 6-ft (1.8-m) man will be

FREEHAND SKETCHING NOTES

Augustin Edouart began his cuttings with a freehand sketch. Doing this well requires an extended period of learning how to draw the human figure. If you have some experience with life drawing, you might wish to try this for yourself. Draw lightly, either onto watercolor paper for painting or thinner paper for cutting. Begin by sketching in the vertical proportions, working out the size of the head in relation to the body and of the body in relation to the whole figure. Once you are happy, refine the sketch, working toward a single outline.

between 7½ and 9 in (19 and 23 cm) tall. Before you continue, take a look at the pose and try to imagine how it will look in solid black. Consider any changes to the outline and mark them in red crayon. Look at the feet and hands, checking that one foot is dead flat and at least one hand is visible outside the line. Again, draw any changes in red crayon as shown in Figure 1 on page 60. If you set the pose correctly when taking your photograph, you should only need to make a few simple adjustments at this stage.

Look also at the natural curves of the body and try to accentuate a few of them. For example, you can emphasize the pose by exaggerating the curve of the spine. It also helps to ground the silhouette if you can accentuate the shape of the calf muscle on the

A pair of seated figures by Hubert Leslie, cut with scissors using a freehand sketch.

ANY COLOR YOU LIKE

The finished silhouette

Please refer to the techniques used in Scissor-cut Portraits and Painted Silhouettes (see pages 42–7 and 50–5), depending on whether you plan to cut or paint your silhouette, as the techniques are exactly the same here. When cutting, you will probably start and finish with the right foot. Pay particular attention to the hand, which needs to be cut or painted with the same care and attention as the face.

Adding a shadow

Check to see if the silhouette is standing straight. If it looks as though it could fall into the background, try adding a shadow to indicate the floor (see Figure 5). To do this, take a larger brush with some diluted black watercolor and paint a single stroke under the feet. This technique is similar to painting an eyelash, so it's a good idea to practice on scrap paper beforehand. With a painted silhouette, you can paint over the feet (as long as they are dry), while for a cut silhouette you need to lift the feet and paint underneath.

Figure 5: Cut at a masked ball with a shadow added in watercolor.

rear leg (the one taking the weight). This creates an impression of stability and makes the pose clearer (see Figure 3 on page 61).

The main difference with a full-length silhouette, rather than a bust, is that you shouldn't alter the proportions between the head and body: leave vertical proportions as they are and make changes only to the horizontal.

Appreciation

Although some people are understandably nervous about posing for a full-length silhouette, once they see the finished results they much prefer them. It's said that for a portrait to be a work of art it needs to show personality as well as a good likeness. Full-length silhouettes seem to achieve this more readily, as the way we stand says a great deal about who we are.

Life-size Shadows

This project produces impressively sized artworks, which can be an effective way to decorate a large area, for example if you are renting a party tent. Don't take the project too seriously, though; it's fun to do, but the results are unlikely to be great works of art.

YOU WILL NEED:

- Roll of wall-lining paper or other large, cheap sheets of paper
- Large area of glass; a glazed door works well
- Footstool or box to stand on
- Bright spotlight
- Marker pens for drawing the shadow
- Some large sheets of black paper
- Plenty of adhesive tape
- Large pair of scissors
- Ready supply of volunteers willing to have their silhouette cut

CAPTURING A LIFE-SIZE SHADOW

This is the same as method two for taking a profile that we covered in To Capture a Shadow (see page 17), but on a more ambitious scale. You need to work after dark, with either you or your subject outside.

Working fast and large

Begin by taping a sheet of lining paper on the outside of a glass door, making sure that you tape along the bottom to prevent the paper from rolling itself up again. Place a footstool on the inside of the door and shine a bright light from as far away as possible. Ask your model to stand as close to the glass as possible. The stool is needed to elevate the feet, which otherwise will be obscured below the sill. All the notes on pages 59–61 about posing for a full-length photograph apply.

Figure 1: Taping a life-size shadow to black paper ready for cutting.

Once you are happy with the pose, draw around the shadow as quickly and accurately as possible. Holding a standing pose is far from easy and not practical for more than two or three minutes; you may even start to see significant wobbles after only a minute. If you are making a set of silhouettes for a tent, have lots of paper ready so you can move onto the second pose as soon as you are finished with the first.

Lay the black paper on the floor. If you don't have black paper on a roll, you may need to stick two or three sheets together with tape. Lay the captured shadow on top and tape all around to keep the two pieces of paper together until you finish cutting

ANY COLOR YOU LIKE

(see Figure 1). Now carry out any necessary alterations to the profile, such as making the feet clearer and/or accentuating any natural curves to prevent the silhouette looking too wide. Using a large pair of household scissors (your usual silhouette scissors won't do for this job) cut out the shadow, starting at the feet. It isn't practical to turn the paper at this scale, so you will need to turn the scissors more than usual as you cut. Try to use natural waves as much as possible, taking particular care as you go around the face. As you reach the top of the head and begin to cut down the back of the figure, you will need physically to walk around the paper (most of which is still on the floor) to give yourself a better angle. When cutting at this scale, it's impossible to see what you are doing (there is no way to hold it to the light), so trust the line you drew.

Appreciation

To view this silhouette properly, you need to display it (see right). If you are decorating a space such as a tent, attach the silhouette with a number of packing tape loops (make sure the tape you use won't mark the wall), or stitch some fine thread to the silhouette and suspend it from the ceiling so it hangs close to the wall. Whichever method you use, the arm may need a tape or thread of its own to prevent it flopping over.

Silhouettes cut on this scale are impressive and cannot fail to be immediately noticed by everybody who walks into the space. However, because of their size and inherently floppy nature, they are difficult to display for any length of time, so are best treated as a temporary piece of art. Appreciate them today, as tomorrow they will end up in the recycling box!

A pair of life-size silhouettes suitable for decorating a tent.

Caricature in Silhouette

This project looks at how caricature can be used subtly in silhouette, or sometimes exaggerated for humorous effect. You will need the confidence to make some fairly extreme alterations, as well as a sense of humor for when things go wrong, as they inevitably will!

Researching caricatures

It took me years to work out a reliable way to make caricatures in silhouette, largely due to the lack of an obvious teacher. The first picture I saw that suggested it might be possible was a painted self-portrait by Aubrey Beardsley (1872–1898), who was not a silhouette artist, but a well-known Victorian graphic artist who worked exclusively in black and white. This is the only portrait silhouette by him I have ever seen, perhaps he created it in a capricious moment.

Phil May (1864–1903)

The next caricatures I saw were by Phil May, a talented Victorian cartoonist who worked for the British magazine *Punch* for many years. He was a founding member of the London Sketch Club, created in 1898, and occasionally used silhouettes in his illustrations. The club has the happy tradition of taking life-size silhouettes of prominent members by candlelight, painted onto a large and ever-growing frieze around the room. May's silhouette, which judging by its style is probably a self-portrait, stands out for its lively manner. Over the years, the club has been a magnet for prominent artists and designers, and, as such, provides a fascinating collection of prominent heads.

A self-portrait painted by Aubrey Beardsley.

George Bernard Shaw and Ringo Starr, after Noel Wisdom.

Noel Wisdom (1896–1983)

Next, I discovered the work of Noel Wisdom, a Florida-based artist working in the 1960s. It has been hard to find out anything about him other than the fact that he traveled the world "on scissors," cutting portraits of interesting people along the way. The silhouettes illustrated opposite right are my own interpretations after seeing two postage stamp-size reproductions of his work.

Most of these caricatures are not truly grotesque in the tradition of modern caricature, but show relatively gentle alterations of the actual profile. Although grotesque silhouettes are fun as illustrations, they do not seem to work as caricatures of actual people.

A pair of caricature postcards from the 1940s signed "FB" (collection of Diana Joll).

Phil May's portrait on the London Sketch Club frieze.

Shades of Caricature

Caricatures are all about fun, although they do require practice. You will learn by failing, laughing, and trying again. After a while, you will develop an intuitive feeling for what works and what doesn't; in the meantime, follow these guidelines and see what develops.

YOU WILL NEED:
- Source material: full-length photographs, captured shadows which have been scaled down, or a friend to pose
- Rough paper for sketching
- Pencil and red crayon
- Materials to make a finished silhouette: either black paper, tape, and scissors from Scissor-cut Portraits (see pages 42–7), or watercolor paper, India ink, and brushes from Painted Silhouettes (see pages 50–5)

What is a caricature?
Caricatures take to extreme the convention of altering the proportions of the face and body to accentuate likeness. Likeness is itself an ambiguous concept. Students of portraiture spend a lot of time studying how to draw a human head in proportion, making sure that the eyes, nose, and mouth are all located correctly in relation to the overall shape of the head. So it can be quite frustrating, when these skills have been mastered, to draw a technically accurate portrait and find the likeness is somehow still missing. Even more frustrating is then watching a caricaturist in action, drawing without any regard for classic proportion whatsoever, and getting the likeness spot-on every time. How does this work?

The series of cut silhouettes in Figure 2 opposite are all based on the photograph shown in Figure 1. The first is an exact shadow, created by cutting around the photograph without any of the usual alterations.

A caricature painted in India ink, after Louise Fenne.

Next is a portrait in which the shapes of the bust and head have been altered to make the pose seem more natural, exactly as in Scissor-cut Portraits (see page 43). The third is a freehand cutting in which these alterations have been deliberately over-exaggerated: the effect is to make too flattering a portrait. In the

Figure 1: The model for the stages of caricature shown in Figure 2.

Figure 2: The four stages of caricature:
1. Reality 2. Likeness 3. Flattery 4. Caricature.

last, the exaggeration has been pushed to extremes, so that the silhouette no longer displays any pretence at being a portrait. It has now moved into the realm of caricature. As with a portrait, the biggest changes have been made to the shape of the bust, while the least are to the facial profile. The back of the head has been curved inward to join up with the drastically narrowed neck, and the line under the chin has been stretched for the same reason. Both these alterations appear to exaggerate the chin and nose, which now seem larger than they should in relation to the rest of the head.

CREATING CARICATURES

Caricatures can be either cut or painted, bust length or full length, or any size in between. If you are working from a photograph, refer to the previous projects for notes about preparing and transferring the outline. The big difference here is the extent to which you will alter the line.

Preparing the image

Start at the base of the neck. This is the narrowest part of a silhouette, and is usually brought in a little. Bring it in a lot: to half, or even a quarter, of its original width. You'll find other alterations mostly follow from this simple but drastic step. The upper body, or bust, takes its scale from the neck, so redraw everything about one quarter of the original size. Fitting the head to the narrow neck is trickier, but fun. One way is to taper the neck so it resembles a funnel. Bring the back of the head inward, redrawing the line from the top of the head and gently curving further in until it

Figure 3: Reducing a photographic outline to a caricature (caricature line in red).

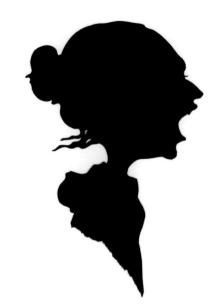

Figure 4: Extremes of expression can work in a caricature.

meets the neck. This makes the head smaller and so exaggerates the facial features, which now look larger in proportion to the head. Lastly, try exaggerating the more prominent features, such as the nose and chin, a little more than usual, but be careful, as too much exaggeration can lead to a loss of likeness.

Once you have established the general shape, there are a number of other things you can do with caricatures that you wouldn't normally do in silhouette. Opening the mouth works well, as this gives the impression that the subject is engaged in conversation. You could even introduce a smile by making a line into the mouth that curves up (or one that curves down if you want a grimace). In reality, you would never see either of these shapes in a shadow, but in caricature they seem to work well. Long hair causes interesting problems. Should it be the same scale as the head or the body? Imagine how it would behave if the body really were that small, and allow it to fall away, leaving a gap between the hair and the diminutive body, even though you may not be able see such a gap in real

life. Finally, remember that caricatures are all about fun. If surprising incongruities turn up, let them do so. If working in full length, you may ignore many of the conventions about setting a pose. Ask your friends to take an action pose and see what happens when you shrink their body to miniature size (see Figure 5, opposite). Consider asking for extremes of expression when taking a photograph (see Figure 4, above). Both of these would never normally work in a portrait silhouette, but in a caricature you might get away with it.

Making the silhouette

Having established a line, either cut or paint your silhouette using the techniques learned in Scissor-cut Portraits and Painted Silhouettes (see pages 42–7 and 50–5). If cutting, use a slightly more jagged, zig-zag style of cut than you would for a portrait, as this creates an unfinished look that works well with a caricature. If painting, a slightly wilder style also works well: the odd, random splash of paint will not look at all amiss and may even add to the overall effect.

ANY COLOR YOU LIKE

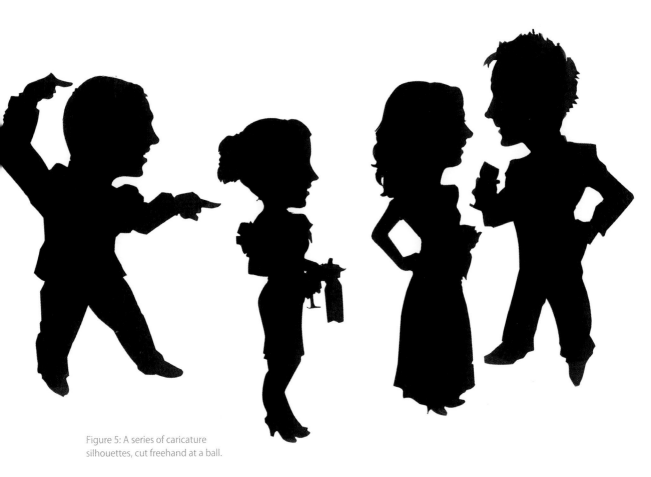

Figure 5: A series of caricature silhouettes, cut freehand at a ball.

Appreciation

Hopefully, your silhouettes made you laugh—perhaps you have been chuckling to yourself throughout this project! If your friends have a similar reaction, you have created a successful caricature.

On a serious note, can you still see a likeness? If the caricature has worked, the likeness should be as obvious as ever, undiminished by the brutality with which you treated the portrait. If not, then you may have taken too many liberties with the face. While it's almost impossible to take too many liberties with the body, the face should still have some aspect of a true shadow. If the likeness is lost, you might have a humorous illustration, but not a caricature.

NOTES ON WORKING FREEHAND

Whether cutting or painting, caricatures cry out to be drawn freehand. They are much more forgiving of errors in the outline; in fact, it's possible to think of a caricature as being simply a collection of different "errors" in the line. If things go wrong, you stand a good chance of being able to rescue the image by altering the design on the fly. Try to accommodate errors as if they were deliberate exaggerations, rather than trying to correct your mistakes.

Peale Museum

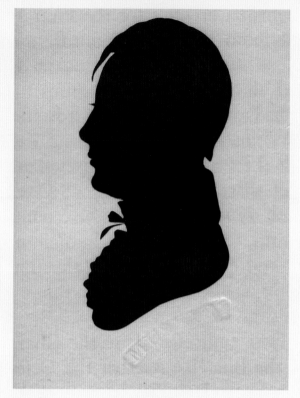

One of the museum silhouettes attributed to Moses Williams.

The technique of hollow cutting, which was so popular in the early nineteenth century, can be used to create a single "inside-out" profile with scissors. To introduce this section, we shall return to America, to a period before Augustin Edouart visited the country. At the same time that Miers and Field were operating in London, a very different partnership was busy making thousands of silhouettes in Philadelphia.

A pioneering spirit

Charles Wilson Peale (1741–1827) seems in many ways to personify the gumption of the men and women who developed the New World. "Silhouettist" was one of his many job descriptions, and one which he later handed on to another artist, Moses Williams (c.1777–1825). His main achievement was to open and run the Peale Museum in Philadelphia, which he filled largely with his own collections: animals he had stuffed himself after inventing a new system of taxidermy. At various times in his life, he was also a sadler, clock maker, dentist, silversmith, and a painter in oils and miniature, as well as being a soldier, politician, and above all a showman.

At that time growth and expansion contributed to the heyday of the "automatic" silhouette machine. Silhouettes taken by these machines play an important part in American history, as many notable figures are represented today only by these shades, especially in the more remote areas where portrait painters had yet to arrive. An important part of the Peale Museum was the Portrait Gallery. After 1802, this contained a modernized version of the facietrace, based on a pantograph (see opposite), and visitors to the museum could opt to have their profile taken for a few cents on top of the entrance fee. This proved so popular that the machine turned out some 8,000 silhouettes a year.

Peale married several times and had in all seventeen children, many of whom were named after artists: Rembrandt Peale, Van Dyck Peale, Raphael Peale, and many others. He later went on to become a politician and legislator, and seems to have been an enlightened thinker: one of his big successes was to lobby for the freedom of slaves in the state, who thereafter became free men at the age of 28. One such was Williams, a slave who had been brought up among the Peale family. It became Williams's job to operate the facietrace, which he continued to do as a free man. His silhouettes are all stamped "museum" under the bust line. Early examples may

ANY COLOR YOU LIKE

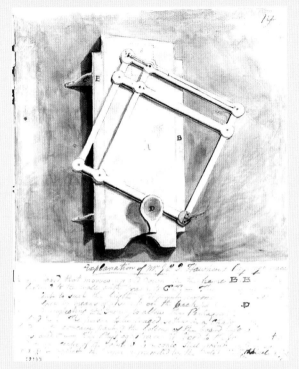

The Peale Museum facietrace. Sitters sat with their cheek pressed against the round plate (D) and their shoulder under the arch (courtesy of the Library of Congress).

have been created by Peale, but since he had his own stamp (simply "Peale"), the vast majority of museum silhouettes are likely to have been cut by Williams.

The facietrace was operated by passing a rod around the face and upper body. This operated the levers of the pantograph, which scored a reduced upside-down profile onto a small piece of white paper above the sitter's head. Once complete, Williams carefully cut away inside the line with a small pair of scissors, cutting a number of copies at once if required. The resulting hollow cut was mounted over a piece of black paper or cloth to create the finished shade.

Machine-made or freehand?

Looking at these "machine-made" silhouettes begs an interesting question: were they as accurate as claimed. And if so, why didn't they suffer the same apparent distortions as other captured shadows? Professional silhouettes made in early nineteenth-century America are generally small, neat, and well proportioned; they obey all the conventions of proportion outlined at the beginning of this section.

It is possible that these machines were not relied on as much as previously believed. Thirsty for new ideas and inventions, the public would have been impressed by the fact that their shade was created by a machine, and the artists of the day were no doubt anxious to create at least the illusion that this was the case.

Augustin Edouart (see page 56) shed an interesting light on the matter. Questioned as to whether he thought machine-made silhouettes inferior to his own, he replied (surprisingly) that he did not look down on the operators of such machines and believed they were true artists. In Edouart's view, the machines were quite incapable of producing the results they did, and therefore he felt certain the operators altered the results by hand to make a satisfying shade.

On close inspection, the museum silhouette illustrates this clearly. The natural-looking shape of the head is, on measuring, too thin to be a real head. It is hard to imagine how the kerchief at the man's neck could have been cut, or even drawn, by passing a rod around a cloth. A notable collector of American silhouettes has described a Peale silhouette in her collection. The faint marks left by the facietrace were still clearly visible and the shade cut well within that line. She concluded that Peale "evidently felt he could improve on nature," without considering that this might have been the way silhouettes were always made.

Interesting though these machines are, they can be left in the museum. Instead, use your favorite method to reduce the scale and concentrate on what happens once the paper leaves the machine.

Hollow Cuts

Hollow-cut silhouettes—sometimes referred to as "the hole in the donut"—are quite puzzling. At first, you may think there is no obvious way into the paper. However, once you do find a way in, the cutting technique becomes intuitive, since the cuts are made inside the silhouette rather than outside, using a similar pattern as for a painted silhouette.

YOU WILL NEED:

- 80–100 gsm white paper, either laid or smooth
- Scaled-down, captured shadow or photograph printed at the right scale for cutting
- Sharp pencil
- Red crayon
- Small pair of scissors

Optional:

- Sharp knife and cutting board
- Watercolors and a set of small brushes

Cut paper and silk

One of the joys of hollow cutting is the ability to divide the silhouette into more than one section, so that, for example, areas of white clothing can be left as white paper. Although never seen in machine-made profiles, this device was often used by amateur nineteenth-century silhouettists, especially in America, who combined hollow cutting with painted details.

If using right-handed scissors, it's easier to cut a left-facing profile; if using left-handed scissors, it's best to cut the right, otherwise the upper blade of the scissors will tend to obscure the line. The shade is finished by backing the cutting with any dark material, such as black silk or velvet. This gives a much richer color than paper: if you place black paper next to cloth you will see that the paper looks gray by comparison (see Figure 1).

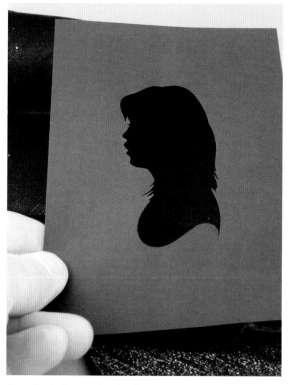

Figure 1: A hollow cut from black paper laid over black silk.

MAKING A HOLLOW CUT

Take a sheet of white paper and fold it in half. Draw an outline on one side using any of the techniques studied in the previous projects, making sure that you place the composition firmly in the center. Plan in pencil which parts of the profile you intend

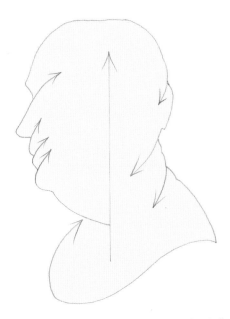

Figure 2: Natural wave pattern (see pages 32–5) for a hollow cut, showing breakaway lines inside the profile.

scissors) you will need to insert the scissors from above, which is one reason why this side is harder. You may find that there are moments when space is tight and you need to remove the scissors and insert them briefly from above. For a right-handed artist, this can happen when you make a left turn with the scissors, as the handles may catch the other side of the paper. In general, turning into the profile is easier (see Figure 2), and you should do as much cutting from underneath the paper as possible.

If in doubt, cut well inside the line: you can correct a hollow cut by making it wider, but never by making it narrower. As you finish, a small white head will drop out from the middle of your cutting. To continue, there are two possibilities: either add extra details by "second cutting," or else follow the technique popular with many American artists and add these details using watercolor or ink outside the profile.

to cut away and which will be left as white paper. If you are working from a scaled photograph, mark what you need in red (see page 43). Be careful not to follow the photograph too literally, remembering Augustin Edouart's words about the limitations of the facietrace (see page 73).

Cutting inside-out

Start by making a single vertical incision across the profile (see Figure 2), either piercing with one point of the scissors or using a sharp knife on a cutting board; this will give you the access you need to begin cutting. Insert the scissors from underneath, placing the jaws of the scissors at the bottom of the incision (see Figure 3) and begin cutting the neck, chin, mouth, nose and so on (ignore the eyelash for now). At first you may find it hard to manipulate the scissors, but rest assured that it gets easier as you go around. If you are cutting a reverse profile (for example, if you are cutting the right profile with right-handed

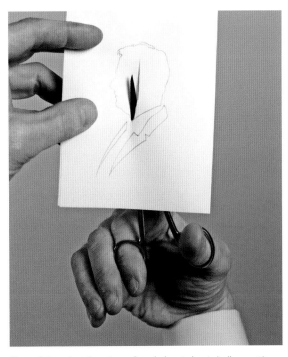

Figure 3: Inserting the scissors from below to begin hollow cutting.

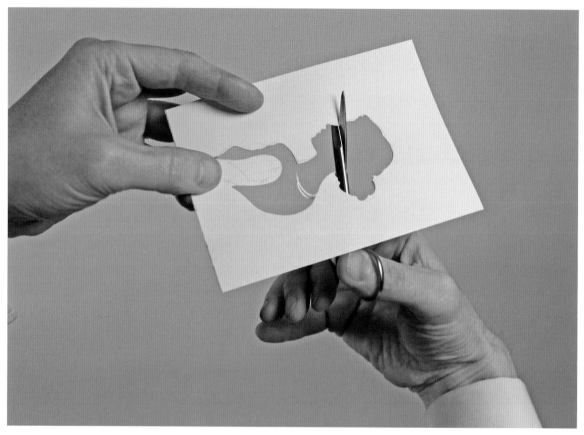
Figure 4: Second cutting a hollow cut, here adding an eyelash.

Second cutting

As with a cut silhouette, go around the profile again, refining the detail (see Figure 4, above). This time you can only enlarge the profile rather than reduce it. Cut hair in the direction it's flowing and add details such as neck scarves by cutting into the white paper. Peeling away a short sliver of paper will create a line of light going into the hair, rather than a single flyaway hair going out. Take a moment to add an eyelash with a couple of short snips.

Using paint

As an alternative to second cutting, you can add details to the silhouette using black watercolor or ink (see Figure 5 and the finished silhouette, opposite). This creates an interesting combination of painted and cut silhouette, combining the solid black of a cutting with the delicately detailed edges of a painting. Place the hollow cut onto a scrap of paper to protect the surface of the table and proceed exactly as in Painted Silhouettes (see page 54, step E).

If you have divided your cutting into several sections (for instance to indicate a white shirt), you may also paint details into the "gaps" using diluted watercolor. Bear in mind that as with any painted silhouette, less is sometimes more. Knowing when to stop is a precious skill in any artist.

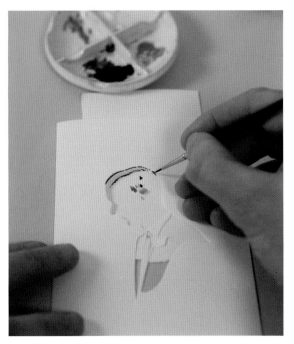

Figure 5: Adding details in watercolor; note the scrap paper under the hollow cut.

Appreciation

People do admire hollow cuts. Their "inside-out" nature somehow makes the cutting process more mysterious, yet with practice they are no more difficult than a silhouette cut the right way around. You have just created a form of silhouette that was last produced professionally in the early nineteenth century, using almost exactly the same technique. None of the twentieth-century artists ever chose to revive it. Despite appearances, your digital camera didn't help you any more than the facietrace helped Moses Williams; it simply positioned the silhouette and gave you a starting point. The rest was down to your growing skill as an artist.

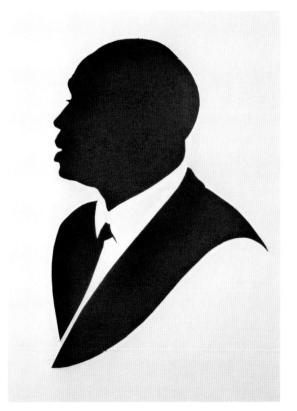

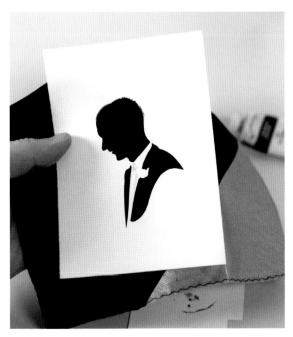

The finished silhouette held against silk.

A hollow cut in three sections.

Isabella Beetham
(1753–1825)

One of Beetham's "caricatured" profiles, painted on card (collection of Diana Joll).

The technique of painting silhouettes onto glass was practiced by many artists in the eighteenth century. After looking at the work of one of the most famous of them, you will have a chance to try it out for yourself. Such silhouettes were usually mounted with a gap behind the glass so that the silhouette throws a miniature shadow of itself onto a white plaster base behind it.

A creative partnership

A 12-minute walk through Georgian London from the John Miers studio at 111 Strand (see pages 14–15) would have led to the studio of Isabella Beetham at 27 Fleet Street, from which came an extraordinary series of silhouettes painted on oval convex glass.

A relative, Ernest Betham, helps set the scene. In *A House of Letters* he writes:

"The Beetham house...commanded an uninterrupted view of that bustling thoroughfare. At that time, Fleet Street and Chancery Lane and their neighborhood was the center for booksellers, publishers, and engravers, and the residence of the literary, legal, and artistic world."

Isabella was married to Edward Beetham. He was an actor when they met, and from a rather grand family in the north of England. In those days acting was considered a lowly and vulgar occupation, and he therefore changed his name, adding an extra "e," to save his family embarrassment. He was an enterprising man who created a safer system of floodlighting for the theater (old systems were prone to catching fire) and invented a new design of washing machine with wooden rollers. It was

Edward's theatrical friends who encouraged Isabella to take painting lessons and embark on a career as an artist. The Beethams settled in Fleet Street in 1785 and remained there for 25 years. The ground floor was used as a showroom for washing machines, while the silhouette studio was upstairs. Her studio became well known and at one point she had a number of assistants working with her. Even Edward was employed in making the distinctive gilded glass ovals on which she painted, using a technique known as *verre eglomisé,* which he traveled to Italy to learn. Many notable people had their profiles taken there, while Beetham herself was painted by Gainsborough.

As well as creating some of the most collectable Georgian silhouettes that survive today, the Beethams also had six children. Their eldest daughter, Jane, worked in the studio and became a talented

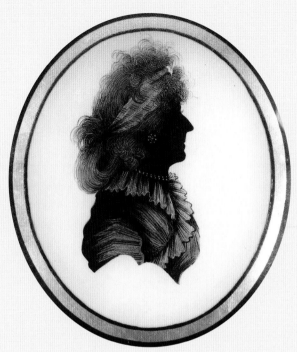

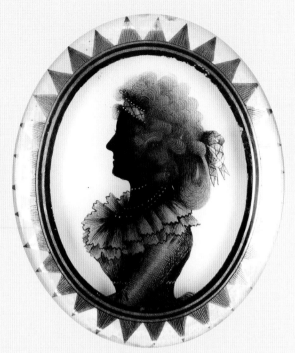

A silhouette by Beetham backed with wax (collection of Diana Joll).

A silhouette on glass by Beetham (collection of Diana Joll).

artist in her own right, developing a unique blend of silhouette and miniature portrait on glass.

Like her rival John Miers, Beetham needed just a one-minute sitting. As no facietrace was available in the 1780s, this probably means she worked from a life-size cartoon taken from a shadow. After scaling down the outline, she established a shadowy base by fingerprinting the area of glass inside the line with black paint, as well as painting the face in solid black. Clothing and hats were added without the presence of the sitter, who chose these beforehand from fashionable drapery and wigs in the studio. Beetham painted these in a series of straight and wavy lines, all going in different directions, which indicates that she turned the glass frequently as she worked, holding it in one hand while painting with the other. She was known for her detail in painting hair, on occasion using as many as 24 strokes to show a single curl.

A range of styles

Unlike John Miers, Beetham's silhouettes come in a variety of styles and techniques. Some of her glass paintings are framed to throw a shadow onto white plaster, while others have been backed with wax, which creates a surprisingly luminous effect. She also painted profiles on paper, card, and ivory, and, early in her career, she even made a few cut-out silhouettes. There is also an interesting series of half-length, almost "caricatured," silhouettes in which the sitters' bodies are reduced nearly to the same size as the heads. Mostly of anonymous young ladies, these silhouettes clearly express Beetham's love of style and are miniature essays on the fanciful fashions of the day.

After Edward's death in 1810, Beetham moved to a quieter part of London known as Somers Town and sadly, seems to have given up painting altogether.

Painted Silhouettes on Glass

This is an advanced project, but accessible if you follow the steps carefully. You should have completed at least Painted Silhouettes (see pages 50–5) first, as most of the lessons on painting apply here. You will start with a plain shade before experimenting with fingerprints.

YOU WILL NEED:

- Small piece of flat or convex glass (the glass from a small photograph frame is ideal)
- Glass-cleaning solution and a clean lint-free cloth
- Cotton gloves
- Scaled-down captured shadow or a profile photograph printed at the correct size
- Adhesive tape
- Range of sable paintbrushes, sizes from 1 to 000; a slightly larger brush is also useful for filling in
- Red crayon
- Black glass paint (available in both water- and solvent-based forms)
- Small, sharp knife and/or needle

Working in reverse

Glass painting is always done in reverse from the back, to be viewed from the front. The main advantage of glass is that you can see through it, which does away with the need to transfer an outline to the surface; you can attach a drawing underneath and proceed straight to painting your silhouette. Another advantage is that there is no need to rush your work, feeling you have to fill in the silhouette before the paint dries. Take your time to paint carefully and then turn the glass over. Solid areas of black will always look perfectly smooth, as smooth as the glass itself, no matter how blotchy and uneven they look from the back.

The main problem with painting on glass is the difficulty of handling the paint. You will find the brush tends to "skid" across the surface, which has none of the tooth of paper (paper offers a slight resistance, making it easier to control your brush). The other problem is getting the paint to adhere properly. The glass needs to be perfectly clean, as even the slightest trace of grease on the surface will cause the paint to contract, leaving areas of thin paint (or even actual holes) in your silhouette. Worse still, small areas of paint may peel away over time, unable to adhere to a greasy surface.

Nowadays, painting on glass is easier as craft stores offer a wide choice of paint designed for this purpose. These are available as either oil- or water-based paint, and there are also some that require drying in an oven. Oil-based paint is better for silhouette art as it tends to be more opaque. Whichever type you buy, it will come with instructions for cleaning glass. Generally, a mild soap solution or commercial window cleaning spray works well, together with a lint-free cloth to wipe the glass clean.

Wear light cotton gloves while handling glass. This protects the glass from the natural grease of your hands, as well as your hands from the sharp edges of the glass. Once you have cleaned the glass, try not to touch the back of it, as however clean your hands are, the slightest touch will leave a faint, greasy mark on the surface, and once you start painting it will be impossible to clean this side again. Touching the front of the glass is not a problem as this can be cleaned again after you finish painting.

PAINTING WITH SHADOWS

You will be painting in reverse, which means there are two considerations to bear in mind. The first is that if you paint a profile facing left, the resulting silhouette will face right. The second is the paint you apply first is the paint that appears in front and therefore backgrounds need to be painted last. As long as you are painting in just one color—in this case black—this second concern doesn't apply, but do be aware of it.

A) Print a photograph at the correct size and make alterations to the outline in red crayon (see page 43). Hold the printed photograph against a window (or place it face down on a light box) and draw the altered outline on the back with a pencil. This gives you a clear line to work from as well as reversing the image, ensuring that the finished silhouette will face the correct way when seen from the front. Cut the paper to the same size as the glass and fix it to the front with adhesive tape so that you can see the pencil line in the center of the glass.

B) Begin painting as in Painted Silhouettes, adopting a natural wave pattern with lines breaking away inside the profile (see page 53).

C) Take your time to paint the outline carefully. Each time you dip your brush in paint, use the area inside the line to test the brush and check that the paint is flowing properly. Once the shape is filled in, these small paint splodges will disappear forever and be invisible from the front. If you make any minor errors outside the line, leave them alone until the paint is dry.

D) Fill in the silhouette with a larger brush.

E) Go around the silhouette, adding details of hair and clothing with small flicks and lines. Use the same consistency of paint as for the profile itself.

F) Once the paint is dry to the touch, take a small, pointed knife or large needle and gently scrape away any points in the hair where light might show through. You can also use the knife to correct the outline if needed, carefully scraping away any accidental overpainting and making minute alterations to the profile itself. This ability to correct errors is a unique advantage of painting on glass, but don't wait too long, as if the paint is bone-dry, it tends to crack.

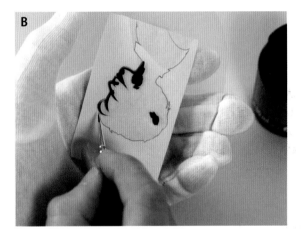

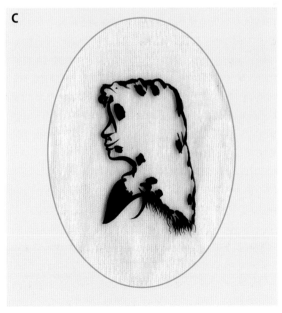

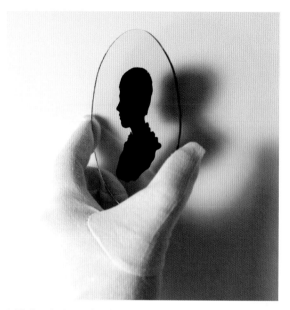

A filled-in shade on glass, held so as to cast a shadow.

FINGERPRINTED SHADES

Once you have created a simple shade on glass, you might wish to try Isabella Beetham's method of painting over a fingerprinted base.

When drawing the initial outline, include the position of the ear as well as the main lines of hair and clothing. Next, with the outline taped to the glass, dip your forefinger into a dish of partly dried paint and print all over the area inside the line. Your fingerprint should be clearly visible; if you make black blobs, the paint is too liquid. Print up to—and slightly over—the line, except in the area of the face (see Figure 1, right).

Take a fine brush and paint the facial profile, filling in the area of the face up to the ear. This should overlap the fingerprinted area without a gap. Set the glass aside until the paint has dried, then scrape the fingerprinting back inside the line (which should still be visible) to make a clean edge.

Paint the clothing and hair in a series of straight and wavy lines, leaving lighter areas as fingerprinting.

FREEHAND PAINTING NOTES

Although the one-minute sitting indicates that Isabella Beetham would have painted her profiles using a captured shadow, it is possible to paint a silhouette freehand from a live model, either on card or glass. Hold the base firmly in one hand, turning it in your fingers so that you can always see the edge of the line you are painting. Oval glass works well for this, or better still the concave ovals used by Beetham as they fit naturally in the hand. Use cotton gloves and/or a clean white cloth to cushion it.

Begin by painting the face in a series of confident waves before moving on to the hair and body. You should aim to complete the whole silhouette in a few minutes, so don't be tentative about the marks you make.

Figure 1: Fingerprinting inside the outline in the manner of Isabella Beetham.

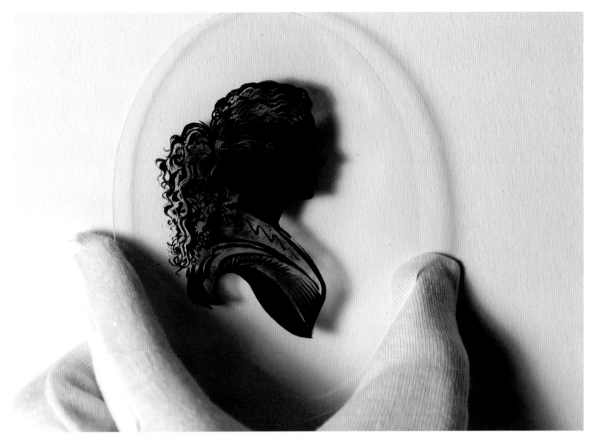

A silhouette painted over a fingerprinted base, showing the translucent nature of the shadow.

Fine lines will be easier to apply, as the fingerprinted base provides a "tooth," meaning the brush no longer skids on the glass. Fingerprinting won't show over your lines when seen from the front as glass has the effect of flattening the paint, making it all seem completely smooth. Finish off with touches of hair outside the line as before, as well as adding an eyelash. Wait until the paint is dry to the touch, then use your knife or needle to make small highlights in the hair and clothing.

Sign your silhouette if you wish, using a needle to write just above the bust line; you need to use mirror writing, so that from the front it appears the right way around.

Appreciation

Looking at a finished shade brings to mind the last, and greatest, advantage of painting on glass. The finished silhouette seems to float magically in the middle of the glass, in much the same manner as a cut silhouette when held up to the light, yet with all the detail of a painted silhouette on a card.

Hold it up to cast a shadow on a wall. If you have been successful, this shadow will seem more lifelike than any you have made so far, almost as if it's about to get off the glass and walk away. Consider framing it in a deep frame, leaving a gap between the glass and a white background so that this shadow will remain an intrinsic part of the silhouette forever.

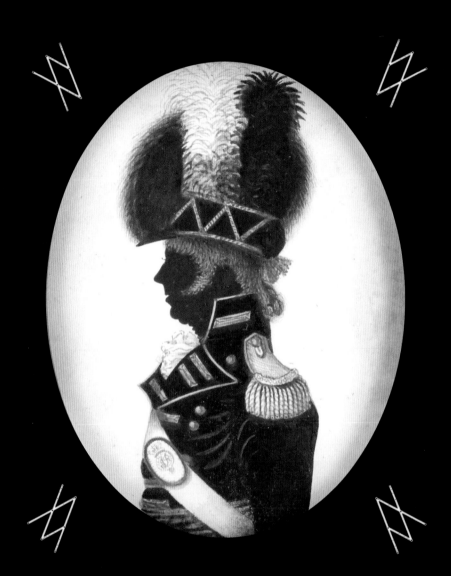

Working with Light

Shades and Profiles

By now you should have created a number of successful silhouettes and be beginning to feel confident in the art. You may have noticed that one of the questions people often ask when you take their photograph or ask them to pose for a silhouette is:

"Which is my best side?"

When it comes to silhouettes, this is not an easy question to answer. If wise, you will ignore it and choose to work on the easier side for you (depending on whether you are right- or left-handed).

The best side

It is helpful to define certain terms. When considering "the best side," it is useful to divide silhouettes into two styles. Until now you have been making "shades," or shadow portraits. A shadow does not have a best side. Anatomically speaking, the line of a shadow corresponds exactly to the line that runs up the middle of the face, over the top of the head and down the back of the neck. This line is identical whether you look at it from right or left, since from either side you are looking at the same line.

You will have noticed that some of the artists discussed so far, particularly Mr. Charles and Isabella Beetham (see pages 48–9 and 78–9), did not really make shades at all as they included details of hair and clothing inside the edge of the silhouette. Such details of dress and hairstyle can, and do, vary from one side to the other. Even faces are not exactly symmetrical: for example ears may be located differently on each side. This style of silhouette, which for convenience can be called "profiles" or profile portraits, certainly can have a best side.

Have a look at the pair of silhouettes opposite by an artist called Handrup (see pages 156–7). They are of the same person and were cut together, out of a single sheet of folded paper. Handrup pasted them onto two cards, face to face. Had he left them like that, both sides would have been equally correct as a likeness. Instead, he added details to the hat in white pencil, while indicating the collar and front of the blouse with a little gray watercolor. Adding details in this way is known as "embellishing" a silhouette. Having embellished one side, Handrup then asked the client to turn around so he could embellish the other, which as you can see turned out differently. As soon as he started to draw this way, he could no longer rely on the symmetry of a shadow; the silhouette stopped being a shade and instead became a profile.

As with all aspects of silhouette, there are various conventions on how to embellish a profile, although they can seem hard to pin down. Many artists regularly break the rules, so this section has been structured to examine these conventions by similarly "breaking rules" over the next few projects.

An old debate: which is better?

A long-standing debate among silhouettists is: which is better, a shade or a profile? Artists such as John Miers and Augustin Edouart (see pages 14–15 and 56–8) thought a silhouette should show just the shadow, while artists such as John Field and Baron Scotford (see pages 94–5 and 100–2) felt there was much to be gained by adding such details. Without wishing to take sides, while the previous section was all about shades, this one is all about profiles.

A pair of silhouettes by Jens Handrup, showing different embellishments on each side of the same silhouette.

An anonymous early nineteenth-century profile of a young lady with ringlets in her hair and the same silhouette with the color removed. There is no way to show her ringlets in a plain shade.

George Lloyd
(1821–1900)

We talked about breaking rules, and the first one to break is about not using a camera. We have already looked at how to use a camera to make raw material for your silhouettes; the following project uses photography to create the silhouette itself.

Occasionally, silhouettes are referred to as "the earliest form of photography." Initially, this seems odd as it is hard to imagine anything less like a photographer's studio than the simple materials of the silhouettist. However, on reading the history of silhouettes, it begins to make sense. What photography so easily achieved was the goal that silhouettists were striving for with all their mechanics and optics: to find the perfect way to capture a likeness without human intervention. The invention of the "daguerreotype"—an early photographic process—and later the photograph, seems to have been a defining moment. One can almost hear the exclamation: "So that's what we've been looking for!"

Demise of the silhouette

The dawn of photography soon put most silhouettists out of business. In the latter part of the nineteenth century, photography was all the rage and crowds flocked to the photographers' studios to have their likeness taken by this amazing new technology. Many silhouettists conceded defeat, put down their scissors, and bought a camera instead. Most collectors agree that the silhouette's heyday was 1760–1860, after which they virtually disappeared.

Devices such as the facietrace and *camera obscura* were a thing of the past.

However, there was a brief period when the two managed to coexist. Early cameras were expensive

A silhouette by George Lloyd (collection of John and Janey Haselden).

and difficult to use, while exposures were so long that the time needed was no shorter than taking a silhouette (for early daguerreotypes, for example, the subject might have had to pose without moving for up to ten minutes). For a time, a few silhouettists tried to compete by under-selling the photographers, but as technology improved and prices fell, this business model rapidly became untenable.

Photographer and artist

One artist who worked at this time was George Azariah Lloyd. Lloyd began cutting silhouettes in the 1840s and worked for a time as an itinerant artist, traveling around England. In the early 1860s, he settled in Brighton and took over the silhouette concession at the number three tower on Chain Pier. By 1868, he had bought his first camera and was describing himself as a "photographic artist and profilist." Today his work as a photographer is better known than his silhouettes, as his photographs depict life in the early Victorian era. The photograph of the Chain Pier in Brighton shows the kind of booth from which so many silhouettists had worked over the years.

As time went by, Lloyd naturally worked more as a photographer and less as a silhouettist—an experience that was undoubtedly typical for many silhouette artists of the day.

An early photograph showing the number three tower, Chain Pier, Brighton (James Gray collection, The Regency Society). The silhouette concession opened here in 1823.

Photographic Silhouettes

For this project, you will be turning one of the rooms in your own home into a temporary photographer's studio. This is less daunting than it sounds, as you can carry out this project with a fairly ordinary digital camera and no other special equipment.

YOU WILL NEED:

- Two assistants
- Window
- White sheet
- Digital camera
- Camera tripod (optional) or small table
- Table light or portable spotlight
- Candle, contained in a lantern or glass jar

EXPERIMENTING WITH LIGHT

Begin by choosing a room with a single large window that gets plenty of light. Indirect light is best, so a north-facing window is ideal. Otherwise, you can use a west-facing window in the morning or an east-facing window in the afternoon. If your only option is a south-facing window, you will need to wait for a cloudy day!

Clear a space in the room and hang a large, ironed, white sheet across the window. This is to further diffuse the light and prevent the view through the window from cluttering your photographs. If there are any other windows in the room, close the drapes or hang a heavy cloth across them, so the main window becomes the only source of light. Set your camera on a tripod or small table facing the window, making sure that the edges of the window (if visible in the screen) are straight. This will mean that the camera is level. Set the tripod at about head height. If you are using a table, you can pile books under the camera until it reaches the correct height.

Transmitted light

Ask an assistant to model by standing in front of the sheet, facing sideways. You may need to adjust the height or position of the tripod to get a good composition, so that their head is framed by the window. Now turn off any lights in the room.

Figure 1: Transmitted light.

When you look at the screen on the camera, you should begin to see a silhouette (see Figure 1, opposite). Adjust the settings to give you control over the exposure (if you have never done this before, you may need to refer to the manual). This composition requires an extreme contrast between light and dark. Left in automatic mode, your camera will attempt to even it out by setting an exposure midway between the two; to prevent this, reduce the exposure by two full stops. As you do this, the screen on the back of the camera will get darker, and you should now see a perfect silhouette.

Take a few pictures. It's a good idea to "bracket" your exposures, shooting several photographs with different exposures to be sure of getting at least one good result. If you wish, you can change the composition by adding some extra or half-drawn drapes to frame the silhouette nicely. Take a few more shots, then connect the camera to a computer and print out a few of the best.

The image you have taken is as close to a true "shadow" as it's possible to create. Bearing in mind the notes about achieving a likeness (see pages 38–9), how do you feel about your shadow? You may find the likeness surprisingly good, although you are likely to find that some people's profiles seem to work better than others. Compared to a cut or painted shade, a photographic silhouette has a softer feel at the edges, which lessens the need to compensate for optical illusions. Take a look at the hair. If this is curly or wavy, or if there are any stray wisps at the nape of the neck, you will see a complexity of fine detail that is quite impossible to achieve with either scissors or paint, as light filters through the hair. Photographers call this "transmitted light," since it passes through the subject on its way to the camera. Transmitted light is the very essence of a shade.

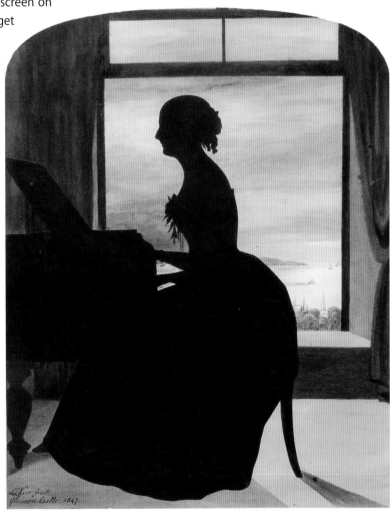

A silhouette by Louisa Kerr showing a composition based on transmitted light (collection of Diana Joll).

Figure 2: Reflected light.

Figure 3: Candlelight.

Reflected light

One of the most striking things about the transmitted light silhouette on page 91 is how two-dimensional it is. To add a third dimension you need additional light. Eighteenth-century artists worked by candlelight, but you may of course use electricity.

Position a table light or spotlight to one side of the model (or ask an assistant to hold it), shining the light at the back of the head. The aim is to illuminate detail at the back while leaving the face itself in shadow (see Figure 2, above). You may need to move the light about a bit to get this right, checking your progress in the LED screen of the camera. Try to highlight the back of the head without swamping altogether the transmitted light shining through the

hair. If the light seems too strong, move it back a bit (or try a dimmer lamp). If the light is too weak, bring it closer. Take a number of shots as you move the light around, since subtle changes in light are difficult to judge on a small screen. When you are happy, print out a few of the best.

Looking at these new photographs, it's clear the silhouette now has a third dimension. Lamplight is reflected off the hair, shoulders, and ear, and even though the face remains in shadow, the portrait will be quite recognizable. This is the effect eighteenth-century artists had in mind when they began to embellish silhouettes with gold paint. Have a look at the silhouette opposite by John Field, as the effect you have just created is similar to his style of silhouette. Photographers call this "reflected light," since it bounces off the subject on its way to the camera.

Candlelight

For the last (optional) stage of this project, substitute a candle for the lamp. For safety, put the candle in a lantern or tall glass jar. Ask an assistant to hold the candle close behind the model's head (see Figure 3, opposite). Depending on how bright a day it is, this may need to be very close. If the daylight is too strong, try drawing the drapes a bit to cut out some of the light, while still leaving enough to throw the head into shadow.

Candlelight creates a much more intimate effect than electric light. Play around with the height, angle, and distance of the candle, shooting a number of photographs as you do so.

Notice the quality of light falling on the hair, which appears a rich golden-red color. Illuminated areas seem to blend with the shadows in a kinder and more natural way. Also notice that the light is no longer shining parallel onto the back of the head; instead, it may be shining sideways onto the hair, and at the same time down onto the shoulders, creating interesting shadows as it does so. These are the shadows that would have been so familiar to artists of the eighteenth and nineteenth centuries. Try to capture all of these effects with your camera.

Appreciation

You should have shot some interesting and unusual photographs, very different from the many snapshots you have of friends and family. Print out a couple of them onto photographic paper and keep them on hand as you work through the next few projects. Be aware of the difference between

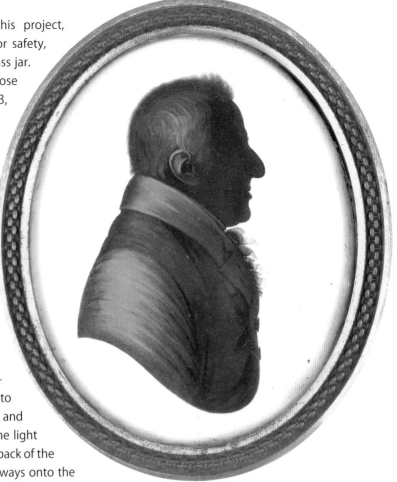

A silhouette of Arthur Young by John Field, showing reflected light in gold (collection of Diana Joll).

transmitted and reflected light and the different roles they play in silhouette. Although you cannot create a mini-studio for every silhouette, imagining the effect of the candle held close behind your subject's head will help you in the following projects.

John Field
(1771—1841)

This project begins to break the rule that a silhouette should always show a shadow. You will learn how to add traditional bronzed embellishments to a black silhouette, as if painting by candlelight. To explore how to paint reflected light, we will return once more to John Miers' studio (see pages 14–15), around the beginning of the nineteenth century, and take a look at the work of his star apprentice, John Field.

A talented apprentice

John Field started his career as assistant to John Miers and worked very much as the junior partner in the studio. Many of his works are labeled simply "John Miers, the Strand," which led some collectors to conclude that they were a radical new departure for the master himself. It is now known that John Miers retired from painting early in the nineteenth century, leaving his assistant both to make copies of past silhouettes and develop his own style. From the start, Field seems to have been fascinated by the idea of adding reflected light on the back of the head, which he did by applying areas of fine gold. The gold takes on a reflective life of its own, occasionally glinting as you walk past one of his silhouettes and giving the slightly uncomfortable feeling that these heads are actually turning.

One might question whether this created a difference of opinion between the two men: one a master of the true shade, dealing only with

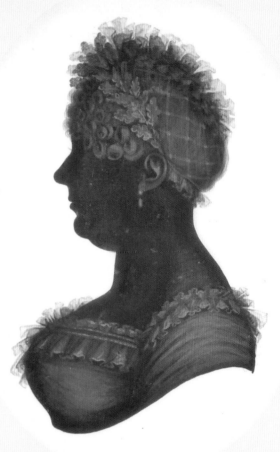

Unknown lady by John Field (collection of Diana Joll).

transmitted light, the other a master of the profile, using both kinds of light and blending them together with great skill (see pages 90–3). A look at the detail of the lady's clothing in the silhouette above shows how Field used both transmitted and reflected light. The lacy frills on her dress initially are shown in shadow against white and then give way to gold against black. However, the two men obviously

WORKING WITH LIGHT

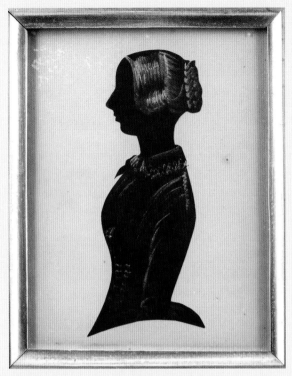

A simpler style of bronzing, probably by J.L. Maginn, an itinerant artist working in the north of England during the 1840s.

worked well together and did so right up until Miers's death. For a time, Field continued in partnership with John Miers's son, changing the name of the famous studio to Miers & Field. This partnership did not work out, though, and Field finally set up in his own name, taking care to point out that for many years he had been the sole artist at the John Miers studio.

Working methods

Like his original partner, Field is known to have used a pantograph to reduce his profiles from life-size cartoons. An early twentieth-century collector of silhouettes had one of Field's pantographs, together with a box of gold leaf, in her collection, so it seems that he continued using this tried-and-trusted technique despite the many more "modern" aids for

taking a profile. Perhaps, like Edouart, he recognized they offered little in the way of improvement (see page 73). Field's advertisements stated that he needed a three-minute sitting to create a profile. Although the technique of capturing the shadow had not changed, he needed the extra two minutes to make brief freehand notes about hairstyle and clothing inside the profile.

What is not clear is how the gold was applied, as gold paint was not available at the time. Some collectors assume it was literally burnished using gold leaf, or else applied dry with a brush, but a close look at the detail of his brushwork shows that some kind of liquid was certainly used. Did he grind his gold to a fine dust and mix it with beer, as he did with his soot?

A craze for bronzing

Whatever the method, Field's idea was rapidly and widely copied, although almost never with the same degree of patience and skill. Itinerant artists working at the lower end of the market were quick to spot an opportunity to "up sell" to a client already pleased with a freshly cut portrait. Typically, such artists might charge a shilling and sixpence to cut two copies of a profile, and then would charge a further shilling (per copy) to embellish them with gold.

One such artist was J.L. Maginn, who worked in the north of England during the late 1840s. He seems to have been an itinerant artist, with no permanent studio. The example illustrated does not sit at all well next to Field's silhouettes, yet it is more typical of the period. Such cheaper embellished silhouettes were very popular throughout the country. Maginn's work is interesting as he was one of the very few artists who preferred to truncate his silhouettes with a waistline rather than a bust line, which means that his cuttings can be thought of as "half-length" silhouettes. The kind of bronzing in this example would have been executed in a few minutes with a single fine brush.

Bronzed Silhouettes

This is one of the more advanced projects in this book and builds on the skills you have learned already. You need to have made several silhouettes, not least because you will need them as raw material for this project. These should be bust-length portraits, which can be either cut, painted, or hollow-cut. Bronzing is a difficult skill to master, but once you begin to create successful bronzed profiles, you will experience the thrill of seeing a profile almost seem to come alive and move on the paper.

YOU WILL NEED:
- Plain black silhouette, either scissor-cut (see pages 42–7) or painted (see pages 50–5)
- The photograph or sketch from which this silhouette was made
- Needle tool (a pin with a handle)
- Gold and black paint; gouache is the easiest to use
- Set of small paintbrushes
- Illuminated magnifying glass if working at a small scale

Brushing with candlelight
The technique pioneered by John Field became known as bronzing, and people are generally divided into those who love it and those who hate it.

Those who love it do so because of the very intimate sense of detail it imparts through the use of light. This style of silhouette can assume an almost jewel-like quality in the hands of an expert, seeming both tangibly real and yet remotely shadowy at the same time. Those who hate it believe it detracts from the purity of a true shade, taking away the very real feeling of looking at a living shadow.

Take a look at the examples illustrated opposite. Whichever group you fall into, these silhouettes are clearly all about reflected light, which is a big departure from the ones we have looked at previously.

Anatomically, these are often very accurate profiles, with artists daring to use a line much truer to the captured shadow. Bronzing tends to offset the optical illusion encountered in a shade, and by giving us a glimpse of a third dimension, it makes these portraits curve away from us and so seem less flat. For those who love them, this realism is part of their charm.

PAINTING A THIRD DIMENSION
First choose, or make, a silhouette to bronze. Generally, the best silhouettes to start with are the simplest, especially those without much carefully painted or cut detail in the hair. This is because transmitted and reflected light are difficult to mix together in one picture; they seem to negate each other, so it becomes hard to tell which details are based on light passing through the hair and which on light reflected from the hair. Choose a cut silhouette with minimal second cutting (see page 44) or else a fairly solid painted silhouette with minimal use of thinned paint to indicate light passing through the hair (see page 54).

Black embellishments
Place your silhouette on a flat surface together with your reference material, either a photograph or drawing of the subject. Begin by sketching out the

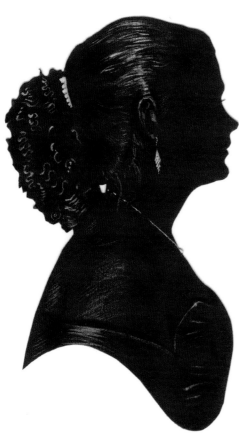

Figure 1: A silhouette cut from black laid paper then embellished with gold and touches of white.

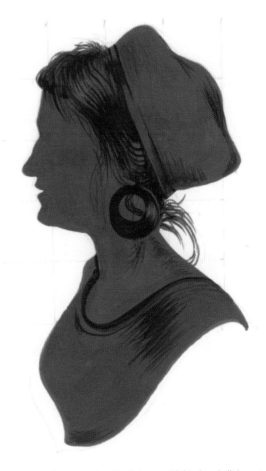

Figure 2: A silhouette painted in dark gray with black embellishment.

details of hair and clothing with black paint, using a size 1 brush. Painting black on black might seem counterintuitive, but is surprisingly effective, although the main purpose of the black is to act as a guide for the gold. Black paint on black paper (see Figure 1, above left) shows up well, while a painted silhouette embellished in a different "shade" of black creates an interesting effect (see Figure 2, above right).

If you have experience with drawing, you can paint directly with a brush; any mistakes will recede once you apply gold paint, so don't worry if it isn't right first time. Otherwise, if you are working from a scaled photograph, you can try an old technique by using a pin to transfer the image. Lay the photograph exactly on top of the silhouette and prick it with a needle tool at various points, say at the top and bottom of the ear and around the hair, so that the pricks show faintly. Use the pinpricks as a guide for the black paint.

Start by painting a line outside the ear and then paint the line between the face and hair, as well as darker lines in the hair itself. Mark the line of the collar, as well as lapels and other details in the clothing. Work quickly, taking care to paint the shadows rather than the highlights.

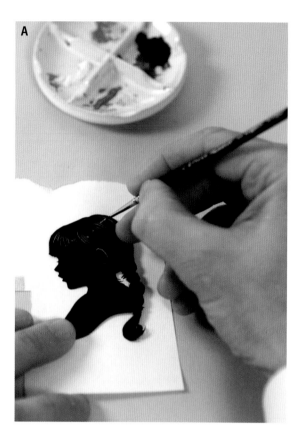

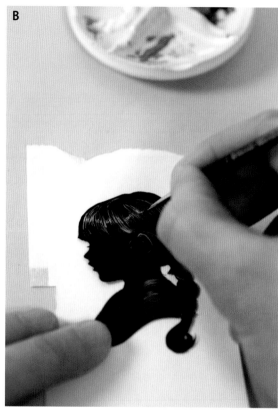

Bronzing with gold

Stop and have a look at your profile so far. There are times when black-on-black embellishment works well on its own. At this stage, a silhouette retains the purity of a true shadow when seen from afar, yet reveals itself in surprising detail when looked at closely. Consider whether you need to add more detail: Figure 2 on page 97 was originally intended to be bronzed with gold, but felt quite finished at this stage.

A) Assuming that you have decided to continue, you can start working with gold. Take a finer brush (size 0 or 00) and thin some gold paint to about half its usual consistency. Try out the thinned paint on a scrap of black paper; it should be a pale ocher color. Start by picking out the ear with a thin line of gold,

then begin painting the hair. The idea is to "stroke" the gold onto the silhouette in a series of fine parallel lines, following the direction of the hair or clothing. Work next to the black paint, this time working over areas where light strikes the profile rather than the shadows. Continue this all over the back of the head and then start picking out details on the back of the neck and clothing. Imagine the candle we used in the photography project (see page 93) and the way it illuminated the features. It would strike the hair almost horizontally at the top of the head, yet fall more vertically onto the shoulders, with small splashes of gold spilling onto the chest. Avoid painting right to the edge of the silhouette; leave a space of pure black (even if only the width of your paintbrush) between the gold and the white of the background.

B) Once the thinned gold paint is dry (and it should dry quickly), use a size 00 brush to start working over the highlights in slightly thicker paint. Don't cover all of the area you have already painted, but go over each line, reinforcing about a third or a half of it with thicker paint in the center. This creates an effect of waves in the hair by making them appear to curve away from the light. Apply more paint in places where the light is strong and less where it's weak.

You can repeat this process several times, each time painting progressively thicker and more opaque paint onto progressively smaller areas of the original gold lines. John Field started with a very dilute layer, then went over his silhouettes five or six times. Other artists of the period only used two or three layers, presumably feeling (as ever with silhouettists) that time was money.

For the final layer, use opaque paint straight from the tube. Using an 000 brush, apply a single "blob" of gold in the center of the last layer in each line. These blobs should be arranged in rows, so each line of bronzing has a blob in about the same place. This final touch suggests light glinting onto the hair from an imagined candle. If done well, it completes the illusion and creates a strong visual effect.

Appreciation

If things didn't go to plan, you may feel that you wrecked what was a perfectly good silhouette. If so, don't worry; you are not alone. Bronzing is a difficult and delicate art, and nobody gets it right first time. Hopefully, you will have gained some insight into the way the process works and ideas to make it work better next time.

In a traditional bronzed silhouette, the white of the background represents transmitted light, while the gold represents reflected light. This clear difference in color helps the viewer tell them apart, which in turn makes it easier to "read" the portrait, as does

A painted silhouette embellished in black and gold with touches of color.

the gap of pure black that you left between the gold and the edge of the silhouette. This gap represents the point where reflected light is swamped by the stronger transmitted light coming from behind the profile. If some gold paint is too close to the edge, you might be able to improve the illusion by painting this out with thick black paint, reinforcing the edge. This has the strange effect of making the background seem lighter.

Baron Scotford
(1884–1967)

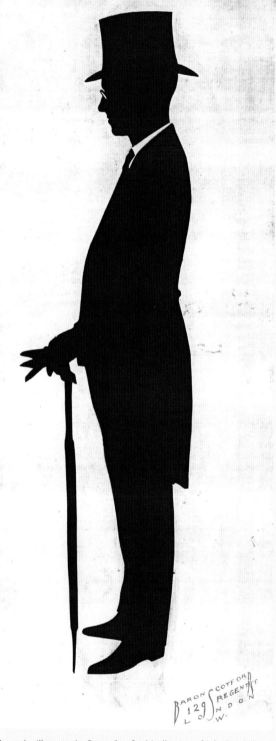

A cut silhouette should normally be considered a plain black outline, and many artists regard this rule as the very definition of a silhouette. Our next teacher had no respect for this rule at all and pioneered a style known as "slash cutting" from his studio in Regent Street, London.

Slash and paste

Baron Scotford, christened "Le Baron Henri Scotford" in honour of an ancestor, was an American artist descended from one of the first families to sail to the New World. In about 1910, he moved to Europe and enjoyed a long career cutting thousands of silhouettes, mostly in London between the wars, where he became a well-known figure. His cuttings are still relatively easy to collect because of the sheer number he produced.

Like most artists of the time, Scotford usually worked on sable surface paper, folded in half to create two copies of each silhouette facing in opposite directions. By insetting an extra folded sheet he could create four copies, and (rumor has it) by inserting a third he could create six. My own attempts to try this have ended in failure, not to mention a sore wrist. The main problem is to stop the sheets slipping. Even when taped, they move, relative to each other, so each copy ends up a different width. When cutting a plain black shade, it is just about possible; but Scotford did not cut plain black shades, he took a different path altogether.

From the start, Scotford seems to have preferred working in full length. His earliest cuttings tend to

An early silhouette by Baron Scotford (collection of Julia Randall).

WORKING WITH LIGHT

Le Baron Henri Scotford (center) outside his Regent Street studio in the 1920s (courtesy of Jo Scotford Rice).

be unembellished, apart from collar slashes, which silhouette artists have used since the early 1800s. The man shown opposite was cut in two parts, the head being pasted above the body. This was common practice, but Scotford soon abandoned it in favor of his own increasingly elaborate style of slash cutting. Although he did not invent the idea (his friend Hubert Leslie used slash cuts for arms and legs, see pages 40–1), Scotford took it to extremes, literally drawing with the scissor points. Some of his silhouettes give the impression they have almost been cut to ribbons before being carefully reassembled and pasted onto card. Once the pieces were stuck down, he would sometimes add extra details—wisps of hair or fur collars—outside the profile with a thin black pen.

On one occasion early in his career, Scotford was cutting silhouettes at an exhibition in Earls Court when a gentleman stopped to have his silhouette done.

"People say I look something like the King; do you think so?" he asked as Scotford was working. Not wishing to disillusion a paying customer, Baron replied:

"Yes, I suppose you do look a 'little' bit like him."

A member of the watching crowd later informed Scotford that he had actually just taken the profile of King Edward VII. Scotford was naturally a bit discomforted, but quickly gathered up some of the offcuts littering the floor to keep a copy as a souvenir. Perhaps it is better he did not know; the King probably received a better portrait that day precisely because it was one of Scotford's "everyday" silhouettes.

Above: Detail of Scotford's slash work, showing the way some of his silhouettes seem almost to have been cut to ribbons before being pasted to the card.

Right: A man in costume by Scotford. Note the use of slash and point work to show the detail of the costume.

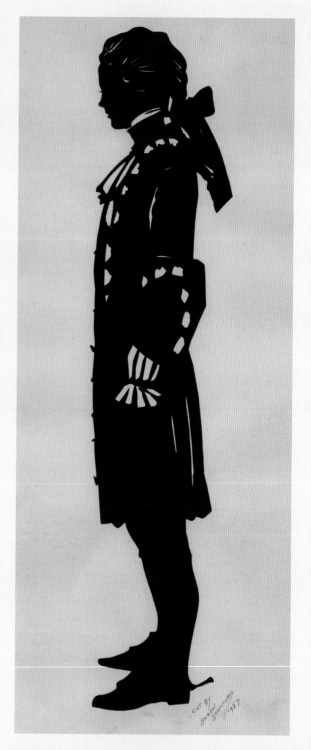

Scotford's silhouettes are almost always signed and dated in the lower right-hand corner, often with the location as well. His cuttings therefore tell the story of the many places where he worked, from Paris, Brussels, and Rome before World War I to various London locations (including Wembley, Regent Street, and Crystal Palace) during the 1920s and 1930s. His later work comes from the "Snip Sketch" studio in New Jersey, where he worked after his return to America shortly before World War II. Scotford later emigrated to South Africa.

Scissor-cut Embellishments

When people look at a cut silhouette, they tend to focus on details, whereas the artist (as should be clear by now) focuses on the overall shape and making a clean, flowing line. However, this project is all about detail, addressing many common questions such as "Can you do glasses?," "How can you cut such curly hair?," and "Can you get my tie in?"

The project assumes that you have carried out at least Scissor-cut Portraits (see pages 42–7) and have spent time practicing how to use scissors.

YOU WILL NEED:

- Some unfinished cut silhouettes, together with a copy of the photographs from which they were made, or a model or photograph ready to make some new silhouettes
- Your favorite pair of scissors
- Sharpening stone
- Small leather thimble
- Pencil
- White cardstock for mounting silhouettes
- Spray adhesive, paste, or double-sided tape
- Some old newspaper
- Rolling pin or piece of dowel

CUTTING OUT LIGHT

Scissor-cut embellishments potentially add a new dimension to cut silhouettes, but can also ruin a good shade. First, put aside the best of your plain black cuttings from Scissor-cut Portraits (see pages 42–7) as they are not suitable for this project. Choose instead profiles with relatively simple outlines. Although you can embellish a finished silhouette, it's better to work while the cutting guide is still attached, so you might prefer to start from scratch and plan a new cutting. The idea behind scissor-cut embellishments is to cut lines representing areas of reflected light.

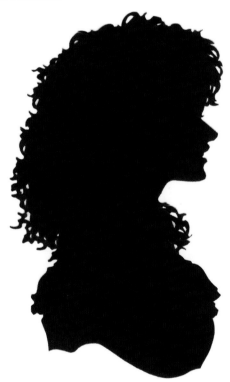

Point work used to show the effects of transmitted light in the hair. This silhouette is still a true shade, and so identical from each side. It doesn't need any further embellishment.

These could be areas that are actually white, such as white shirt collars or handkerchiefs, or else places where the light glints off the subject. Light can glint off anything shiny, for example, earrings, the arm of

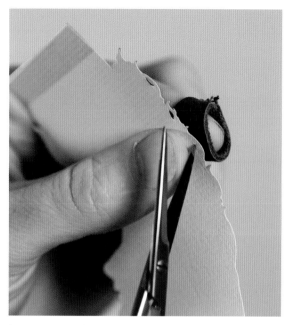

Figure 1: Piercing the paper with a sharpened scissor point.

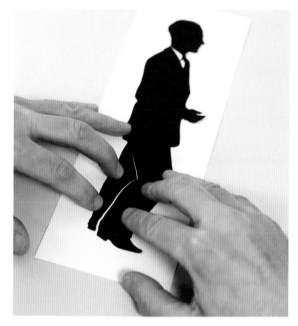

Figure 2: Pasting a Leslie-style slash cut.

a pair of eyeglasses, or even the natural shine of hair. The difficulty of drawing with scissors is that there is no room for error, so this style of cutting needs to be carefully executed. With practice, it can be done speedily, but it should always be done with care. To begin with, you need to draw before cutting.

There are many artists using these techniques today, some of whom appear to cut successfully into their work without any planning whatsoever. However, they do this by building up their own repertoire of patterns; for example, there are any number of ways to "do eyeglasses."

There are two methods of embellishment: point work, where the points are used to pierce the paper, and slash work, where the blades are used to cut into the paper. It's important to study both techniques as they are also useful in second cutting (see page 44) a plain shade. They are just as effective in showing transmitted light (for example, through a mass of curly hair) as they are at showing reflected light.

Point work

To pierce the paper neatly, the lower blade of your scissors needs to have a very sharp point, so you will need to modify it slightly with a sharpening stone. File the tip to a point, making sure not to file the inside edge, where it bears against the upper blade, as this can prevent it cutting at all. Buy or make a small leather thimble for your forefinger.

Gripping a half-finished silhouette between your thumb and forefinger, place the thimble underneath the spot where you wish to pierce the paper. Push the lower blade through the paper, not by stabbing with the scissors, but by placing the sharp point at an angle next to the paper and pushing the paper onto it with the thimble (see Figure 1, above left). Next, move your forefinger next to, rather than under, the hole and snip out the shape you want using the points of the scissors. For small holes, you need to do everything with the points, which realistically means you can cut only a series of short, straight lines. Plan

complex point work as a series of small triangles and rectangles, all at different angles. To see how this works, look carefully at the girl with curly hair on page 103. For larger holes, start with the points and later insert the whole blade, continuing to cut with the jaws as in hollow cutting.

Slash work

The simplest and most elegant style of slash is that used by Hubert Leslie (see pages 40–1). Cut a single line almost through the silhouette and open it up slightly while pasting it down to create a thin, tapering line of light (see Figure 2, opposite right). Use these to indicate arms and legs, as well as the side of eyeglasses. This method relies on the natural "give" of paper, which can deform without buckling as you paste it, as long as there isn't much paper left beyond the cut.

A more usual technique is to cut into the paper, turn it 180 degrees, then carefully peel away a fine sliver (see Figure 3, below). This is similar to lifting strands of hair, except that the sliver is removed altogether.

A single "glint" of this sort is often used to indicate the side of eyeglasses, as shown in Figure 4 (see below right). To create more complex slashes (for instance, to show glints in the hair), cut an access line and make a series of parallel cuts following the flow of the hair (see Figure 5 on page 106). Turn the paper 180 degrees and peel away a section off each. Try to keep the glints a similar length, and ensure that they begin and end at a similar (very acute) angle. Access cuts should also follow natural lines in the hair or clothing. They should vanish when the silhouette is pasted down, yet may still be visible on close inspection. It will look odd if they go straight across the silhouette.

Collar slashes are very traditional and seem to give a silhouette a slightly 1920s look. Make a long entry cut along the line of the jacket and turn the paper 180 degrees. The return cut can indicate other details—typically a tie and shadows under the collar. Figure 4 shows a simple kind of collar slash; once mastered, you will soon be able to create your own.

Perhaps, like Scotford, you will end up almost drawing with your scissors, but be careful not to overdo slash cutting: a single, well-considered slash is often all you need in a silhouette.

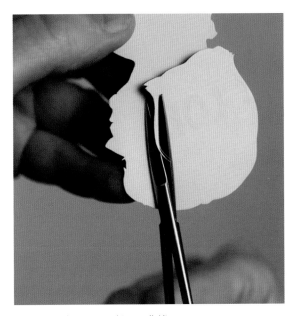

Figure. 3: Peeling away a thin parallel line.

Figure 4: Diagram of two commonly used slash cuts.

Slash work used to indicate the reflected light on the white shirt, handkerchief, and glasses. This silhouette is a profile and would be different from the other side.

Pasting your silhouette onto cardstock

A heavily slash-cut silhouette will need to be stuck onto cardstock, as it's too delicate to be left unmounted (see Figure 5, right). A plain, white, acid-free stock is usual, or you can refer to Silhouettes on Paper (see pages 140–3) for more elaborate ideas.

To attach the silhouette onto card, you can use the type of spray-on adhesive used for mounting photographs (see also box opposite on Alternative Adhesives). Spray-on

adhesives are available as either permanent or "re-positionable" and are easy to use. The spray does get everywhere, so use plenty of newspaper to protect the table as you work. If you have a large number of silhouettes to mount, it's a good idea to construct a spray "booth" with three sides of wood surrounding the working area, which will stop 90 percent of the excess spray that might otherwise drift around the room. Do read the safety instructions that come with the aerosol, and always work in a well-ventilated area.

Lay your cutting facedown on some old newspaper and spray adhesive to the back, then place it onto your card in the correct position, making sure that it's straight. Full-length silhouettes need to stand with the neck directly over the foot taking the weight, while bust-length silhouettes need to be placed so the invisible "eyes" are looking forward.

Check the position carefully and make any small adjustments while you still can (see Figure 6, opposite).

Make sure that the silhouette stays flat by rolling it. A quick and simple way to do this is to place the heel of your hand over the silhouette and apply a firm, rocking action. A more professional way is to put a

Figure 5: A silhouette with complex slash cutting before and after pasting.

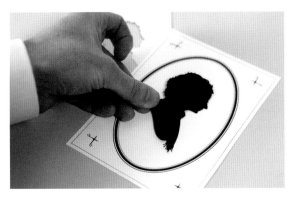

Figure 6: Positioning a silhouette with glue applied.

put a sheet of clean paper on top and use a rolling pin or short piece of thick dowel (see Figure 7, below). Use a clean sheet of newspaper to spray each silhouette, otherwise you will get glue on the front, which the rolling sheet will in turn stick to.

Appreciation

When you look at the result, does the embellishment "read" as reflected light? As with bronzing, this technique is at its best when you can visualize seeing it in a certain trick of the light. For example, could your friend have appeared this way, in front of an open doorway at night with the moonlight in their hair? Before pasting, try holding the silhouette so it casts a shadow. How do the cut lines seem now?

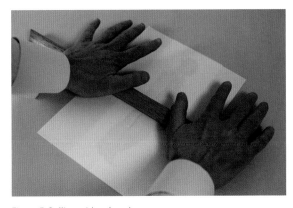

Figure 7: Rolling with a dowel.

ALTERNATIVE ADHESIVES

If spray-on adhesive is impractical for any reason, there are a number of alternatives.

Brush-on pastes

There are a number of brush-on pastes suitable for paper, although some may need to be diluted when working with thin paper. The routine is the same, except that the glue is applied with a large brush and your rolling sheet will need to be absorbent to take up any excess paste squeezing out from under the silhouette. When using a new brand of glue, experiment with some scraps of paper before working on a finished cutting. When framing a recently pasted silhouette, use a card window mount to create a slight gap between it and the glass or over time the silhouette may glue itself to the glass.

Double-sided tape

If you are short on time, or don't have materials on hand (for example, if you cut a silhouette at somebody's house and wish to leave it as a memento), it's fine to use a small square of double-sided tape. For a plain shade, a small piece in the middle of the head will work fine, but if you used intensive slash cutting, you may need several strategically placed pieces. The silhouette won't lie flat, although some artists prefer this as it clearly shows the way the silhouette was made. When framing, there is no need for a window mount; allow the glass to hold the paper flat. Make sure that the tape you buy is labeled "acid-free," otherwise in a few years you will see a small square of darkened paper appear (yes, even black paper can get darker).

Artists Who Work in Color

Soldier in red by John Buncombe (collection of Diana Joll).

We are now going to break the unspoken rule that a silhouette should be painted all in black. This use of color came as a big surprise to me when I first encountered it. There is no longer any pretence that these are shadows, as there is no way to conceive a trick of the light that throws the face into such pronounced shade while the clothing remains so clearly illuminated. The color lavished on, for example, uniforms and head gear makes this idea meaningless, so the face appears "missing."

For collectors, color silhouettes are prized possessions. The time and trouble involved in making them means they were not produced in vast quantities and so are relatively scarce today. They form the basis of an experimental project in which we will reinvent the idea of silhouette.

John Buncombe

Of the few artists who worked this way, the best known is John Buncombe. He worked on the Isle of Wight, just off the southern coast of England, for about 35 years until 1830. At that time there was a large army base stationed there, within easy access to the ports of Southampton and Portsmouth. Almost all his clients were army officers, who naturally wished to be depicted in their uniforms. It is possible that this is what led to such a strange hybrid between shade and portrait; the technique simply evolved out of a response to market forces. At the time, the cheapness of silhouettes was well established. Artists who offered both shades and miniatures would sell their shades for a shilling or two, while portraits cost a guinea: as much as twenty times the price. Officers on a modest army salary might have balked at the idea of paying guineas for a portrait, yet been happy to pay shillings for a shade. By painting the face in black, Buncombe was able to call his works shades, and thus charge a more realistic price without incurring the censure of fellow artists.

Buncombe's problem was that he spent a lot of time on these works, nearly as much as a miniaturist would, so by all accounts worked for little reward. Little is known about his life other than that his studio was in Newport. As demand for his portraits grew, he

does seem to have tried to speed up the process, his later works becoming less fastidious. The attraction for soldiers was the detail of the uniform: they dressed in their best for a sitting, and wanted every braid and emblem to be included. As Buncombe was familiar with the regiments based on the island, a brief sitting to capture the profile and make notes about the uniform was probably all he required.

Mr. W. Phelps

Even less is known about W. Phelps, an earlier artist who worked in Drury Lane, London, in the 1780s. His first name is not recorded, although it was possibly William. His work is unique (one could speculate whether Buncombe saw, and was influenced by, it); he was one of the few artists to work on plaster slabs before John Miers (see pages 14–15). Some silhouettes were painted directly onto plaster; others were first painted onto buff-laid paper before being cut out with scissors and glued firmly to the plaster. His advertisements state that the plaster slabs would stay white, unlike paper which yellows over time. True to his word, they have done so to this very day, giving his designs a strangely fresh and contemporary feel. Like most silhouettists, Phelps needed only a short sitting. One collector commented that the same caps seem to be worn by many of his women, leading her to suspect these were painted from a stock of hats in his studio. Sadly, it seems Phelps gave up painting shortly after Miers's studio was set up.

Both these artists clearly worked from a rule that the face should be in shadow, while the body could have color. For them, this defined a silhouette. Their work is so individual that it is impossible to try to reproduce it today, but we can see what happens if we take this rule and apply it to modern subject matter.

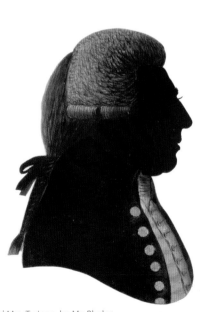

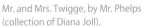
Mr. and Mrs. Twigge, by Mr. Phelps
(collection of Diana Joll).

Silhouettes in Color

Before embarking on this project, you should have attempted at least Painted Silhouettes (pages 50–5) and Bronzed Silhouettes (pages 96–9). This is a fun project, giving you a chance to play with paint, then leaving you with a set of intriguing artistic questions.

YOU WILL NEED:

- Either a photograph or a reduced captured shadow with notes about clothing and hairstyle
- Cardstock or paper for painting on
- Hard pencil and an eraser
- Good-quality watercolors and gouache black
- Some fine paintbrushes

CREATING FACES IN SHADOW

You are going to create a color silhouette using watercolor paint. Watercolor purists will tell you never to use black, and they regard white with some suspicion too. This is normally good advice, but in the

world of silhouette it isn't relevant. It is true that you should keep your black paint well away from your set of watercolors, as black contaminates any paint it touches, robbing it of all purity. For this reason, you should reverse the normal way of painting black shades and leave the profile until last. If you start with the face, black will contaminate all your colors.

A) When you are dealing with color, it's important to plan your work. Transfer a faint outline to paper, then think carefully about which areas you will paint in color and which in black. You can be quite abstract in the design, but make sure to mark divisions clearly

A

B

C

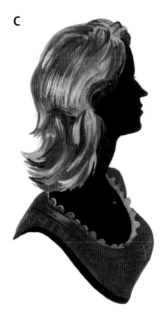

inside the outline. Choose a color to start and paint with pure pigment into the colored areas. You can overlap the dividing lines, into the black areas, as these will be painted over later.

B) Once these areas are dry, embellish the color with darker tones and then add highlights in white. This should be stroked on in much the same way as working with gold (see pages 98–9). When you are happy with the colored areas, put your watercolors away and paint the profile.

C) Use gouache for black rather than watercolor. You only have one chance to paint the profile; unlike painting a shade, there is no way to "move right" and have another go if things go badly, as the painting will be too far advanced. Be confident in your approach and paint it right first time. Fill in the space behind and carefully paint the line dividing the face from the colored areas, painting over any color that has overlapped so that there are no gaps.

Girl with purple hair; watercolor and gouache on card.

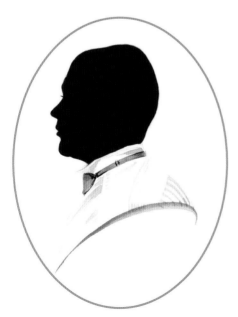

Man with green bow-tie; watercolor and gouache on card.

Appreciation

These are odd images, probably the strangest of silhouettes, yet interesting precisely because of that. Did painting the face in black at the end seem a strange thing to do? How did you deal with the "division" between the areas in black and the areas in color? Such a division has no basis in nature, so it did not help to look at your model or photograph. Did you find yourself inventing "rules" to help decide which is which? If you wish, there is still an opportunity to touch in your silhouette. When the black paint is thoroughly dry, you could even embellish it a little, for instance by adding a necklace with a row of dots in gold. With such a strange marriage of media, there is nothing to fear from adding another.

Elizabeth Baverstock
(1923–2002)

A cutting guide for Churchill
(collection of Roger Baverstock).

The following project challenges the rule that a silhouette needs to be a carefully observed portrait, and instead allows your imagination to take over. The inspiration for this is Elizabeth Baverstock, whose work I became aware of early in my own career. A pair of her silhouettes were the first by another artist I ever bought, and so she started my collection.

A collection of notables

Elizabeth Baverstock was born in Belgium and spent her childhood in Dresden, Germany. Soon after World War II, she met her husband, Major Baverstock, in Italy, and together they settled in England in 1948. After seeing some antique silhouettes that she was unable to afford, she was inspired to try making her own. She began by depicting famous people, such as Lord Nelson and the Brontë sisters, who she copied from older silhouettes or adapted from paintings. She also made silhouettes from photographs in newspapers and magazines, choosing profile photographs to use as a cutting guide. She would make two copies of each silhouette, sending both to the subject explaining that one was a gift, and requesting that they kindly return the other with a signature. In this way she collected signed silhouettes of all the British prime ministers from Harold Macmillan to Margaret Thatcher, as well as US President Ford, Indian Prime Minister Indira Ghandi, and many other heads of state and notable figures of the day.

When Prince Charles and Lady Diana Spencer married in 1981, she sent them a pair of silhouettes, mounted face to face, as a wedding present. Some years later, after they divorced, she created another set, this time showing them back to back. This copy still remains with Baverstock's family.

Her historical silhouettes were popular, appearing in retail outlets as well as mail-order catalogs, and were available as cards, framed pictures, and even paperweights. At one point, the demand for her work was so great that she was making some 5,000 silhouettes a year. A typical order was from the Churchill Society, which requested a hundred "Churchills." Interestingly, one of the cutting guides for this order still exists. Baverstock cut it out from a newspaper photograph (see above) and the remains of her drawing to plan the bust line are still visible.

Baverstock's favorite outlet for selling her silhouettes was at craft fairs. Her most popular silhouettes were those with Victorian lace appliqué. She enjoyed hearing the public's comments at the fairs and was also able to demonstrate her technique, beginning with a silhouette cut from a pattern with embroidery scissors and embellished with black and gold paint. She kept her cut heads fairly simple so that they were easier to decorate, for example with

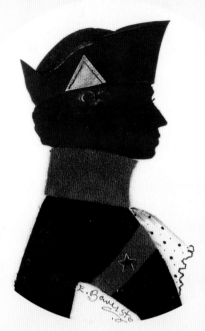

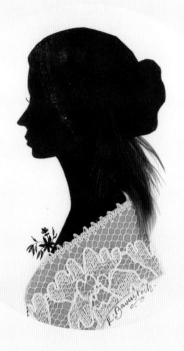

A pair of silhouettes by Elizabeth Baverstock, originally under a paperweight.

small sections of antique lace, colored paper and material, and occasionally even small feathers and gold stars.

In the final years of her life, suffering ill health in a nursing home, she still loved to create silhouettes for those around her. She would cut any piece of paper that she could lay her hands on, even discarded candy wrappers!

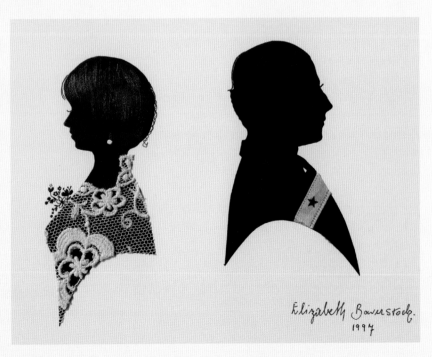

Charles and Diana, by Elizabeth Baverstock (collection of Roger Baverstock).

Silhouette Collage

This is an easy, fun project, but you will need to have completed some earlier projects so that you have silhouettes to work with. Hollow-cut silhouettes (see pages 74–7) work well for collage, which calls for a silhouette that can be divided into different sections. However, you can choose any kind of cut or painted silhouette you like.

YOU WILL NEED:

- Some silhouettes
- Sharp pencil and thin black pen
- Watercolors, gold paint, and fine paintbrushes
- Scissors
- Decorative paper in various colors (including black)
- Decorative trimmings (see step B)
- Glue (see pages 106–7)

DECORATING A SILHOUETTE

Be as radical and experimental as you can in the way you approach this project. These silhouettes are loved for their decorative qualities, so feel free to mix any of the skills and techniques learned in this book.

A) Start by planning the layout. Divide a reduced captured shadow into the profile (denoted here by the red line) and areas for decoration (the blue areas), then make a cutting guide. Carefully cut out these areas from white and colored paper as needed.

B) Assemble a range of small scraps, such as lace, ribbon, cloth, pressed flowers, metal foil, trimmings, and feathers.

C) Embellish your cuttings as needed with gold or colored paint, using the skills you learned in Bronzed Silhouettes (pages 96–9) and Silhouettes in Color (see pages 110–111).

D) Begin arranging small scraps on top of your painted cuttings. Start with a piece of lace or a torn section of handmade paper, then drape this around the profile and see if the effect appeals to you. If so, cut it down to fit the composition. Don't stick anything down yet. Instead, keep playing with these various elements

A

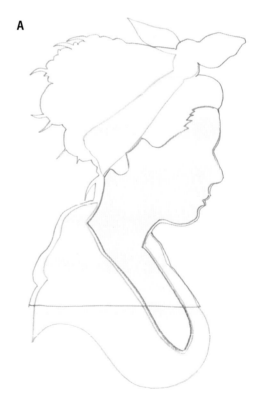

WORKING WITH LIGHT

until something new and interesting begins to emerge. Collage is a contemplative process and you may find yourself pushing pieces of paper around for some time. If you get stuck, try putting the silhouette to one side and start again with a new one: you may find a second attempt works out faster.

E) Make a final check that you are happy with the design, then stick everything down. Add some final touches, perhaps using a black pen in the manner of Elizabeth Baverstock, or include further small items of collage.

As an example, the girl with the blue headscarf shown below was hollow-cut from white paper, while the headscarf and upper body were cut from blue and ocher origami paper. The blue scarf was embellished with ultramarine watercolor and the upper body in a red ocher. The hair was first painted in burnt sienna, then embellished with a dark umber. Once the paint was dry, the scarf, upper body, and lace paper were stuck down with spray-on adhesive and the hollow cut backed with black paper. As a final touch, a necklace was painted in white and the earring cut from aluminum foil.

Appreciation

You have begun to take your silhouettes in a new direction, which you may or may not prefer. At its best, this style is still a portrait: the carefully cut profile anchors the composition firmly in reality, even though the collage elements add an abstract layer to the work. As a portrait, it should still portray character as well as physical likeness.

C and D

E

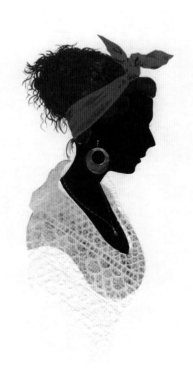

Captain Oakley
(1882–1960)

Worthington Silhouettes

No.1. The Landlord

This design by Oakley shows a silhouette can work without being in profile.

That a silhouette should be seen in profile is usually viewed as a fundamental rule of silhouette art; however, it is possible to take a different approach. The modern use of silhouettes in graphic design has evolved to the point where a silhouette is the reduction of any object, including the human figure from any angle, to a single outline in black. This begins to take us away from the portraits that form the subject of this book, yet there was one portrait silhouettist who understood this aspect of the art very well.

Silhouettes in graphic design

As you work through the projects in this book, you might have begun to notice something odd: you are starting to see silhouettes everywhere you look. You may wonder if a new trend is sweeping through the design of everything from advertisements to road signs. The truth is that silhouettes have always been there. Ever since Victorian times, since the demise of the portrait silhouette itself, they have lived on. You can see them in posters, on the side of buses, vending machines, instruction manuals, book jackets, websites, and cereal boxes. For the most part, these are not portraits of real people, but the silhouette's unique ability to evoke a sense of person in a simple outline makes us believe that we know the people in these pictures. This is one reason why designers like them so much. Silhouettes draw us in by creating a sense of the familiar while at the same time receding into the background, quite literally into the shadows,

leaving us to absorb the main message of the image (which all too often is an advertisement).

The main reason you are noticing silhouettes now is simply that you have become more attuned to them through the act of making them.

An old soldier

The English silhouettist H.L. Oakley (Lawrence to his friends) trained in art and was one of the new generation of silhouette artists who revived the art of silhouette early in the twentieth century. He began cutting silhouettes before World War I, but was far from certain he wished to make a living out of the art, being influenced somewhat by the common perception that it was not a "proper" activity for an artist. However, during the war he was asked to make recruiting posters for the British army, which included one famous design reproduced here. As these had such a stark message to

convey, Oakley felt that the silhouette was the ideal medium to use. He was fond of telling the story of how this design was almost not commissioned. One of the committee members felt the soldier's chin did not properly show the "bulldog breed." Oakley later sat near him on the train home, so took a sketch of the man's own jawline and included that in the final design.

He continued making portraits of his fellow soldiers during the war, as well as creating a series of silhouette designs about life in the trenches. These were featured as a regular column in *Bystander* magazine.

After the war, he found that his reputation as a silhouette artist had been cemented and he was able to work full time in this area. He created a great many designs for a wide range of clients, all using silhouette as the main medium. He was also in great demand for his portraits and spent many years traveling Britain, making appearances at various department stores

"Think!" a Great War recruitment poster by Oakley (collection of the Imperial War Museum, London).

and other venues. During the summer he would take a booth on Llandudno pier in North Wales, which was his favorite venue of all, and became a kind of second home for him. He was still working there just a couple of years before he died.

Lawrence Oakley on the wall of the London Sketch Club, complete with his scissors!

Design and Motion in Silhouette

All the projects in this book are based on artists who worked before the invention of the digital camera, but what kind of silhouette can we create when a camera and inkjet printer are an indispensable part of the process? This technology has enormous potential for creating interesting paper cuttings.

YOU WILL NEED:

- A party of children or adults, with fancy-dress costumes and interesting props
- Digital camera and an inkjet printer
- Tape, pencil, and scissors
- A wide selection of colored and patterned paper (as well as some black if you like)

HAVING FUN WITH CAMERAS

For this project, you will need to collect some more images. You could throw a silhouette party, whether for children or adults doesn't matter. Tell your guests to dress up in fancy-dress costume. Just as you did in To Reduce the Scale (see pages 24–5), go around the room taking photographs of everybody, but this time the rules are different. Either ask your guests to strike an "action" pose or even photograph them while they are moving (any kind of movement is fine). Whether in profile or not in profile, if your camera can catch it, you can silhouette it.

You can shoot the whole body, just the face or any portion in between. Encourage your guests to be as imaginative as possible both in their poses and in their use of props. You will need to take lots of photographs, possibly hundreds, making good use of the almost unlimited storage space on your digital camera. Don't worry too much about composition, just keep pressing the shutter as people move about and play.

Figure 1: This simple cutting on patterned paper works well, even though it's not in profile.

Composing the cutting

Upload the photographs onto a computer and sort them into good, bad, and indifferent, then print out the best onto ordinary paper in a variety of sizes. Choose one to use as a cutting guide. For a simple

Figure 2: Cutting all colors using the same cutting guide.

Figure 3: The complete image mounted on black makes an effective reversal of a usual silhouette.

composition, such as the pink man in Figure 1, opposite, cut directly through a photograph taped to a sheet of colored paper. For more complex designs, plan the composition by making a line drawing using a lightbox or window. You may find that it's not clear where the "edge" should be: is the photograph blurred in places? If so, try to approximate the right line, imagining what the design will look like as a cutting. Don't attempt to hide the fact that this is a photograph, as an action silhouette cannot possibly be made any other way, not even by the fastest of freehand cutters. If the photograph shows only part of the body, think about how to define the edge of the silhouette. Will an "S"-shaped line work, or would a straight line look more modern?

Once you are happy with the composition, start to cut the silhouette. The girl with the violin (see Figure 2, above left) was made by taping two sheets of colored origami paper firmly under the cutting guide. After cutting the outline of the whole figure,

the green background sheet was removed and further areas of the figure were cut away. Lastly, the violin was cut, using the photograph itself as a cutting guide, and inserted under her arm (see Figure 3, above right).

In general, cutting should be done slowly and carefully, as you will be encountering odd shapes and angles not usually seen in silhouette. If there are any holes to be taken out—for example, inside a bent elbow—you should cut these out first, using a hollow-cutting technique to pierce the paper (see pages 74–7). Cut the outline in clean, confident curves.

Appreciation

The results of this project may surprise you as the images seem more familiar and accessible than the dated silhouettes of the eighteenth and nineteenth centuries. Scanned and printed, they make original and striking images to use for a poster, for example, to advertise a school play or local event.

Artists Who Include the Face

The final rule we will break is the one which states that facial features should not be shown. This advanced project looks at the boundary between silhouettes and portrait miniatures. I first conceived my own portraits in gray as a cross between a freehand scissor cutting and the ten-minute pencil drawings I used to make in Covent Garden, London. I searched in vain for an eighteenth-century equivalent, and although I found none, I did find some interesting and very individual artists.

Arthur Lea (1768–1828)

Several artists loosely thought of as profilists did include facial features, although none started with a paper cutting. Most painted either on card or glass; some created miniatures in profile while others made portraits described as *en grisaille*. This term (meaning literally "in gray") has a longer history than silhouette and refers to a picture, usually a painting, created entirely in shades of pale gray. Some were intended as underpainting, over which color was later to be applied, while others were finished works in their own right. They look like drawings on plaster or marble busts, or the figures on traditional blue and white Wedgwood pottery.

An interesting and very different artist, working in a manner entirely his own, was Arthur Lea. Little is known about his life, other than that he lived near Portsmouth, England, and, over many years, created a series of rather ghostly portraits on glass.

An obituary in the *Hampshire Telegraph* says of him:

"His superior natural intelligence, his various knowledge, his conversational talents, his unaffected piety and the active benevolence of his character were such that it was impossible to know him and not respect him."

Perhaps that is all one needs to know.

A portrait on glass by Arthur Lea (collection of Diana Joll).

WORKING WITH LIGHT

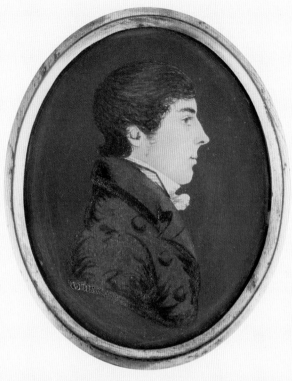

A watercolor *en grisaille* by Jacob Spornberg; note the painted shadows outside the outline that create a convincing 3-D effect (collection of Alan Everitt).

A watercolor by Gillespie, painted in imitation of copperplate busts (collection of Diana Joll).

Microscopic technique

Lea created his profiles with a stippling effect onto concave glass. The exact technique is difficult to decipher, but it seems to be a kind of grayscale pointillism on an almost microscopic scale. His faces are composed of many thousands of dots, although you would need to look through a magnifying glass to see them, as they are far finer than the dots of newspaper print. It is possible to see right through the image to a plain white plaster background, onto which a shadow falls creating a ghostly projection of the face. Lea painted in black watercolor on glass, which means that his portraits are easily smudged if removed from their frames. This may be one reason why they are so rare today.

Mr. Gillespie

A similar lack of information surrounds the life of Mr. Gillespie, the only definite piece of information being that he left Liverpool for Nova Scotia in 1820. Copies of his publicity and advertisements in the local press tell us he worked in various cities in England for about ten years before emigrating, and then he worked in Nova Scotia, Baltimore, Philadelphia, and New York. He used a "physiognograph" (sic) to take profiles, and painted silhouettes in dark gray with black embellishments, as well as an interesting series of profile portraits, which he described as "in imitation of copperplate busts." The bodies are very similar to his silhouettes, while the faces are painted in muted color against a gray watercolor background.

Portraits in Gray

At first sight, this project seems more daunting than it really is. Anybody who has ever tried to draw a freehand portrait will know the frustration of trying to capture a likeness, and working at a miniature scale doesn't make this any easier. However, starting with an accurate scissor-cut silhouette (see pages 42–7) gives you a huge head start, as the cutting acts as a guide for the drawing. Learning how to bronze a silhouette in black (see pages 96–7) will give you a feel for the way to use the pencil.

YOU WILL NEED:
- Captured shadow, photograph, or live model
- Good-quality white paper (100 gsm is ideal)
- Your favorite scissors
- Sharp, hard pencil (2H or 3H) or a mechanical pencil with a fine lead (0.3 or 0.5 mm)
- Fine emery paper and a pencil sharpener
- A needle tool (a pin with a handle) or a lightbox

Optional:
- An illuminated magnifying glass

DRAWING *EN GRISAILLE*

You will start with a silhouette cut from a sheet of smooth or laid, white, acid-free paper, no heavier than 100 gsm. This style of silhouette works best at a small scale: ⅛ is ideal.

A) Begin as usual by transferring the outline. This will be an accurate portrait, so don't alter the line as much as you would for a black silhouette. If you are working from a photograph, print it at the correct size and tape white paper securely behind the photograph for cutting. The facial profile in particular shouldn't be exaggerated; our eyes do not "spread" white paper in the same way as black, and the drawing will compensate for the two-dimensional nature of

A graphite portrait on cut paper by the author (collection of Michael Herbert).

the cutting. However, you will still need to design a bust line for the upper body, which will keep the composition neat and compact.

B) Cut the line in a series of confident waves. White profiles can be hard to judge by looking, so check the likeness by holding the silhouette near a light to throw a shadow onto a sheet of white paper. If you can't see a likeness, throw it away and try again: you will be spending time embellishing this silhouette, so you need to start with a good cutting.

C) If working from a photograph, mark the positions of the main features by pricking through with a needle tool (as shown), or put the photograph behind the silhouette (either against a window or on a lightbox) and lightly sketch in the features with a hard pencil. If working from a live model, you will need to do this freehand.

D) Begin drawing by marking the position of the ear and the edge of the hair. Continue down the face, lightly marking the line of the eyebrow, the triangle of the eye, the flare of the nostrils, and the corner of the mouth.

E) This stage is the most absorbing. Work all over the silhouette with the same fine pencil, drawing a series of parallel lines as if bronzing the silhouette in black, working over darker areas rather than lighter ones. Use a piece of fine emery paper to periodically sharpen the point of the pencil as you work. One of the joys of working in pencil is the ability to vary tonality by simply changing the pressure on the pencil, rather than reloading a brush with thicker or thinner paint. You can draw simultaneously in a range of "layers," from light to dark, allowing you to complete each area before moving on to the next. Use the magnifying glass to help you see smaller details.

C
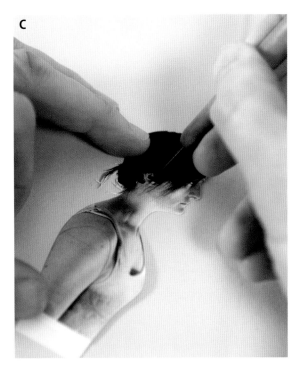

D
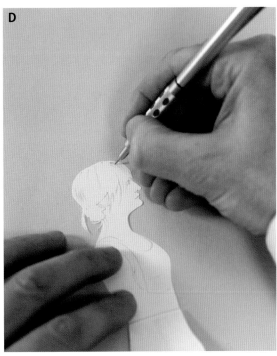

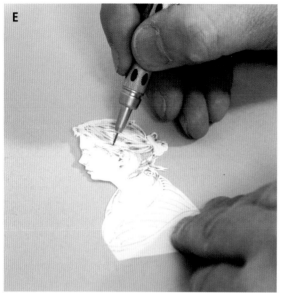

E

Ignore the overall tonality of the photograph and just draw the shadows, as if your subject were sculpted in plaster. It's a mistake to draw more heavily just because your subject has dark hair or skin, for example. When working close to the edge, allow the scissor-cut line to be your guide and draw in a manner that complements this line. Try not to draw right up to the edge, but leave a fraction of a millimeter of white paper (about the thickness of the paper) between the outermost pencil marks and the cut line.

You should draw the face after the hair, especially if this is the first time you have used a pencil this way. The face is close to the paper's edge, so be guided by the profile. If you think that you have cut a fraction too wide, or too tight, ignore this and draw the face *as if* the cut edge were exactly right. If you have portrait-drawing experience, this will seem odd, but please persist as it can work well. The effect is to enhance the reality of the silhouette by ensuring that drawing and cutting are in harmony. As long as a likeness resides in the cutting, you may take surprising liberties in the drawing without losing the likeness.

Work over the face lightly with a combination of shading on the skin and fine lines to define

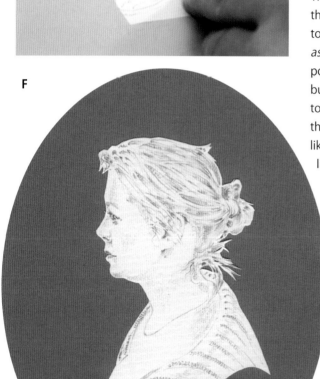

F

FREEHAND CUTTING NOTES

If you have some experience cutting freehand, this project is a good way to check the accuracy of your silhouettes. When you draw the hair, any errors in the outline will immediately become apparent, while drawing the face is almost impossible without a highly accurate cutting. A freehand sketch of the features will highlight unconscious habitual alterations you may be making in your black silhouettes.

the features. When you are working on the eyes, you might like to follow the example of eighteenth-century miniaturists and enlarge them slightly. Eyes are the focal point of the face, so this helps draw attention to them at small scales, as well as making them easier to draw. Draw clothing details on the upper body. This can be done in a loose, sketchy manner, giving your drawing a modern feel, or else carefully drawn in more detailed fashion. Finally, take a look at the whole drawing; if there are areas that strike you as unfinished, go over them again. Don't overwork the image; after a while, you should feel it come to a natural halt.

F) Choose a color of dark paper over which to mount your silhouette. They work well over blue, but can also be mounted onto black or gray. Alternatively, you can choose any color to match the room in which they will be displayed.

Appreciation

The first time you remove a drawing from under a magnifying glass you will get a shock. These miniature profiles do seem to have a life of their own and are quite unmistakeable. Although you have had to do a lot of work to produce something so small, you are almost certain to have improved the likeness of the original cutting. Being cut-outs, these portraits in gray have the versatility of a paper silhouette, so can either be pasted onto dark cardstock or left unmounted. If unmounted, place it in a glassine slip to protect the graphite surface.

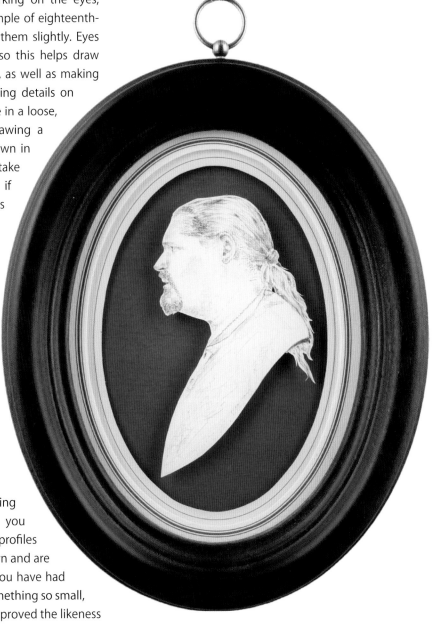

A graphite portrait mounted on glass.

Jacob Spornberg
(1768–c.1840s)

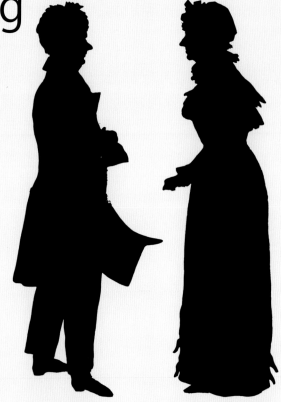

T he next project is inspired by the artist Jacob Spornberg, the eighteenth-century inventor of the Etruscan profile. Although some might regard these as miniature portraits, they are generally still considered silhouettes since the emphasis is on a strong outline painted in a series of waves.

A marriage of love

Jacob Spornberg was born in Finland and went on to study painting in Stockholm, Sweden. In 1785, his drawing master made a trip to England, then asked his wife to join him with Spornberg acting as chaperone. Once there, Spornberg decided that England was where he should pursue his career as an artist. An accomplished portrait and landscape painter, he was skilled in oil, watercolor, and etching techniques, but it was with silhouettes that he made his mark.

Spornberg found that there were already plenty of silhouettists offering painted and cut profiles in a wide variety of styles and a range of prices. Rather than compete directly, he sought to reinvent the genre. Taking his inspiration from the striking red and black paintings found on Etruscan pottery, he decided to paint outside the profile, rather than the profile itself. He then embellished the whole head, including the facial features, in thin black paint. Spornberg painted a number of these portraits *en grisaille* on paper (see page 121), but his most famous works were painted on small, convex glass ovals, backed with a striking vermilion enamel.

Jacob and Rebecca Spornberg. A pair of paper silhouettes cut by Lucius Gahagan in 1828. Lucius was not a silhouettist but a sculptor based in Bath and a friend of the Spornbergs. He seems to have made these silhouettes for fun.

Soon after inventing this process, which he advertised as "profiles painted in the Etruscan manner," Spornberg met his wife and lifelong partner, Rebecca. This union caused a certain amount of eyebrow-raising as Rebecca was a widow more than ten years his senior, with a number of children of her own. When they married, Jacob was 27 and Rebecca was in her late thirties. Sadly, it seems Rebecca was ostracized by her own family (including her children), who didn't approve of the young unknown artist from Finland. Nevertheless, the marriage succeeded and the couple went on to have two children of their own,

the second born when Rebecca was nearly 50. They settled in the fashionable city of Bath, a well-known center for silhouettists at the time. Then, as now, visitors flocked to the city to "take the waters" and perambulate the ancient town, often commissioning shades as souvenirs as they did so.

For his Etruscan profiles, Spornberg requested two sittings, each of about three minutes. The first was to paint a solid outline, while the second was to embellish the details of the face, hair, and clothing using thinner paint. The outline needed time to dry or the solvent used to thin the paint would spoil it. This two-stage process suggests that Spornberg was working freehand onto glass, rather than relying on sketches or cartoons.

Etruscan profiles were a success for a while and copied by a number of other artists. Dated Spornberg silhouettes span nearly a quarter of a century, so they clearly formed an important part of the family finances for some time. In the end, though, demand for them does seem to have waned. In the new "modernism" of the time they began to look a little "last century," a bit too early eighteenth century, in fact. Rebecca, on the other hand, did well in the world of fashion. In her later years, she reinvented herself as a milliner and dressmaker, and seems to have been much sought

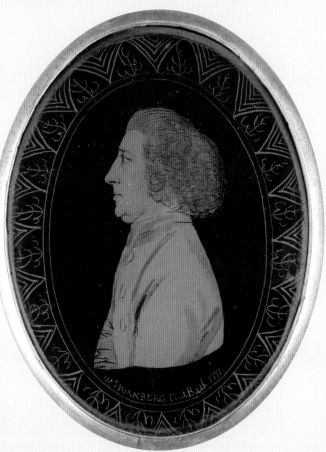

An Etruscan profile by Spornberg (collection of Diana Joll).

Etruscan pottery detail (collection of the Vatican Museums).

after. She was even commissioned to make a dress for Queen Charlotte on a visit to Bath. Perhaps Spornberg became involved in working for his wife's business as the demand for his Etruscan profiles dried up.

It is not known when Rebecca died, but it is thought that she was still working as a dressmaker into her 70s. It is known that Spornberg sailed alone to the New World on board the *Gladiator* in the summer of 1840, presumably to join their son, who had emigrated a number of years earlier and was working as a cabinet maker in Indiana. Spornberg had often told his children that he believed the United States was the country with the greatest future of all and that it was there he wished to die. This was a wish that seems to have come true.

Etruscan Silhouettes

This type of silhouette is created by painting outside the profile in black paint on glass, then filling in the details of the face and hair with a very fine brush, and backing the whole silhouette with vermilion paint. Spornberg used concave glass ovals, but as these are expensive, flat glass makes a good alternative. This is the most complex project in the book and builds on both the previous project and Painted Silhouettes on Glass (see pages 80–3), both of which you need to have studied before attempting this one.

YOU WILL NEED:
- Captured shadow, photograph, or live model
- Oval or rectangular glass (one taken from a photograph frame is ideal)
- A lint-free cloth and soap solution
- Black glass paint
- Two or three paintbrushes, at least one very small (size: 000)
- Needle or other pointed implement for scratching
- Ruler and/or a paper oval template (see borders, page 130)
- Vermilion paint (enamel or acrylic)
- White paper and pencil or crayon

HOLLOW PAINTING (The first sitting)
If you are right-handed, you will find it easier to work with a right profile, and with a left profile if you are left-handed, as you will be looking at the line outside the image.

A) Begin by cleaning the glass with a lint-free cloth and dilute soap solution; once clean, try not to touch the surface at all during the project.

An Etruscan silhouette in a gold-colored frame

B) Attach your painting guide to the front of the glass, then work on the back so that the finished picture appears in reverse. Traditionally, these portraits do appear in reverse, but if working from a digital photograph, you may wish first to flip the image horizontally. Print the photograph to the correct size and draw in the bust line and any adjustments in red crayon (as in the previous project on page 122, keep these minimal). Lay the glass directly on top so that you can see the image through the glass.

C) Paint the outline with a medium (size 1 or 0) brush using confident, clean lines. You should usually begin with the face and then work around the back of the head, turning the glass as you work to keep the line on the "easy" side of the brush (see pages 50–1).

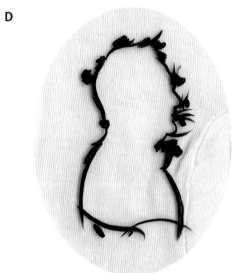

D) Continue painting using a natural waves pattern with lines breaking away outside the profile, leaving an empty space as the silhouette. This is the same pattern you used when cutting with scissors and is illustrated on page 42. Paint your natural waves in a relaxed and regular rhythm, aiming to create a pleasing shape and a clean line.

E) When you have finished, go around the profile a second time to strengthen the line. This is to ensure that you don't cross the line accidentally when painting the background.

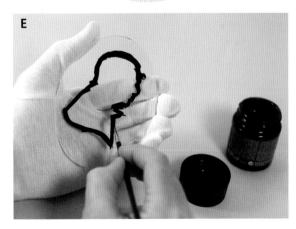

F) Take a large brush and paint out all of the background to the edge of the glass, leaving a 2-mm gap at the edge. This gap makes it easier to handle the glass during the next stages. Hold the silhouette to the light and check for any thin areas or holes, then touch these in. Try not to get paint inside the profile, but if you do, just leave it. This can be corrected later by scraping away dry paint. Put the glass aside to dry for a few hours.

PLANNING A BORDER (Between sittings)

While the paint is drying, you can think about the kind of border to use. Such borders (see Figure 2, below) are usually considered an integral part of an Etruscan silhouette, but do feel free to skip this step if you would prefer not to include one, or didn't leave enough space around the profile.

Borders are made by scoring a pattern in the paint with a metal point. This shouldn't be too sharp: a tapestry needle is ideal, while a sewing needle will leave too fine a line. Figure 2 shows various possibilities, some inspired by Spornberg's designs (see page 127), but all based on a pair of oval lines with a hand-drawn pattern around. To score the lines, you will need to create a pair of templates. Use an image editing program on your computer to generate two ovals to match the proportions of your glass, then print them out onto fairly stiff paper or cardstock. The ovals need to be about 1–1½ in (2.5–4 cm) smaller than the glass in both directions. For example, for a 6- x 4-in (15- x 10-cm) glass, generate 5- x 3-in (12- x 7-cm) and 4½- x 2½-in (11- x 6-cm) ovals. Cut out the insides with a pair of scissors.

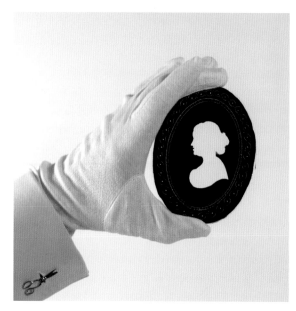

Figure 1: A profile with a scratch border and signature

Scoring a border and signing your work

Wait until the paint is dry to the touch, but not yet solid. The exact time to wait will vary depending on the paint you are using and how warm it is. If you start too soon, you will only succeed in smearing the paint,

Figure 2: Various oval borders to scratch into paint before fully dry

while if you leave it too long, the paint will tend to crack, making a jagged line. Place the smaller template over the glass so that the profile is centered within it. If you are using flat glass, you can prevent the template from sticking to the paint by creating a gap. To do this, place some books or strips of thick cardstock around the glass and lay the template across them. If you are working on concave glass, as Spornberg did, this will not be a problem as the concavity of the glass will create the gap for you. You will need to use some blobs of putty to prevent concave glass from rocking.

Hold the needle vertically and draw inside the oval so that you can see a clear line through the paint. For a double oval, repeat the process, placing the larger template so that the first line sits evenly inside the second. Using the needle, draw in the remainder of your design freehand. Try to make the pattern regular, but don't worry if it goes wrong in places. Spornberg's borders were frequently uneven; such imperfection adds to the charm of hand-decorated glass.

Whether or not you make a border, sign your work with the needle while the paint is still touch dry, either inside the border or underneath the bust line. Use mirror writing, since whatever you do will appear in reverse from the front (see Figure 1, opposite top).

You can also use the needle to scratch wisps of hair into the paint, bearing in mind the transmitted light discussed in Photographic Silhouettes (see pages 90–3). Make minor corrections, for example by carefully scraping away the paint if you accidentally went over the line when filling in the background. Put the glass aside again, allowing it to dry completely.

ADDING THE FEATURES (The second sitting)
When the paint is dry, embellish the silhouette using a small brush; refer to the notes in Bronzed Silhouettes about embellishing in black (see pages 96–7). Begin by painting the outline of the ear and then work over the hair, painting in the natural shadows and dark lines. Paint right up to the edge. When working on the hair, you may find yourself painting over parts of the outline at the back of the head. Spornberg did this as well, and it creates the interesting illusion of a head emerging from deep shadow.

Use your smallest brush (size 000) to pick out the facial features. As in the previous project, use the painted outline as a guide and extend the features into the face. Start with the nose and mouth and leave the eyes until last. If the outline is correct and the ears are in the right place, it should come together well. Even if the face looks a little distorted, have faith in the outline and use it as a guide; such distortion can work in surprising ways. Continue working over the image in diluted paint, adding shading and detail to the hair and face. As the paint dries, score highlights in the hair with the needle.

At the end, set the glass aside until the paint is dry (see Figure 3, below). If you are using glass paint that needs to be set in an oven, do this now.

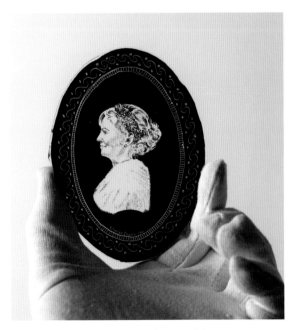

Figure 3: A finished silhouette with fine embellishment.

A

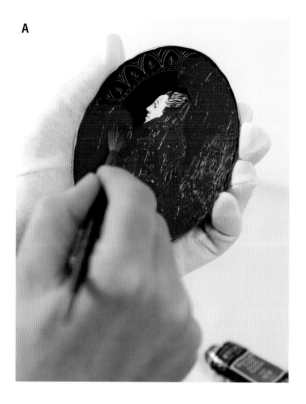

Vermilion paint

Etruscan silhouettes are traditionally finished in vermilion. This may seem an extreme color, but it creates a striking, warm and surprisingly human effect. The vermilion available today is not exactly the same hue as the one used by Spornberg: true vermilion was then a more orangey-red, produced from the mineral cinnabar. A synthetic vermilion was also made from mercury and sulfur, but this has been discontinued because of toxicity. If you want a subtler hue, you can add a little cadmium yellow to your vermilion.

A) Take a big brush, well loaded with vermilion, and quickly paint over your entire work with thick layers of paint. Hold your work to the light to check for uncovered areas and touch these in.

B) Allow the paint to dry. Turn the glass over to see the finished Etruscan silhouette.

B

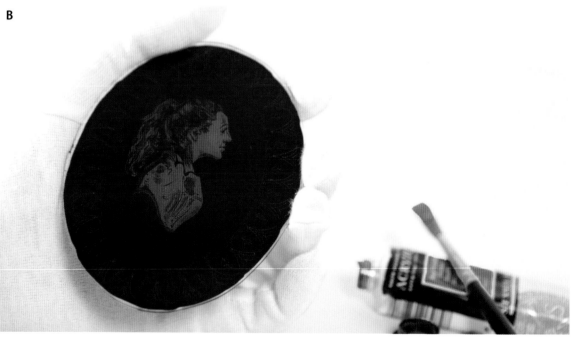

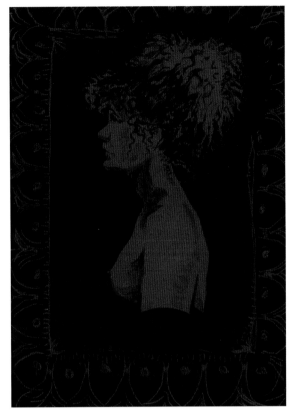

A modern Etruscan portrait painted freehand during a life-drawing session and backed with a subtle hue of vermilion.

FREEHAND PAINTING NOTES

Etruscan profiles can be painted freehand from life. Like Spornberg, you will need to arrange two short sittings a couple of days apart. The first is to paint the outline, which you will do freehand, without any kind of drawing, directly onto the glass. As you paint the first lines, try to visualize the position of the head so that it "lands" in the center of the glass.

The second sitting is to embellish the features (after adding a border and signature). The model should have the same hairstyle and clothing as in the first sitting. Spornberg probably sketched in just enough detail to complete the embellishment afterward, but if your model has time, it's better to complete the silhouette while they are present.

Appreciation

People are instinctively drawn to these profiles. The bright color and miniscule detail seem to demand close inspection, and you will receive many interesting comments and questions as to how you achieved such effects. To keep it safe, any painting on glass should be framed. If the glass came from a photograph frame, simply return it there, but do make sure that the vermilion is completely dry.

Once you have painted a few examples on flat glass, you should consider moving onto convex glass. Seen from the front, the convexity gives a curve to the face, giving the impression you are looking at a miniature sculpted head rather than a painting.

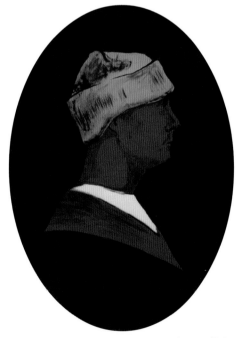

An experimental portrait in which some areas of the profile have been backed with different colors.

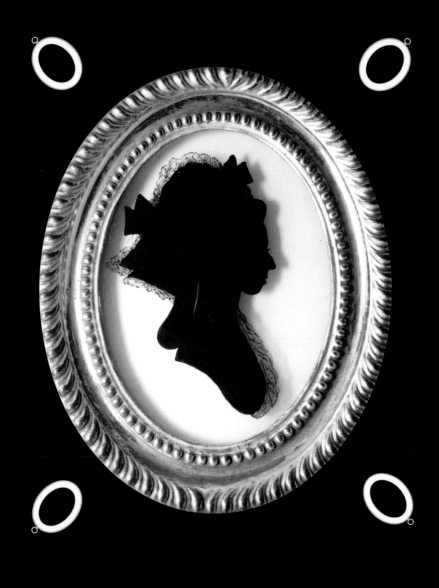

Presenting
Silhouettes
to the World

Presenting Your Work

By now, you will have a good working knowledge of silhouette art and should be well on your way to calling yourself a master of the art. This section looks at various ways to present your portraits to the world. You will learn how to mount and frame your work, and we will take a look at what silhouettes can offer at social occasions. Nineteenth-century artists understood the social importance of silhouettes very well, as most visitors to their studios were looking for a sense of occasion and fun as much as a well-presented silhouette.

A simple arrangement of silhouettes by Hubert Leslie.

Frames

If you want to frame your silhouettes, you may be wondering whether to use a traditional or modern frame. Traditionally, individual silhouettes sit well inside ovals, and many silhouettes in this book have been presented this way. Although oval frames can be expensive, they will give an authentic "period" feel. Traditional ovals are small, sometimes just 3 or 4 in (7.5 or 10 cm) tall, which can make silhouettes look a bit squashed, while modern ovals tend to be larger.

The best modern frames are fairly simple. It is hard to beat the lightweight plain black molding that has been the frame of choice for most twentieth-century artists. Today there is a huge range of frames on the market, any of which will accommodate silhouettes as long as they are on standard-size cards.

Breathing space

Whichever style of frame you use, a silhouette needs "room to breathe." The intense black benefits from some white space around it; otherwise it can seem crowded or even appear like a hole in the wall. When you choose an oval (whether a frame or a mat), make sure that no part of the silhouette touches the edge. A good rule of thumb is that the shortest distance to any part of the oval should be no less than the width of the neck. In an oval of this size, your portrait will seem to float quite happily.

Signing your silhouette

Do sign and date your silhouettes. This simple act was sometimes omitted by silhouette artists in the past, who saw no commercial value in doing this

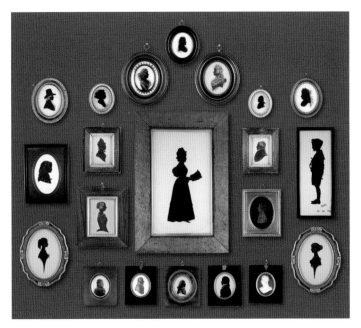

An impressive collection of silhouettes in traditional frames, arranged symmetrically around a central figure.

A shade in a modern "frameless" frame will seem to float by itself in space.

A pair of silhouettes either side of a painting make an interesting accent in a room.

as it added unnecessary seconds to their allotted time per customer, slightly reducing the number of silhouettes they could take in a day. As a result, antique stores are full of unsigned silhouettes on plain white postcards, perhaps taken on seaside piers and other resorts, but with no clue as to their origin. These are worthless to collectors and have completely failed in their role of preserving the likenesses of the past for us today.

As well as a signature, it is a good idea to write the name of the sitter and the occasion on which the silhouette was taken. Such details may seem obvious to you, but do not forget that your silhouettes will survive far longer than you do, and future generations may not remember who they are.

Some artists today use "signature cuts" rather than a written signature. Collectors can sometimes identify an unsigned silhouette by the shape of the bust line, for example, so rather than a traditional "S" shape, artists use a wide variety of double or triple curves and loops, which over time become a kind of signature.

Francis Torond
(1743–1812)

An arrangement of several silhouettes in a single frame, such as a family group of full-length figures, is known as a "conversation piece." Many silhouettists advertised these, although relatively few were sold. Conversation pieces—created to impress—would have been prominently displayed in the silhouettist's studio, the largest and most expensive items on show. The vast majority of clients would admire these pieces first before going on to purchase a small, bust-length shade or possibly a full-length portrait. This selling technique is still used by market traders today, first bringing clients to their stand by showing large, impressive pieces of work, before drawing attention to the smaller, more affordable items on show.

However, a few artists did sell conversation pieces successfully and are remembered more for these than for their individual portraits.

Setting the stage

One such artist was Francis Torond. Born in France, Torond painted silhouettes in London for about ten years from 1776, so, like Mr. Phelps (see page 109), he was already established before John Miers's

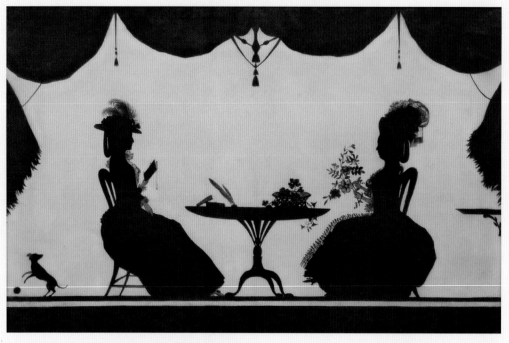

A conversation piece by Francis Torond (collection of Diana Joll).

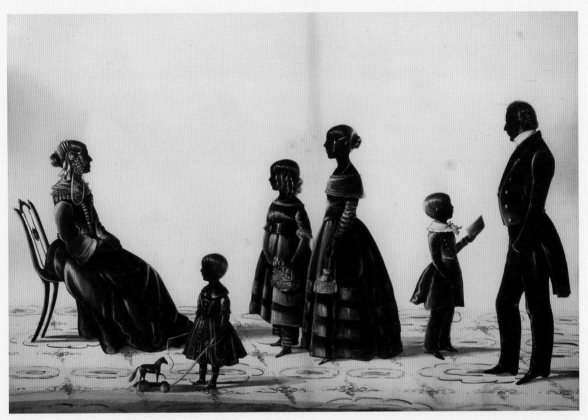

A conversation piece by the Royal Victoria Gallery, a group of artists active in the early nineteenth century (collection of Diana Joll).

arrival (see pages 14–15). He created large groups of figures in silhouette, as well as making miniatures and religious paintings. Created with an intuitive understanding of shadows, these are regarded by some as the quintessential English Georgian silhouettes of the eighteenth century and are a popular choice for book covers and illustrations.

Torond makes no attempt to create a sense of space, but simply paints the floor with a single black line. This creates the impression that his figures are on stage or projected onto a huge white drape. In the hands of a lesser artist, this would be an impossibly difficult contrivance, but Torond's refined sense of balance and composition allowed him to get away with it. He was fond of including large drapes, which add to the sense of theatricality, yet his scenes show intimate views of family life or meetings of friends.

Torond's conversation pieces are unique in being conceived as one picture from the outset. Later artists would first create a set of full-length or seated silhouettes and then consider how to arrange them. Some simply lined them up in a row, while others went to considerable lengths to arrange them onto watercolor or printed backgrounds.

Sadly, Torond was one of several artists who seemed unable to compete with the talents and productive energy of Miers. After 1786, he stopped making silhouettes, probably to concentrate on earning a living as a drawing master. The quality of his work suggests he would have been a good teacher.

Silhouettes on Paper

Here you will learn how to arrange silhouettes on cardstock or paper, first by creating a card for a bust-length shade, then by designing a conversation piece after the manner of Francis Torond. This project assumes you are mounting a collection of cut silhouettes onto cardstock. If you are painting silhouettes, you need to consider the principles of this project from the outset while you plan your painting.

YOU WILL NEED:

- Some silhouettes to display
- Colored origami paper, pencil, and scissors
- Digital camera (medium quality)
- Computer with simple photograph-editing software
- An inkjet printer with some good-quality paper
- Brush and gray watercolor

ARRANGING SILHOUETTES

The simplest and still the best way to mount a bust-length silhouette is on plain, white, acid-free cardstock set into an oval frame or mount. Professional silhouettists often use some form of printed oval, as these can be put straight into a standard frame without further ado. You could create one of these on your computer; otherwise, an online search for "oval borders" will show many interesting shapes suitable for mounting silhouettes. As long as you are not planning to use your frames commercially, you will not infringe any copyright by printing out a few and using them to display your work.

A more creative idea is to hand-cut some ovals while practicing wave exercises (see pages 32–5). Take a sheet of origami paper and fold it diagonally into quarters, then draw a freehand quarter oval between the folded edges. To make a 6- x 4-in (15- x 10-cm) oval, mark 3 in (7.5 cm) and 2 in (5 cm) along the folded edges and draw a curve between them. Now cut a random wave pattern each side of the line, cutting through all four sheets at once (see Figure 1, opposite top). Open this out and you will see a symmetrical pattern lending order and form to your waves (see Figure 2, opposite bottom). You can cut a series of progressively smaller ovals from the same sheet of paper. Keep the patterns simple or they may overpower the silhouette.

If you have a number of bust-length silhouettes to group together, arrange them in "playing card" patterns, like the example of five busts from Hubert Leslie (see page 136). Alternatively, print or paste arrangements of ovals onto a large single card, so each silhouette has an oval of its own. There are many possibilities for arranging your silhouettes, but bear in mind the need for silhouettes to have plenty of white space around them.

MAKING A CONVERSATION PIECE

If you enjoyed the Full-length Silhouettes project (see pages 59–63), you might like to take this a step further and make your own conversation piece.

Begin by considering the background: should it be plain white, a printed background, or even a watercolor? Here is a simple way to make a printed background using a digital camera. The background

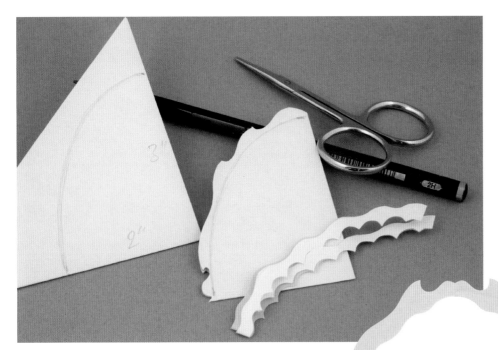

Above: Figure 1: Cutting wave patterns into folded sheets of origami paper.

Right: Figure 2: An oval cutting used to frame a silhouette.

could be an outdoor scene, such as a beach or open landscape, or a large interior space. If you own a room of sufficient grandeur, use that, otherwise use a space in a local museum or hotel. Visit your chosen location and take a photograph, after getting any necessary permissions. Try to keep the photograph empty— there should be no foreground interest at all—so that on its own it will seem a very boring image. The example on page 143 uses a large public space in front of a modern office building. If you are working outside, point the camera toward the sun; if indoors, toward the window (use a tripod if light is low), so that any shadows point toward the viewer. It should be a clear shot, taken at the camera's largest image setting.

Open the photograph in an image-editing program and drain the color. Either make a black-and-white image or tint it in sepia. Reduce the contrast and

increase the brightness so that the image begins to bleach out, making sure there are no dark areas that will interfere with the outline of your silhouettes. Adjust the size to make a large print that can accommodate your cuttings, as well as fit the frame if you have a particular one in mind. This will probably be too big to print at home, so have a print made, and ask the printer to use matte paper rather than gloss. Once you have your photograph, arrange your silhouettes. Avoid placing them all in a row; careful arrangement adds interest and perspective. If some seem to have been cut at a smaller scale than others, place them higher to make them look farther away and suggest that you cut them that size on purpose. Consider cutting a silhouette of the family pet and adding that, and possibly some furniture as well. Augustin Edouart (see pages 56–8) would have cut these items as "extras" and charged a fee for them.

If the silhouettes seem to "float," anchor them to the floor by adding shadows (see page 63). If the background includes the sun or a bright window, plan these shadows so they all point away from it. Mark their positions with a faint pencil line before painting, as they may not all point in the same direction. Paint the shadows with a large brush (no. 4, 5, or 6) and some gray watercolor. Insert the brush under the feet and make either one or several strokes of the brush toward the front of the picture.

Appreciation

Whether you have mounted a single silhouette or embarked on an ambitious conversation piece, it will need to be framed. Seeing a finished piece in a frame is a special moment for any artist. Work that you might have felt unsure about suddenly looks far more professional and finished. If you (like many artists) were feeling your work was somehow less worthwhile, now is a good time to question that assumption, as seeing your silhouettes well mounted and framed will help you feel confident that they could hang alongside any other in this book.

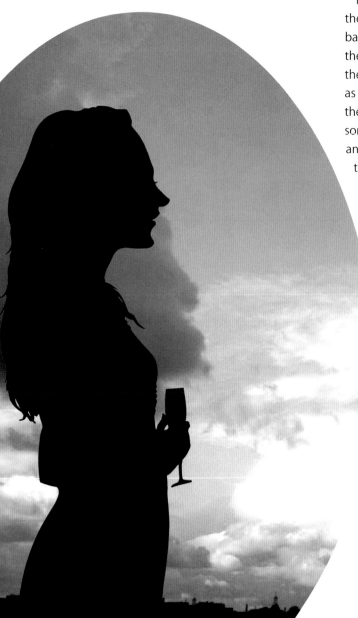

A photograph of the sky makes an effective card for a half-length silhouette.

A selection of home-printed cards useful for mounting silhouettes.

A complex collage is best mounted on a plain card.

A large photograph of a modern building makes an interesting backdrop for this set of musicians.

Taz and Nic

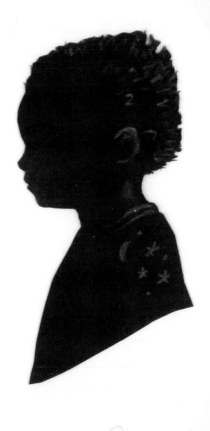

Onne of the attractions of old silhouettes is the connection they make with times past. Whether a portrait of a child now grown, or a grandparent in their youth, silhouettes invoke a nostalgia quite different from a modern photograph. This may be one reason why so many of my clients come back year after year to have silhouettes of their children, keeping a record of how they have grown.

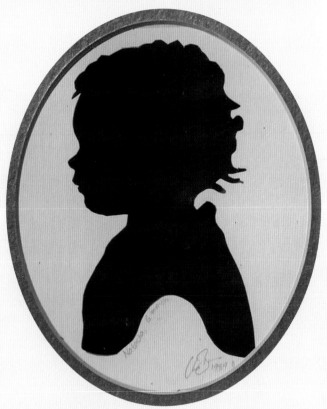

Taz's first silhouette, cut when she was six months old, and one of my first cuttings (silhouette number four). Although very precious, it is far from being an accomplished silhouette.

Nic in his pyjamas, age three. An early and rather crude experiment with embellishing, using a gold crayon.

A very personal history

Forgive my indulgence in illustrating this section with my own children, they will no doubt protest that they are hardly history! It was fortunate that I cut my first silhouette the same year my daughter was born. As the children grew up, and my art evolved, they were always near at hand whenever I needed

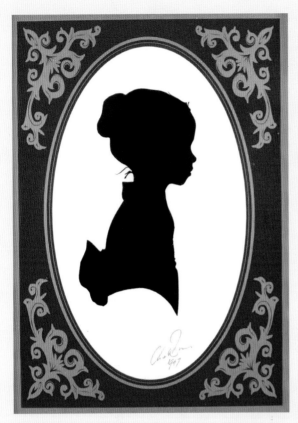

Taz with her hair up, wearing a Japanese kimono, age five. This simple black shade is mounted on an elaborate printed card that I used in Covent Garden in London at the time.

a model to try some new genre of silhouette. The result is a haphazard collection of odd profiles that show both the growth of my children and my own growth as an artist.

With difficulty, the collection has been edited here to just a few selected silhouettes. They include prototypes of many of the projects we have already covered, although not always the most successful examples. More importantly, they show the real personal value of such a collection maintained over many years. There is nothing more magical than watching a child grow into an adult, and silhouettes provide the perfect medium to record this.

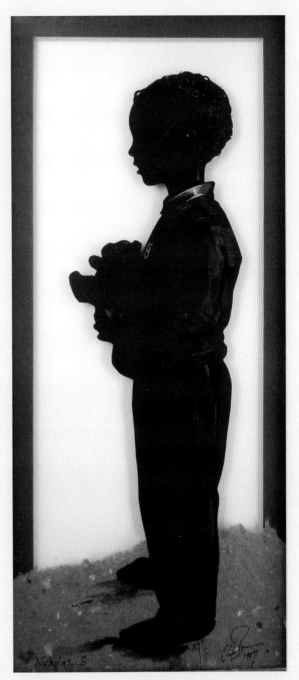

A full-length silhouette of Nic, age six, holding his favorite teddy bear. A piece of Indian paper creates a floor for him to stand on, with a watercolor shadow. The matte is behind the silhouette, creating a gap between it and the background.

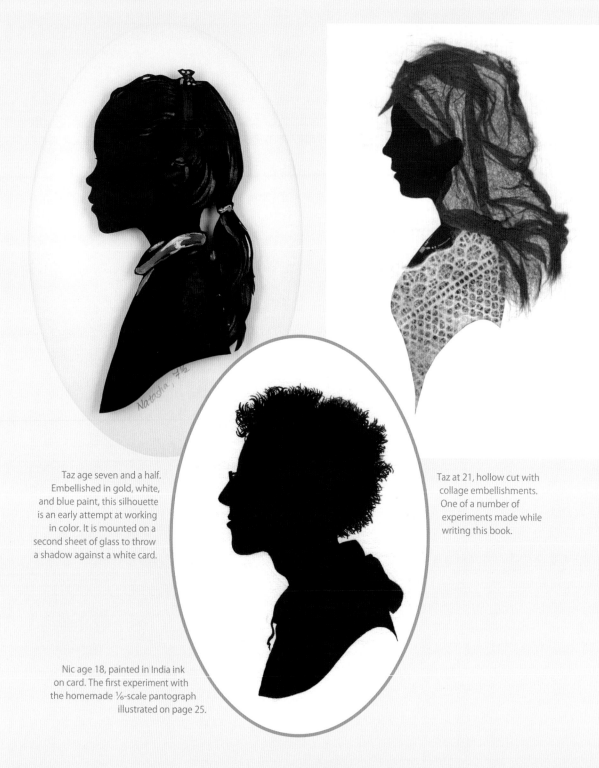

Taz age seven and a half. Embellished in gold, white, and blue paint, this silhouette is an early attempt at working in color. It is mounted on a second sheet of glass to throw a shadow against a white card.

Taz at 21, hollow cut with collage embellishments. One of a number of experiments made while writing this book.

Nic age 18, painted in India ink on card. The first experiment with the homemade ⅙-scale pantograph illustrated on page 25.

Silhouettes Over the Years

This project will give you some ideas for creating a set of portraits of friends and family from the past. There are a number of reasons you may want to do this. If you are researching your family history, then a set of silhouettes is the perfect way to add some human interest to your notes. Or perhaps you may wish to use your new skills as a silhouettist to create a record of the way your children have changed over the years.

YOU WILL NEED:

- Some old photograph albums
- Scanner and computer printer
- Pencil and ruler
- Red crayon
- Magnifying glass
- Materials to either paint or cut a silhouette

COMPILING A RECORD OF TIMES PAST

There are two approaches to this project. The first is to start making silhouettes now and continue making them intermittently for the next 20 years or so. If you have children (or grandchildren, nephews, or nieces) of a young age, this might be a perfectly reasonable thing to do. It is, after all, what I did and it will give you plenty of time to try a variety of projects. If you are looking for quicker results (or if your children are grown up), then the second approach is to start looking through old photograph albums, hunting for any photograph that can be used to create the all-important outline from which to make a silhouette.

Working from tiny profiles

Looking at photograph albums, the first thing you will notice is how rare profile photographs are. You might be lucky, but almost nobody looks sideways when a camera is pointed at them. Those that do are all too often in the background, miniature blobs on the horizon of your photographs (see Figure 1, below). Surprisingly, it is possible to create a convincing silhouette from such a blob. Figure 1 shows a small photograph, measuring just 3½ in (9 cm) square. It seems far too small to work from, but does at least show a profile.

Figure 1: Photograph of two boys taken in the 1970s.

A) If you have the negative (and if your scanner is able to do this), then scan it at the highest possible resolution. If not, scan the photograph. Scan just the small area you are interested in, or the file will be unmanageably huge. Even with an ordinary scanner, it's amazing how much detail you can see.

B) Print out the scan at the size you wish to cut or paint your silhouette. It may look very blurred, but have faith and be aware that likeness resides as much in the stance as in the facial features.

Next draw a cutting guide in red crayon, using whatever clues you can to pick out detail, and guessing those you cannot see at all. Despite the fuzzy nature of the image, try to draw the line in a series of confident curves, making use of the notes in Scissor-cut Portraits on page 43, and adding a bust line with a simple S-shape.

C) Once you have created an outline, proceed to painting or cutting the silhouette using any of the techniques studied in this book. Label the silhouette as soon as you finish, or if it is intended for a family tree, place it there right away as it's easy to forget who these silhouettes are of, especially if you make several of them.

Full-face photographs

If you cannot find any profile shots, another approach is to create a silhouette from a full- or three-quarter face photograph.

A) The illustration opposite shows an anonymous photograph from the 1920s, typical of the material you might have if trying to compile a family tree. Scan and print a copy at the correct size. Although the horizontal dimensions cannot be seen, the vertical

dimensions are clear. Establish these by making a simple grid, extending a series of horizontal lines from fixed points on the photograph, for example, the top and bottom of the nose. Make sure these are exactly parallel, then draw a single vertical line as a guide for the profile.

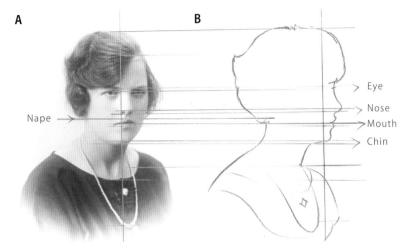

B) Construct the face by making a series of educated guesses based on what you can see in the photograph and your own experience. For each point, consider if it should be further from, or closer to, the vertical line than other points on the face. If the subject is an ancestor, have a look at some living relatives of about the same age who might have similar features. The back of the head is the most awkward part, especially if it is a full-face photograph (three-quarter views are much easier). Look for clues in the hairstyle and the line of the shoulders.

C) Step C shows a finished scissor-cut silhouette of a woman from the 1920s, embellished with a necklace in white paint.

Appreciation

Did it work? If this is somebody you remember at that age, you should be able to recognize them. If so, it can be quite a spooky experience. If the profile is of somebody you don't know, you should at least be able to tell if it could be a likeness by checking to see if the hidden features, such as the eyes and ears, appear as you look at it (see Recognizing a good silhouette on page 13).

An effective way to display these silhouettes is to draw up a family tree with an empty oval next to each name. Ask relatives to hunt for images of people you may not know. As you find them, create silhouettes and begin to fill the ovals.

Charles Rosenberg
(1745–1844)

I am sometimes asked: "How small can you make a silhouette?" In response, I usually show the person a 1:24 scale silhouette set into a locket, although it is possible to make silhouettes even smaller than this. The doll house silhouette on page 154 is just

An "anti-Etruscan" pin by Charles Rosenberg (collection of Diana Joll).

5 mm high. There is something intriguing about a cut silhouette so small it looks as though it could blow out of the palm of your hand if somebody sneezed.

Silhouette jewelry

Many silhouette studios of the late eighteenth century developed profitable sidelines in jewelry. Painting at this scale taxes the skill of any artist, which would have been pointed out to the client. There was also the cost of working with a jeweler to create the finished piece; as a consequence, these were often expensive items.

In some ways, jewelry silhouettes are the most fascinating of all, drawing the viewer in to appreciate the tiny details of the chin, nose, and even an eyelash.

However, as the nineteenth century progressed and silhouettes became cheaper, the practice of making them as jewelry pieces seems to have died out.

Charles Rosenberg is one of the best-known silhouettists of the period. He arrived in Bath, England, in the 1790s, setting up in direct competition to Jacob Spornberg (see pages 126–7), and quickly became well established. Born in Austria, he was already known all over Europe and (if his adverts are to be believed) had taken profiles of members of various European royal families. He went on to take many profiles of the English nobility as well. He became a well-known figure in Bath, possessing a genius for drawing attention to himself. For example, in 1798, on

hearing that a previous client had escaped from prison in France, he took out a paid advertisement in the *Bath Chronicle* announcing to the French authorities that he himself had "captured" the prisoner on several occasions, and for payment of a small fee would be happy to do so again. Like most silhouettists, he kept an archive and by this stage had some 3,000 "captured" shadows in his studio.

As well as his jewelry work, Rosenberg produced a range of bust-length and full-length silhouettes, all painted on glass and often backed with rose-colored paper (a reference to his surname). Seeing the work of Spornberg, Rosenberg immediately announced that he too would make Etruscan profiles and went one better by also advertising an "anti-Etruscan" profile. This was, it seems, an Etruscan profile painted inside-out: in other words, a silhouette!

A pin with an embellished profile by John Field (collection of Diana Joll).

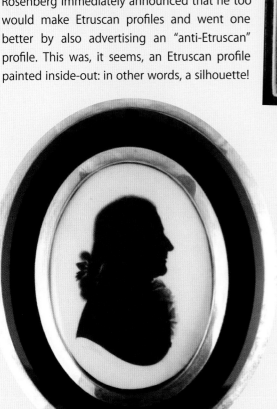

A silhouette pin by John Miers (collection of Diana Joll).

The pin illustrated opposite is painted in his anti-Etruscan style: a minutely detailed shade painted on thin convex glass, and backed with vermilion paint.

Rosenberg lived to the ripe old age of 99, having retired as a profilist in his mid-70s. It seems that he continued to receive royal favor and in later years came out of retirement to take the profile of the young Queen Victoria.

When looking at silhouette jewelry, it is impossible to ignore the John Miers studio in London, which created many such pieces. The illustrations here show examples by both John Miers (see pages 14–15) and John Field (see pages 94–5). As was customary for their individual styles, one is a shade and the other an embellished profile. Both silhouettes are executed in minute detail at an impossibly small scale.

Beyond Miniature Scale

This project pushes the boundaries of scale. You can use these techniques to create silhouettes for lockets and other jewelry, as well as to furnish a doll house. When making such small silhouettes, it becomes clear that using a small brush is far easier than using a pair of scissors. In this project, we will look at both methods.

YOU WILL NEED:

- Desk-mounted illuminated magnifying glass
- Printed photograph to work from
- Thin black paper, such as origami paper
- Miniaturist's scissors
- Zip-lock plastic bags
- Smooth white paper, such as bristol board
- Size 000 brush
- Ruler, fine pencil, and eraser
- Paint: India ink, watercolor, or gouache

Thinking about scale

Many silhouettists hardly ever define their scale, but for miniaturists this is a useful practice. If the distance from the tip of a man's chin to the top of his head is 10 in (24 cm), in a quarter-scale silhouette this distance would be 2½ in (6 cm). Many silhouettes cut by artists today are almost exactly this size, so it seems a natural scale. Since doll houses are constructed at 1:12 scale, the challenge is to create a 1:12 scale model of a quarter-scale silhouette. This is a 1:48 scale portrait. At this scale, the distance from a man's chin to the top of his head will be just over ⅕ in (about 5 mm).

Incidentally, John Miers would have thought a quarter scale large. He usually worked at "true miniature scale" which for him, as with most eighteenth-century artists, was 1:10. At this scale, the distance to the top of the head is 1 in (2.5 cm). It is

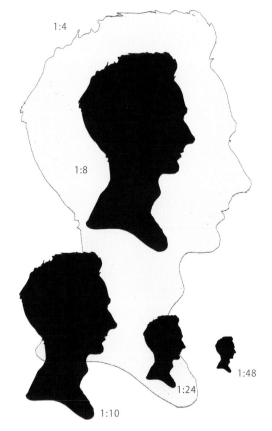

Various scales from 1:4 to 1:48.

interesting to speculate what a doll house model of a Miers silhouette would look like. The measurement would be ¹/₁₂ in (or 2 mm) and you would be working at 1:120 scale, which wouldn't be practical without a low-power microscope.

CREATING A DOLL HOUSE SILHOUETTE

Trying to print a photograph at 1:48 scale is not practical: even with the best of printers, the result will be too indistinct to see the shape of the face. Sketch the design freehand with a fine pencil, then rely on your scissors or brush to create the portrait.

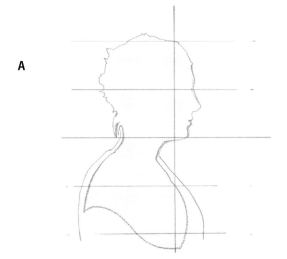

A) Start with either a printed photograph or an outline drawing and make a simplified grid. Draw horizontal lines at the top and bottom of the head, and a single vertical line across them. Divide the distance by two and draw an extra line in between, then extend this grid over the bust by adding two more horizontal lines to make five in all. Mark any alterations to the outline in red crayon. Next, using either origami paper for cutting or bristol board for painting, draw two horizontal lines 5 mm apart near the center of the paper. These represent the top and bottom of the head. Use the magnifying glass to construct the rest of the grid so it matches the one drawn over your sketch. Transfer the shape of the head and bust into this grid by hand. Whether you are cutting or painting, leave plenty of space around the drawing to handle the paper as you work.

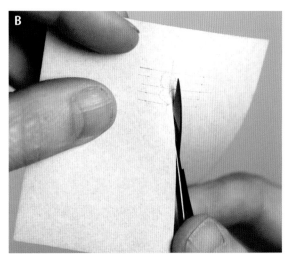

B) To make a cut silhouette with a pair of miniaturist's scissors, cut carefully around the line. As with all cutting, try to keep the scissors still and manipulate the paper using the white border. Refer to the photograph or sketch as you cut, as your drawing will be indistinct in places.

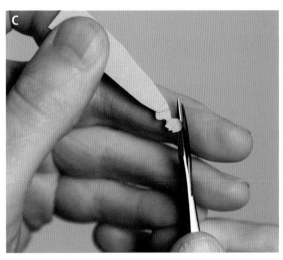

C) To make a "second cut" (which is possible) leave plenty of paper under the bust so you can hold the silhouette. If you want to bronze the silhouette, do so while this paper is still attached. Finish by cutting the bust line. When you have finished, place this silhouette straight into a zip-lock bag: if it blows out of your hand, it will be gone forever.

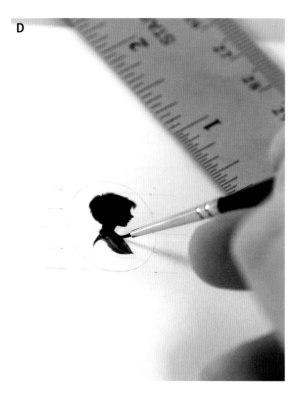

D

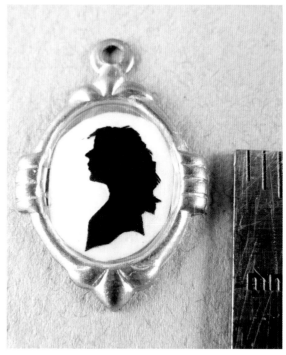

A 1:48 scale cut silhouette, set in a doll house frame.

D) To make a painted silhouette, use a 000 size brush to paint carefully inside the line. As this brush holds so little liquid, the paint may dry on the bristles before you make your first mark. To avoid this, dilute the paint more than usual, initially painting in a watery gray, and work as fast as possible without rushing. This brush will make much finer lines than a pencil, so your drawing will seem crude and inaccurate through a magnifying glass. Go around the outline again, adding details of hair and clothing while layering the paint to create a denser black. When the paint is dry, carefully rub away all traces of pencil and think about embellishing it with a few microscopic touches of gold. If you have a locket or frame ready, draw the interior shape around the profile and cut it out carefully. If not, leave the paper intact as it is less easy to lose that way. Paint several silhouettes on one sheet of paper and cut them up later for framing.

A MINIATURE GALLERY

Now you need to display your selection of tiny silhouettes. If you have a doll house, hang them on the wall; if not, use a room box to create a gallery. The illustration opposite top shows a box constructed from three sheets of cardboard, with a window and door cut into one side. The window was made by drawing a grid onto black paper and hollow-cutting the spaces between. A set of painted 1:48 scale silhouettes has been hung on the wall with miniature pins, and more placed on the table. The artist and her model were cut from thick black paper at 1:12 scale, so the man is 6 in (15 cm) high. They are held up with folding stays, and the man is strengthened with a strip of paper behind.

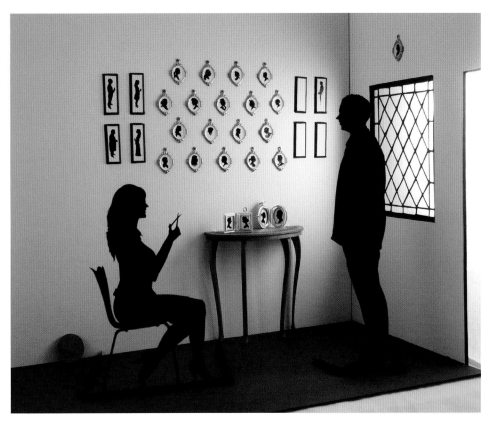

A miniature 1:12 scale scene of a silhouette parlor and a selection of 1:48 scale silhouettes.

Appreciation

When you first remove your silhouette from under the magnifying glass, you will be astonished at how small it is. In this digital age, when all the images we see are pixelated, it's easy to forget how small a mark our eyes can distinguish. Working smaller than 1:48 scale is not really recommended. Making a larger silhouette, for instance to fit a locket, is a simple matter of adjusting the grid; to work at 1:24 scale, begin with two lines just under ½ in (10 mm) apart.

Silhouettes placed in lockets make unique mementos and are far clearer than the rather fuzzy photographs usually seen in them. You will almost certainly find that everybody you show these silhouettes to will marvel and delight at the skill involved in making them.

A pair of 1:24 scale painted silhouettes set in a small silver locket under red glass.

Jens Handrup
(1884–1930)

Parties have been mentioned a number of times in this book, usually as a good place to gather profile photographs of friends and family. The project that follows is a different kind of party, as the theme itself is silhouette. You will not need your camera, as this is your chance to show off some of the skills you have learned, as well as giving others a chance to make a silhouette for themselves.

Garden parties and bazaars

The Danish artist Handrup arrived in London during the revival of silhouettes shortly before World War I, setting up a new silhouette concession at the D.H. Evans department store in Oxford Street. He cut silhouettes there for many years, most of them identified by an embossed D.H. Evans stamp and wording that reads like an eighteenth-century trade label. As well as the usual references to royal patronage, a new addition is the phrase: "At-homes, garden parties, bazaars etc., attended."

This interesting snippet shows Handrup's awareness that such social occasions represented a good opportunity for a silhouettist, and it was worth leaving his studio on occasion to attend them. He seems to have been the first artist to consider this as a possibility; in the fashionable culture of the 1920s,

The printed envelope used by Handrup so that people could take their silhouettes home safely.

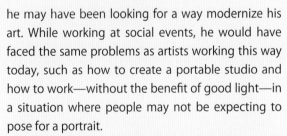

A lady wearing a fox stole by Handrup.

A gentleman with top hat and cigar by Handrup.

he may have been looking for a way modernize his art. While working at social events, he would have faced the same problems as artists working this way today, such as how to create a portable studio and how to work—without the benefit of good light—in a situation where people may not be expecting to pose for a portrait.

As well as the D.H. Evans cards, some of Handrup's silhouettes were set on plain cardstock in specially printed envelopes. Possibly these were the ones cut at social events; the envelope would have been a handy way to give silhouettes to people, who could then put them straight into coat pockets or purses as they continued socializing.

Handrup was a versatile artist and his portrait heads at least were always cut freehand. He often used two sheets of folded paper to cut four copies of a silhouette, keeping one for his records and giving three to the client. He left some as plain shades while embellishing others with crayon inside the profile, or adding details outside with gray watercolor and black pen. Occasionally, he used refined slash cutting, as seen in the portrait above of a top-hatted gentleman, which uses creative slashes to indicate reflected light on the silky surface of the hat.

Very sadly, Handrup's career was cut short when he was knocked down by a vehicle on a London street in February 1930 and he died soon afterward.

The Silhouette Party

Children and adults alike will enjoy this project, which builds on the idea of silhouette making as a social occasion. You are going to demonstrate how to cut a silhouette with scissors. This is an advanced project, and so you need to have practiced your scissor-handling skills to a level where you are happy for others to watch you at work.

YOU WILL NEED:

- Black-surfaced paper
- White cardstock or printed card mounts
- Plenty of pencils and scissors (inexpensive schoolroom scissors are fine)
- Double-sided tape or other adhesive

ENTERTAINING WITH SCISSORS

Before the event, make sure that you have all the materials you need, and enough of each item for everybody to have a try. You need a pencil and one pair of scissors for every two guests, as well as paper and card for everyone. Either use plain white cards for mounting silhouettes, or print a card with a pair of ovals (see Figure 1, right) for people to take their silhouettes home, which adds a professional touch. Print these on your inkjet printer using heavy paper—a letter sheet folded in half.

Taking charge on the day

When demonstrating how to cut a silhouette, a good rule of thumb is to say everything three times. First, explain what you are about to do; second, say what you are doing; and finally, recap on what you have just done. The routine goes something like this:

1) Make sure that you are holding a pencil, scissors, and a piece of black-surfaced paper folded in half.

2) Start by explaining a little about silhouettes and their history. Use one of the histories in this book, such as that of Augustin Edouart (see pages 56–8). Explain that Edouart cut his shades with just the aid of a freehand sketch, which is exactly what you are about to do.

3) Bring up a volunteer, then ask him or her to face to the right, explaining to the guests that you are now sketching the profile and now cutting it with scissors. Tell them to watch carefully as you do so, demonstrating how to cut up the face and down the back of the head.

4) After a few minutes, hold up the finished silhouette. Don't worry if it's not one of your best; if you managed to cut something looking like a head your audience

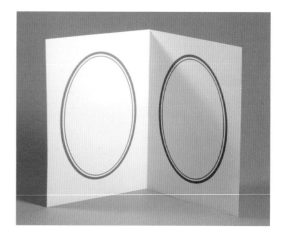

Figure 1: A homemade card; guests put their own cutting on one side and the silhouette they received on the other.

will be impressed. Briefly recap how you made it.

5) There are two copies of the silhouette. Make a show of giving one to the volunteer and keeping one for yourself.

"Now it's your turn"

Ask everybody to find a partner, then distribute pencils, scissors, and paper. Each couple needs to decide who is the artist and who is the model. If there are an odd number of people, you will need to take part, too.

1) State that there is a limited time to complete the silhouette (about a minute longer than you just took) and explain the process again patiently to those who ask you to repeat it.

2) Tell everyone when to start drawing and when to cut. Stick to the time allotted, and stress this by counting down the last minute.

3) When the time is up, ask couples to change places, then repeat the process.

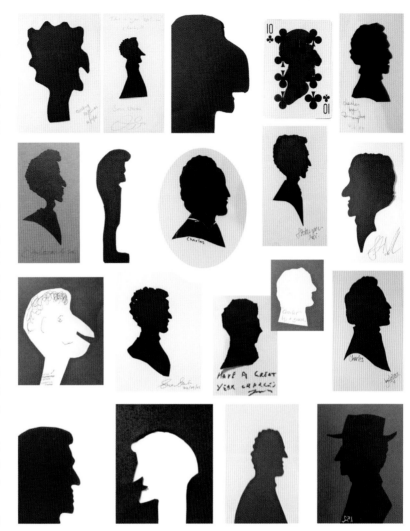

A collection of amateur silhouettes cut of the author at a variety of events.

At the end, you need to take charge again. There will be much general excitement in the room with everybody comparing everybody else's profile. Wait for this to die down—which may take some time — then show the guests the printed cards and explain that one side is to stick the copy of the silhouette they made, and the other is for the silhouette they received. Distribute the tape or adhesive and encourage people to sign their silhouettes. If there is time, everyone can change partners and have another try.

Appreciation

At the end you will be exhausted, but your guests will have had fun. Some silhouettes will be surprisingly good, although the experience itself is more important than the end result. Emphasize this by offering two prizes: one for the best and one for the worst silhouette. You are also bound to hear stories from people who have had silhouettes done before or have old silhouettes in the family. In this digital age an activity so "low tech" is a breath of fresh air, and people will talk about this event for many years to come.

William Hubard
(1800–1862)

Years ahead of his time, one artist—William Hubard—did away with all the contraptions of the nineteenth century and simply cut freehand with scissors. I suspect he would have been quite at home in the twenty-first century, cutting his 20-second profiles at weddings and corporate events.

A child prodigy

Very much the Mozart of the silhouette world, Hubard discovered his natural gift for portraiture as a child by cutting profiles of the congregation in church. Looking sideways along the pew gave him a wonderful row of profiles, and for him this was far more interesting than paying attention to the service!

At the age of just 13 he was discovered by Mr. Smith, a music hall manager from London, who was so enthused by Hubard's speed and skill that he set up the Hubard Gallery as a showcase for his talents. Mr. Smith billed this new sensation as "papyrotomia" (cutting a design with scissors) and created a touring exhibition of silhouettes cut and embellished by this precocious artist. As well as portraits, there were the usual conversation pieces on show, together with any number of horses, dogs, carriages, and so on. Mr. Smith promoted the show by saying that "any object in nature" could be cut by the "talismanic scissors of the young Master Hubard." The biggest selling point of the show was that the entire exhibition had been cut with ordinary scissors by a child of 13.

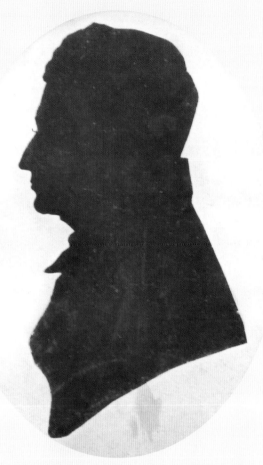

A rapid silhouette cutting by William Hubard at age 13 (collection of Diana Joll).

The Hubard Gallery was a success, and Hubard was quickly invited to take silhouettes of several distinguished sitters, including the young Princess Victoria. The exhibition toured all over England and Ireland, and two years later, they sailed to New York for a tour of America. For an entrance fee of 50 cents, visitors were invited to view the papyrotomic exhibition and have their own likeness taken in just

PRESENTING SILHOUETTES TO THE WORLD

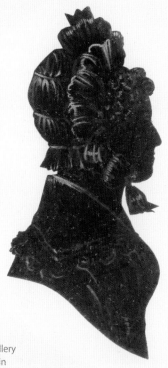

A pair of Hubard Gallery silhouettes created in London in the 1830s.

20 seconds by Hubard himself. These "20-second" silhouettes were a plain outline with no second cutting. Full-length and embellished silhouettes were available at extra cost.

Hubard was, of course, growing up and, as he did so, realized that his talents as an artist went far beyond cutting 20-second profiles, and that the traveling circus the Hubard Gallery had become was no longer for him. The life that must have seemed so exciting to a child of 13 was no longer attractive to a young man of 17. In 1826, while touring America, Hubard decided to remain there to pursue his own career as a portrait artist and sculptor. Mr. Smith, not one to let such a minor setback get in his way, quickly found and engaged several other prodigies

and continued touring the Hubard Gallery into Canada with an exhibition *in memoriam* of Hubard. The Gallery flourished, later returning to England and finding a more permanent base in London at 109 Strand. It remained in operation for another 20 years or so, employing a variety of artists and turning out many thousands of silhouettes.

Meanwhile, Hubard, after further travels in Europe, eventually settled in Richmond, Virginia, where the Valentine Museum still has a collection of his paintings. As well as painting, he set up a foundry to cast sculptures, which was later used in the Civil War to make cannon for the Confederate government. Sadly, while testing gunpowder for cannon, he was killed by an explosion in the foundry.

Silhouettes at Weddings

Weddings and silhouettes go together well. Whether making a portrait for the bride and groom or cutting profiles of the guests, the nostalgia and romance of the art blend well with the mood of the event. You may wish to hire a professional silhouettist or do the silhouettes yourself. This project looks at ideas to carry out on your own, as well as how to get the best out of a professional should you choose to hire one.

YOU WILL NEED:

- Digital camera
- Computer and printer (either bring your own or arrange the use of these)
- Black paper, red crayon, adhesive tape, and scissors from Scissor-cut Portraits (see page 42)
- Your favorite scissors
- Printed backing cards (see page 143)
- Adhesive (see pages 106–7)
- Pencil (to sign the work)
- A frame the same size as the card

AN UNUSUAL WEDDING PRESENT

A silhouette of the bride and groom, made using almost any process in this book, will make an unexpected and special present. To prepare the gift in advance, find an occasion to photograph the couple beforehand; otherwise you can take photographs on the day and give them the present afterward.

If you want to be more adventurous, with a little planning it's possible to create silhouettes on the actual day. You will need to bring the materials listed and a frame. If you are staying at the venue, you may be able to bring a laptop and printer so that you can take, and immediately print, photographs to make a cutting guide. If not, ask in advance if the hotel will let you print them on their computer (explaining to them that quality is not important and ordinary thin paper is all you need). Do a timed rehearsal beforehand to make sure that you can take and print a photograph, use adhesive tape to stick black paper behind it, then cut, mount, and frame the silhouettes in a reasonable time, aiming for around 30 minutes.

On the day, take the photographs, find the appropriate moment to disappear for half an hour or so, and reappear with a framed portrait. If you wish, give it unwrapped so that it can be passed around for everyone to see.

If you are feeling very confident, you could even attempt to make a pair of full-length silhouettes on the day in the style of Augustin Edouart himself, with just a brief freehand sketch and a pair of scissors (see freehand notes on page 62).

USING A PROFESSIONAL

There are two ways you might like to use a professional artist. The first is to commission a silhouette portrait of the bride and groom, using photographs taken on the day, either by you or in consultation with the wedding photographer. The second, if you are organizing the wedding, is to ask the artist to attend the reception and create instant portraits for the guests as souvenirs. For this, it's better to find an artist who specializes in rapid freehand cuttings.

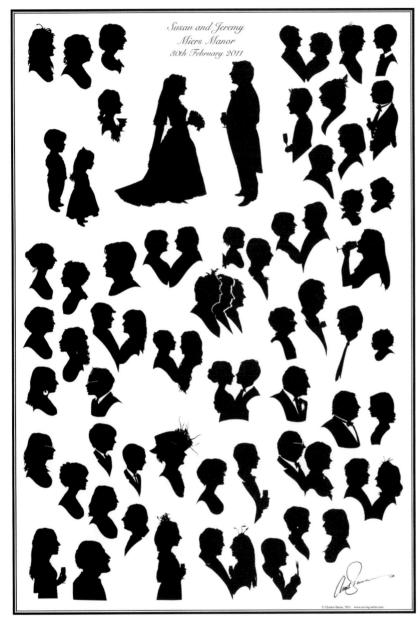

Susan and Jeremy
Miers Manor
30th February 2011

© Charles Burns, 2011 www.swing-artist.com

A montage of all the cuttings made at a wedding.

Rapid freehand cuttings

Booking an artist to attend a wedding requires a little thought. Find out how silhouettes will be presented to guests on the day. The artist should provide smart

cards to mount silhouettes as they are made, and there will be other extras for sale. For example, silhouettes of the bride and groom cut in advance can be used on invitations and other event stationery, as well as the silhouette mounting cards used on the day. You could now make these yourself; otherwise, send some photographs to the artist. This helps to create a theme, making silhouettes seem a natural part of the proceedings.

A paper memento

The illustration, left, shows a montage of silhouettes created after a wedding, which was made by scanning the duplicate copy of each silhouette. Most of the guests are cut bust length, and others are half length. The bride and groom—together with a flower girl and a ring bearer—are cut in full length, while other guests have been cut as couples, either facing each other or side by side. Many of the silhouettes are plain shades, while others have restrained slash-cut embellishments to indicate collars and ties. Although most are straight portraits, one or two have a degree of caricature. Variety is part of the fun of freehand

silhouette cutting; most of these cuttings were not planned or thought about for more than a few seconds. This level of spontaneity arises after years of determined practice and is an important part of the joy a professional artist can bring to an event.

Thinking about numbers

A professional silhouette cutter can cut even the most complicated of profiles within two minutes. Allowing time to stick silhouettes on card and exchange a few words with the guests means that you can expect around 25 to 30 silhouettes an hour. This is a cold calculation, but it's worth comparing this to the total number of guests at the wedding. For example, if there are 100 guests, it could take four hours of continuous cutting to silhouette everybody. Does the artist charge by the hour or a onetime fee?

Allowing for a break, is this much time even available during the reception? Consider, therefore, if it's necessary for everybody to receive a silhouette, or simply to allow the silhouette cutting to be part of the fun of the day. A professional will be used to dealing with this situation and will know how to entertain everybody without necessarily cutting everybody out. A big part of the joy in silhouettes comes from watching them appear as if by magic in the hands of an expert.

Alternatively, if you have a large number of guests, does the artist know another silhouettist who could help out on the day? Four hands can cut many more silhouettes than two, but of course there will be an extra fee to pay.

Giving all these questions some thought in advance will help ensure expectations are reasonable and everything goes well on the day.

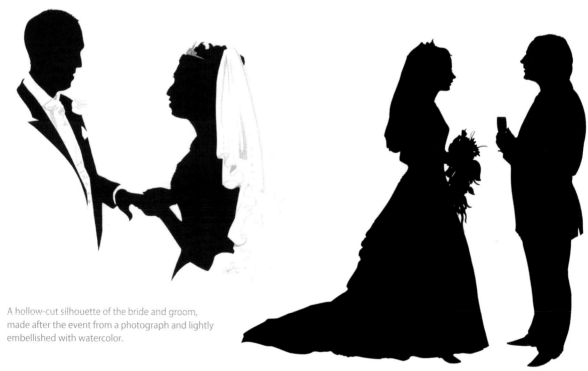

A hollow-cut silhouette of the bride and groom, made after the event from a photograph and lightly embellished with watercolor.

A pair of full-length silhouettes cut freehand on the day.

A Historical Re-creation

For those curious about the Georgian world in which silhouettes were created, the following project is an invitation to step back in time, do away with modern conveniences, such as electricity, and experience the world of an eighteenth-century profilist. A certain amount of preparation is needed, but the project is great fun and highly educational.

YOU WILL NEED:

Preparation:

- Several sheets of heavy drawing paper
- Linseed oil and several old rags
- A sturdy frame with glass
- Framing pins
- Strips of card
- Clear adhesive vinyl (such as that used to cover books)
- A pair of easels, or some other device to hold the frame

On the day:

- Small group of interested friends and suitable refreshments
- A chair
- Small table
- Candle in a lantern or tall glass jar
- Metal clips (large enough to fit your frame)
- Soft pencil

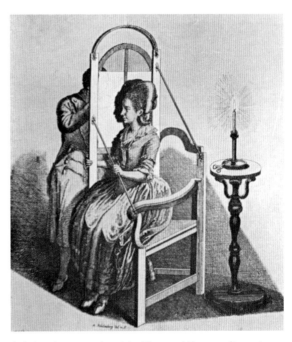

A chair and screen such as John Miers would have used to capture a shadow.

Back to the beginning

In To Capture a Shadow (see pages 16-19) we looked at John Miers's method to catch a shadow. There is one problem, however: we used a marker pen, flip-chart paper, and an electric light, but none of these were available in the eighteenth and early nineteenth centuries. Without these working aids, can you actually see a shadow through the paper? Is it possible at all to capture a shadow without using electricity?

PREPARING OILED PAPER AND GLASS

Several days beforehand, lay a sheet of paper on a flat surface and pour on some linseed oil. You will notice that the paper becomes almost transparent, absorbing a surprising amount of oil in the process. Spread the oil about using a rag, letting it soak all over the paper, then wipe off the excess before hanging it up to dry for a few days. Prepare enough sheets for the number of people you expect to take part.

As a safety precaution, soak the rags in water before disposing of them as they are flammable. Now for the screen. Find an old picture frame, big enough for your paper, then take it apart and remove the picture. Clean the glass and cover it with transparent vinyl as a precaution against it breaking or, better still, replace the 2 mm picture glass with 4 mm window glass, which is stronger. Fix the glass in place with cardboard strips and framing pins.

To secure the frame at the correct height, strap it securely to a pair of artist's easels if you have some, or else construct some simple A-frame legs. Make sure that this arrangement is stable. Place a chair in front of the screen and put the clips at the top of the frame to hold the paper (don't try to use tape as this won't stick to the oiled paper).

CATCHING A SHADOW

Place a candle in a lantern or jar on a table at about head height, a short distance from the screen, using the print as a guide. Use a pile of books if necessary to adjust the height. The further from the screen the light is, the more accurate the size of the head will be. Make sure the candle is secure and kept well away from any sheets of oiled paper as these are flammable. If you are planning to make several drawings, stack the oiled paper neatly behind the screen, and have another stack ready to receive drawings as you make them. Leaving the lights on for now, close the doors and draw the drapes to make sure no other light can enter the room, then clip the first sheet of paper to the screen.

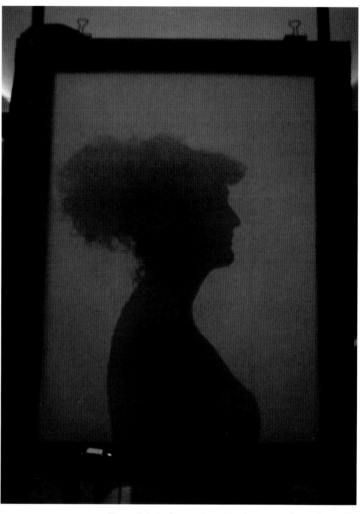

Figure 1: A shadow projected by the power of a single candle.

Ask your first subject to take a seat, then turn out the lights. You are now looking through oiled paper at a shadow projected by a candle in a darkened room (see Figure 1, above). Suddenly, it seems as though the shadow itself has taken on a whole new character; you can almost see one of John Miers's shadowy miracles living and breathing in front of you. Your model is no longer a citizen of the twenty-first century, but has been transported back in time to a forgotten, simpler age. Shadows such as this were

all around us then, an everyday experience after the sun went down and the only way to do anything was by candlelight.

Using a soft pencil (a marker pen won't "take" on oiled paper), draw the outline. You need to work quickly as your friend won't be able to sit still for long. If the oil is at all wet, it will draw out the graphite from the pencil, creating a surprisingly dark line. Note the points where light shows through the shadow, such as underneath curls of hair or behind ponytails. If your friend is wearing a scarf, look for light showing through the material, and draw this as well. Pause for a moment to study the interaction between the shadow and the marks you have made, looking for anything you may wish to recall.

If you are planning to make several profiles, clip a new sheet of paper to the screen and ask the next person to take a seat. Everybody can take turns in posing, observing, and drawing. Stack the drawings neatly to one side as you work, but make sure that the oil is fully dry before storing them in a folio.

Appreciation

Once you turn the lights back on you are bound to experience a small moment of regret, as electric light is so flat compared to the world of shadows revealed by your candle. The drawings you made have a beauty of their own, as the combination of the oil, which brings out the grain of the paper, and the quality of graphite all amounts to a pleasing effect. The likeness may seem to have vanished, as fleeting as the shadow on which it's based, but by now you are used to this and know what to do.

Be sure to sign your work, as John Miers would have done. These are your silhouette cartoons, from which any number of copies can be reduced, cut, or painted in a wide variety of styles. They are as precious to the silhouettist as photographic negatives are to the photographer.

Storing a set of captured shadows in a large cachet portfolio.

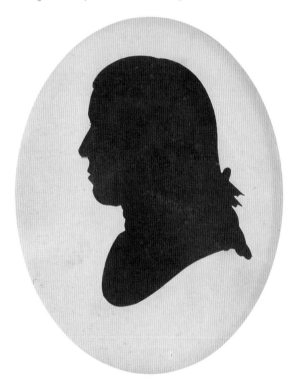

A hollow cut by Sarah Harrington (c.1774–1787) backed with blue paper and created using a candle and screen (collection of Diana Joll).

Further Study

Portrait silhouettes are deeply embedded in Western culture, forming connections with many aspects of life and art. Here are a few of the most obvious avenues of further study. By now, you will be seeing silhouettes everywhere and may well find other connections yourself.

DRAWING A PORTRAIT

The skill of being able to draw what you see in front of you is a fundamental one, although sadly overlooked by many art students today. A silhouette is a portrait, which involves capturing the likeness of the subject in front of you, and so portraiture is a good place to continue your study after learning about silhouettes.

All the portraits in this book rely on a defined outline of the face to capture likeness. Drawing without this outline necessitates a whole new set of skills. In the

nineteenth century, drawing masters thought that learning to draw the profile was an excellent starting point on the journey toward becoming an artist.

If you enjoyed making the full-length silhouettes, you might also enjoy a course in life drawing, which used to be considered a basic skill for any artist. Drawing is a natural skill we are all born with, and making silhouettes is just one of many ways to use it.

A self-portrait by Baron Scotford (collection of Jo Scotford Rice).

A 1916 drawing by Leon Underwood (1890–1975) of the author's grandfather during World War I (collection of Paul Burns).

A portrait miniature in profile by an unknown artist.

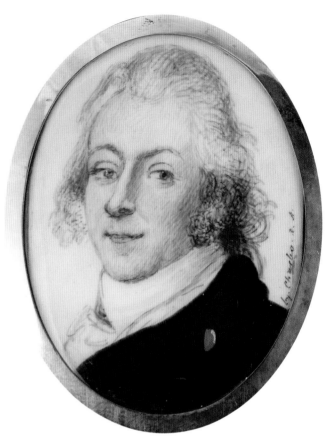

A portrait miniature by Mr. Charles (collection of Diana Joll).

THE PORTRAIT MINIATURE

If you were fascinated by the *en grisaille* and Etruscan projects on pages 122 and 128, portrait miniatures will appeal to you. Many early silhouettists—especially those who painted rather than cut their portraits—were also miniaturists. The market for miniatures in the eighteenth century was highly competitive, and some artists who were first and foremost miniaturists turned to silhouette as a way to make ends meet when times were hard. The miniature profile on the left, above, is an ancestor from the early nineteenth century, a Mr. Burns from Scotland. It shows signs of mild caricature in the treatment of the body and arms, which are not anatomically correct. In addition,

although the eyes seem normal, they are in fact slightly over-emphasized, being the same size as the mouth. Such distortions are common in miniature and are also seen in the portrait above by Mr. Charles, painted in "one hour, by the watch" (see page 48). As in silhouette art, they were done deliberately to compensate for the small scale and create a more natural-looking portrait.

Many portrait miniaturists working today tend to work from photographs, yet it is worth bearing in mind that the miniaturists of the eighteenth century had never seen, and perhaps could not imagine, something as magical as a photograph! For them, distortion seemed a natural way to create a likeness.

This 1930 paper cutting by Hubert Leslie of Peter Pan and his shadow is an interesting interpretation of the nature of shadow.

PAPER CUTTING

If you enjoyed the projects with scissors, you may like to explore paper cutting. The skills you learned can be applied to cutting all manner of designs in paper. Hubert Leslie's paper cuttings betray the same lyricism and humor that characterized his work as a silhouettist and entertainer (see pages 40-1).

Paper cutting today is a popular art, with traditions firmly embedded in almost every country around the world. In Japan, for example, the art is known as *kiri-gami*, while in Germanic culture it is called *scherenschnite*. In the U.S., the Guild of American Papercutters has many hundreds of members and always welcomes new arrivals.

Denmark's most famous author, the nineteenth-century novelist Hans Christian Andersen (1805–1875), was also a talented paper cutter. During his life, he was as well known for his ability to tell stories as to write them. While speaking he would repeatedly fold and cut sometimes large sheets of paper, unfolding them at the end to reveal the complete picture.

Fall leaves, a paper cutting.

A characteristic folded paper cutting by Hans Christian Andersen (Hans Christian Andersen Museum, Odense City Museums, Denmark).

SILHOUETTES AND MAGIC

The link between magic and silhouette is best illustrated by the story of Dai Vernon (1894–1941). Any magician will tell you he's the man who fooled Houdini with a magic trick called "The Ambitious Card."

Less well known is that during the 1920s and 1930s, Vernon made his living as an artist rather than a magician, and his talent for cutting silhouettes gave him a reliable source of income. It also gave him time to study card cheats and invent magic tricks, which is where his real talent lay. In the middle of the American depression, Vernon set up a silhouette stall with a sign saying "No Depression Here," and he invariably had a long line of customers. Almost every magician working today will perform at least one Dai Vernon trick on a regular basis, perhaps not realizing that without silhouettes many of them would not exist.

The tradition of combining silhouette and magic is continued today by Michael Herbert, a magician who—like Vernon—prefers to make his living as a silhouettist. If magic is something that interests you, this is an avenue you might like to explore.

A Dai Vernon freehand silhouette. Note the technique of cutting the head and body in two parts, then reassembling when pasting the silhouette onto a card. The stylish signature is characteristic of Vernon's work (collection of Michael Herbert).

A portrait of the author by Michael Herbert.

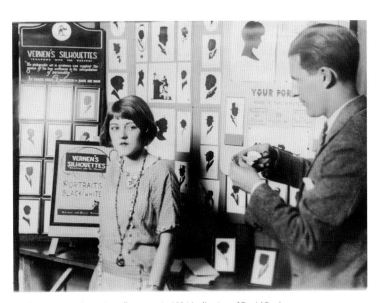

Dai Vernon at work, cutting silhouettes in 1924 (collection of David Ben).

FORTUNE TELLING AND CHARACTER READING

Johann Lavater (1741-1801) gave a huge impetus to the eighteenth-century European craze in silhouettes with his 1772 publication *Essays on Physiognomy*. In it he laid out in great detail the exact science by which one could supposedly read a person's true character from the study of their face, particularly the profile, by making detailed measurements of the features. The book was a hit—it was translated into several languages—and people flocked to silhouettist's studios for the express purpose of obtaining a profile which could later be "read," much as one might visit a palmist to have a reading of your hand.

Physiognomy is entirely discredited today. It was limited in only applying to white Caucasian faces, for which Lavater created endless sub-divisions, for example, of the nose. Today, it is only interesting as an example of the ideas that proliferated at the time.

His theories pander to a feeling in all of us that we are able to instantly make judgments about a person by looking at their face. Have you found yourself wondering about the personalities behind the many silhouettes in this book? They are all shadows of real people, but how much can you tell by looking at them? Bearing in mind these are people you have never met, how much faith can you have in what you think you see?

Pages from Lavater's *Essays on Physiognomy*.

Bibliography

Ben, David. *Dai Vernon: A Biography. Artist, Magician, Muse 1894–1941* (Chicago: Squash, 2006)

Bennet, Jean Francis. *A Shady Hobby* (Milwaukee: Bruce, 1944. 2nd ed. published as *Silhouette Cutting*, 1946)

Carrick, Alice van Leer. *A History of American Silhouettes: A Collector's Guide 1790–1840* (Rutland, VT: Charles Tuttle, 1968)

Coke, Desmond. *The Art of Silhouette* (London: Martin Secker, 1913)

Edouart, Augustin. *A Treatise on Silhouette Likenesses by Monsieur Edouart, Silhouettist to the French Royal Family and Patronized by His Royal Highness the Duke of Gloucester, and the Principal Nobility of England, Scotland and Ireland* (London: Longman, 1835)

Flocken, Kathryn K. *Silhouettes: Rediscovering the Lost Art* (Orlando, FL: PaperPortraits.com Press, 2000)

Hickman, Peggy. *Silhouettes. 'Collectors' Pieces'* 13 (London: Cassell, 1968)

Silhouettes: A Living Art (Newton Abbott: David & Charles, 1975)

Two Centuries of Silhouettes: Celebrities in Profile (London: A&C Black, 1971)

Jackson, E. Nevill. *Silhouette: Notes and Dictionary* (New York: Charles Scribner's Sons, 1938)

The History of Silhouettes (London: The Connoisseur, 1911)

Joll, Diana. *Silhouette Collectors' Club Newsletter* (Brighton: various editions 1997–2011)

Laughon, Helen and Nel. *August Edouart: A Quaker Album* (Richmond, VA: Cheswick, 1987)

Leslie, Hubert. *Artful Art and Breathless Brainwaves* (Crawley: Courier, 1974)

Lister, Raymond. *Silhouettes, an Introduction to Their History and to the Art of Cutting and Painting Them* (London: Isaac Pitman & Sons, 1953)

London, Hannah R. *Miniatures and Silhouettes of Early American Jews* (Rutland, VT: Charles Tuttle, 1970)

Marsh, Honoria D. *Shades from Jane Austen* (London: Parry Jackman, 1975)

May, Leonard Morgan. *A Master of Silhouette, John Miers: Portrait Artist, 1757–1821* (London: Martin Secker, 1938)

Mayne, Arthur. *British Profile Miniaturists* (Boston: Boston Book and Art, 1970)

McKechnie, Sue. *British Silhouette Artists and their Work 1760–1860* (London: Sotheby Parke Bernet, 1978)

Jacob Spornberg, 18th-Century Artist from Finland (London: Tabard, 1971)

McSwiggan, Kevin. *Silhouettes* (Princes Risborough: Shire, 1997)

Mylius, Johan de. *H.C. Andersen: Paper Cuts* (Germany: Aschehoug, 2000)

Oliver, Andrew. *Auguste Edouart's Silhouettes of Eminent Americans, 1839–1844* (Charlottesville, VA: Smithsonian, 1977)

Piper, David. *Shades: An Essay on English Portrait Silhouettes* (New York: Chilmark, 1970)

Rendell, Jerry. *H.L. Oakley, Silhouette Artist 1882–1960* (England: privately printed, 2005)

Rice, Carew. *A Selection of Songs and Scissor-Cut Silhouettes: Low Country Artistry* (Charleston, SC: Walker, Evans & Cogswell, 1961)

Rifken, Blume J. *Silhouettes in America, 1760–1849, A Collectors' Guide* (Burlington, VT: Paradigm Press, 1987)

Roe, F. Gordon. *Women in Profile, A Study in Silhouette* (London: John Baker, 1970)

Rutherford, Emma. *Silhouette: The Art of the Shadow* (New York: Rizzoli, 2009)

Profiles of a New World (published in *America in Britain*, vol XLVIII; Bath: The American Museum in Britain, 2010)

Simms, Leon A. *The Art of Silhouette Cutting* (London: Frederick Warne & Co., 1937)

Von Boehn, Max. *Miniatures and Silhouettes* (2nd ed. New York: Benjamin Blom, 1970)

Woodiwiss, John. *British Silhouettes* (London: Country Life, 1965)

Index

Acknowledgments

AUTHOR'S ACKNOWLEDGMENTS

With thanks firstly to my family, Kazumi, Taz, and Nic, for putting up with my long-standing obsession with silhouettes.

Next thanks to Diana Joll of the Silhouette Collectors' Club, for allowing me to photograph her collection and for her knowledgeable input into the various historical sections.

To the many friends, family and colleagues who have "lent" me their profile for a variety of weird experiments on the theme of silhouette: not all ended up in the book, but all were necessary and valuable.

Especially to my friend and colleague Michael Herbert, for the many long conversations about the minutiae of silhouette cutting and helping to invent so many different cuts.

Lastly to the various living relatives of past silhouettists who have been so patient in answering all my questions.

PUBLISHERS' ACKNOWLEDGMENTS

The Publishers would like to thank Janis Utton for additional design support; Daniela Nava for proofreading; Lynda Swindells for the index.

PICTURE CREDITS

The Publishers would like to thank the following for their kind permission to reproduce images from their collections. The Publishers have endeavored to credit all known holders of copyright or reproduction rights for the illustrations in this book.

Key b = bottom, l= left, r = right, t = top
Roger Baverstock: 112, 113b; David Ben: 171br; Paul Burns: 168r; Alan Everitt: 121l; Hans Christian Andersen Museum, Odense City Museums 170r; James Gray collection, The Regency Society: 89; John and Janey Haselden: 88; Joe Herinckx: 26t; Michael Herbert: 17, 122, 171t; Imperial War Museum: by permission of the Royal Imperial War Museum IWM PST11517, 117t; Diana Joll: 7, 14, 38, 48, 49, 57, 67t, 78, 79, 84, 93, 94, 108, 109, 120, 121r, 127t, 138, 139, 150, 151, 160, 167b, 169r; Library of Congress, LC-USZ62-47217: 73; London Sketch Club: 67b, 117b; Museum of Early Southern Decorative Arts, Old Salem Museums and Gardens: 21tl; National Portrait Gallery, London: 40; Julia Randall: 100; Jo Scotford Rice: 101, 168l; Vatican Museums: 127b

Captions to chapter openers: page 10, A freehand scissor-cut silhouette; page 36, A silhouette painted in black gouache; page 84, A soldier in blue by John Buncombe (collection of Diana Joll); page 134, A lady with lacy frills, painted on flat glass in the 1780s by Walter Jorden (collection of Diana Joll).

All silhouettes are copyright or in the collection of the author unless otherwise stated.

Hand photography by Sue Reeves of SuePix
Additional photography by the author